Jacob Lawrence:

The Migration Series

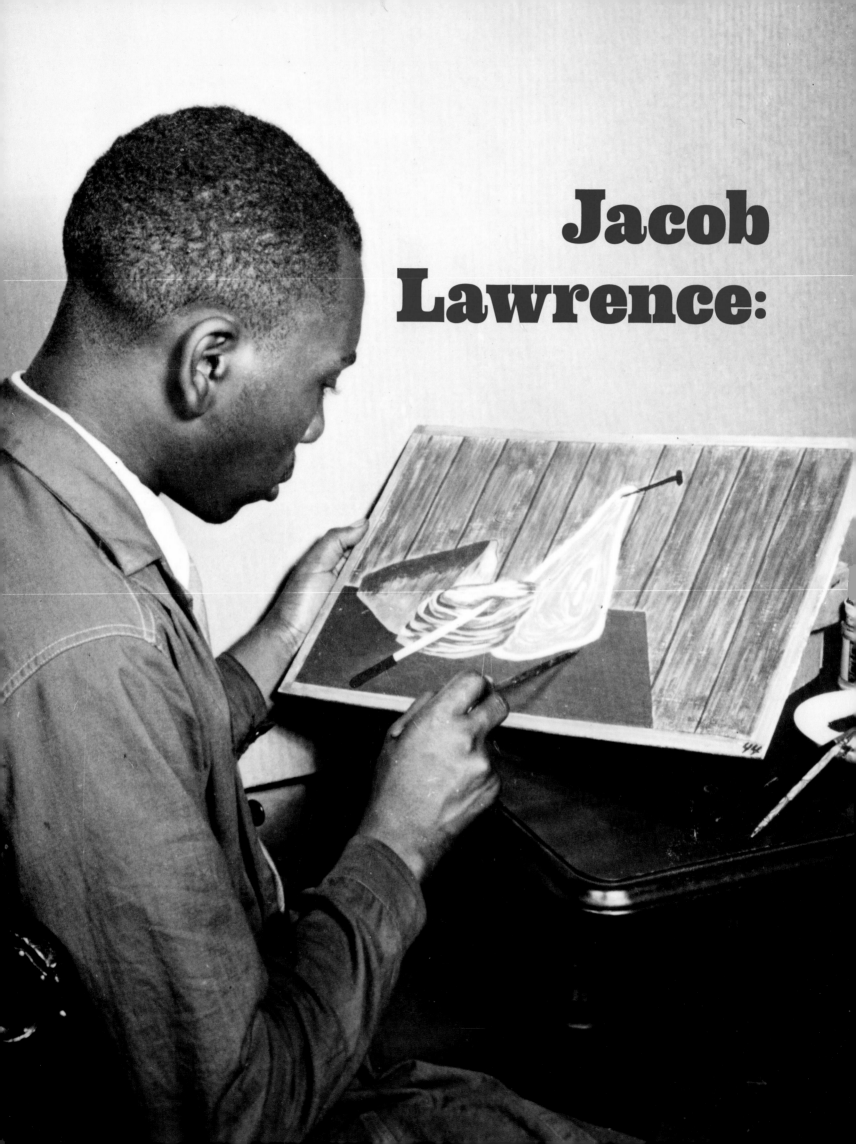

Jacob Lawrence:

The Migration Series

Leah Dickerman and Elsa Smithgall

WITH CONTRIBUTIONS BY:
Elizabeth Alexander, Rita Dove, Nikky Finney, Terrance Hayes,
Tyehimba Jess, Yusef Komunyakaa, Jodi Roberts, Patricia
Spears Jones, Natasha Trethewey, Lyrae Van Clief-Stefanon,
Crystal Williams, and Kevin Young

The Museum of Modern Art, New York, and The Phillips Collection, Washington, D.C.

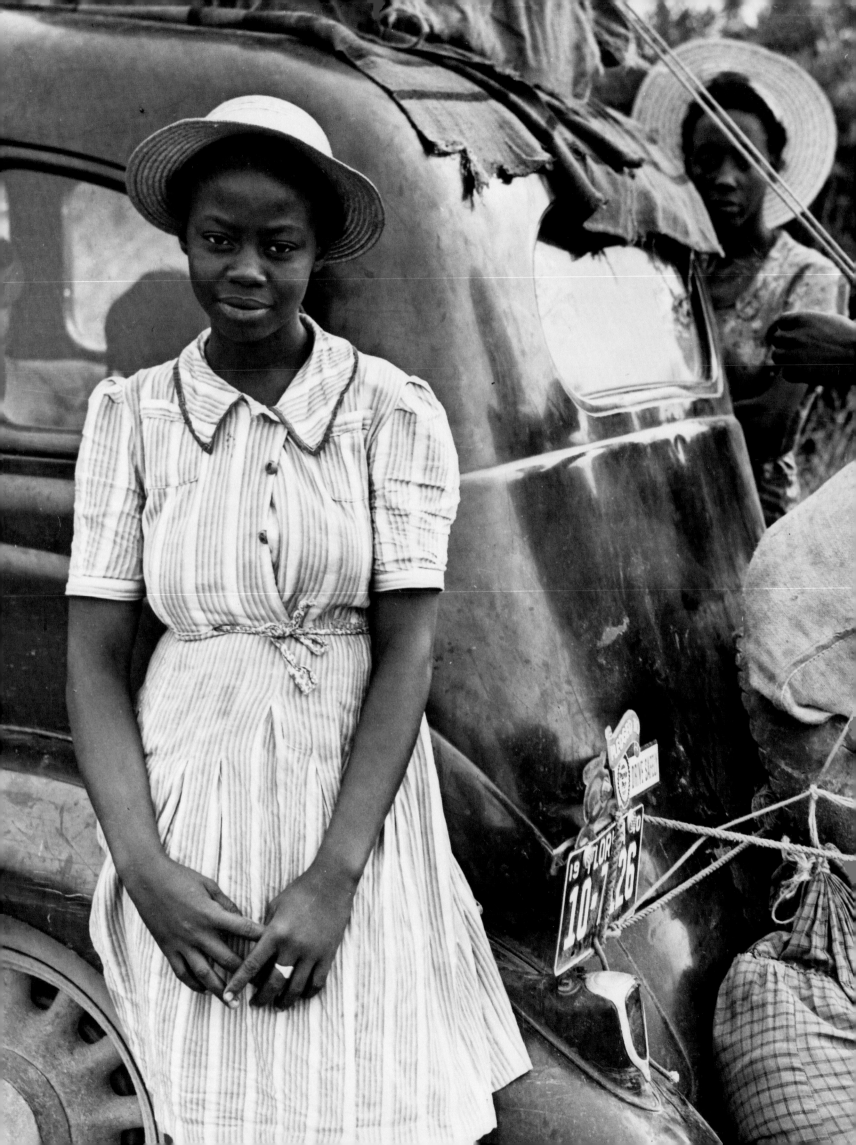

Contents

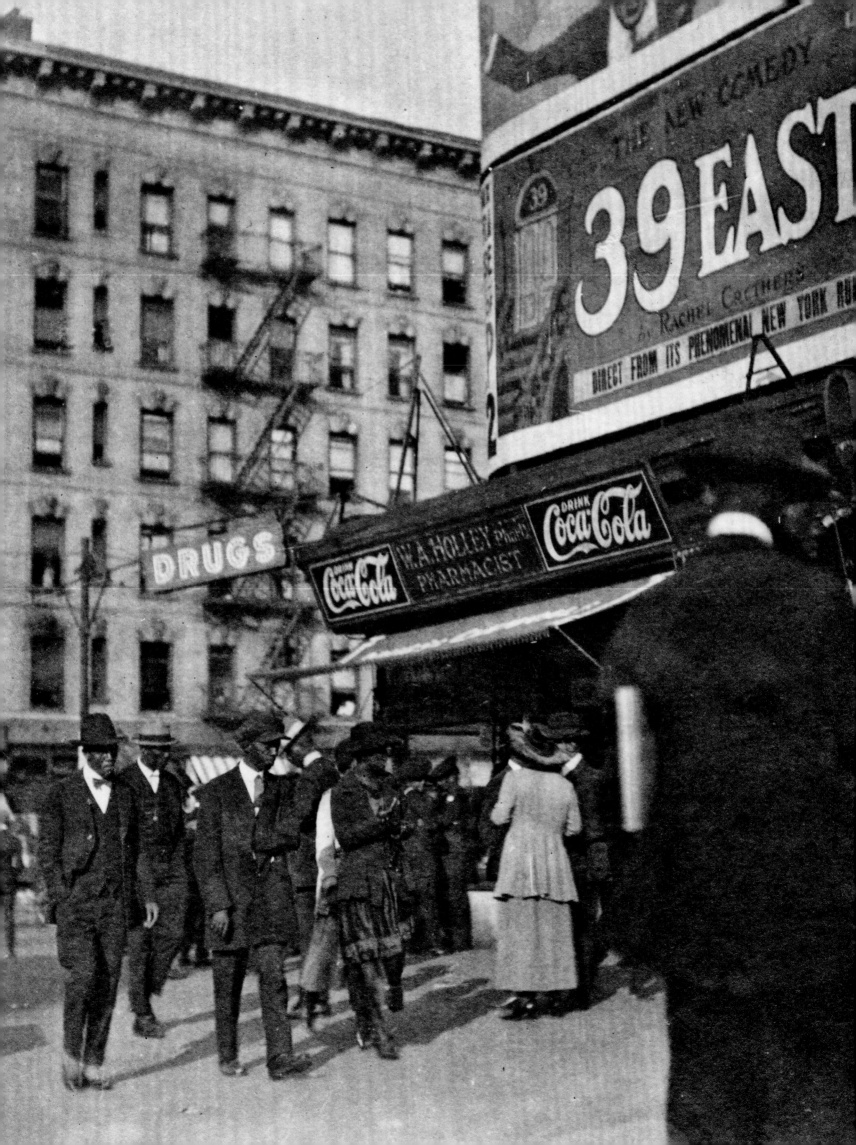

Foreword

In 1941, Jacob Lawrence, then just twenty-three years old, completed a series of sixty small tempera paintings with text captions on the subject of the Great Migration, the mass movement of black Americans from the rural South to the urban North that began during World War I. Lawrence, himself a child of migrants, had lived in Harlem since about age thirteen, and his work as an artist was shaped by immersion in contemporary debates about writing and giving visual form to African-American history. His engagement with these issues is reflected in his intense, research-based working process: before picking up a paintbrush to work on the series, he spent months at the 135th Street branch of the New York Public Library (now the Schomburg Center for Research in Black Culture) studying historical documents, books, photographs, journals, and other printed matter. The resulting work, which moved between scenes of terror and violence and images of strength and perseverance, gave the visual arts a radically new vision of contemporary black experience.

Within months of its making, the series was shown at Manhattan's Downtown Gallery, where it was enthusiastically embraced by Alfred H. Barr, Jr., Director of The Museum of Modern Art, and Duncan Phillips, Director of the Phillips Memorial Gallery (now The Phillips Collection). Each institution soon acquired half of the panels, dividing them on the principle of even (MoMA) and odd numbers (Phillips Collection). A landmark in the history of modern art, and a crucial example of the reimagining of the long tradition of history painting, the Migration Series has remained a cornerstone of both collections.

We are proud of our shared history with this American masterpiece and are delighted to be collaborating to reunite it, displaying the Migration Series in its entirety at MoMA in 2015 and at The Phillips Collection in 2016. At MoMA the exhibition and related initiatives are organized by Leah Dickerman, Curator, with Jodi Roberts, Curatorial Assistant, Department of Painting and Sculpture, and at The Phillips Collection by Elsa Smithgall, Curator. We are also delighted to be working in collaboration with the Schomburg Center for Research in Black Culture, the library that has nurtured so many generations of cultural figures, especially those who have called Harlem their home.

We extend our heartfelt thanks to those who have supported the project at both MoMA and The Phillips Collection. At The Museum of Modern Art we are tremendously grateful to the Ford Foundation; the Museum's Research and Scholarly Publications Endowment established through the generosity of The Andrew W. Mellon Foundation, the Edward John Noble Foundation, Mr. and Mrs. Perry R. Bass, and the National Endowment for the Humanities' Challenge Grant Program; The Friends of Education of The Museum of Modern Art; Marie-Josée and Henry Kravis; MoMA's Wallis Annenberg Fund for Innovation in Contemporary Art through the Annenberg Foundation; Karole Dill Barkley and Eric J. Barkley, and the MoMA Annual Exhibition Fund.

The Phillips Collection is grateful to A. Fenner Milton, Judy and Leo Zickler and the Zickler Family Foundation, and the Henry Luce Foundation for their generous support of the museum's Jacob Lawrence microsite launched in conjunction with the exhibition. We are also grateful to Kymber and Bo Menkiti for their support of The Phillips Collection's exhibition and microsite on the occasion of Menkiti Group's tenth anniversary.

On behalf of the Trustees and staff at our institutions, we wish to extend a special thanks to the Jacob and Gwendolyn Knight Lawrence Foundation. We also acknowledge the lenders to both exhibitions who have entrusted us with the care of their works. Their generosity has earned our profound gratitude.

Glenn D. Lowry
Director, The Museum of Modern Art

Dorothy Kosinski
Director, The Phillips Collection

Acknowledgments

This volume, which accompanies exhibitions and programming initiatives related to Jacob Lawrence's Migration Series at The Museum of Modern Art in 2015 and at The Phillips Collection in 2016, would have been impossible to realize without the dedicated efforts of many.

At The Museum of Modern Art, Director Glenn D. Lowry has offered unwavering commitment. Ann Temkin, The Marie-Josée and Henry Kravis Chief Curator of Painting and Sculpture, has shepherded the project to its realization with sage advice. Ramona Bronkar Bannayan, Senior Deputy Director, Exhibitions and Collections, has overseen its intricacies with patient guidance. Peter Reed, Senior Deputy Director, Curatorial Affairs, offered crucial support in launching the research initiatives that have shaped it in crucial ways. Frank Ahimaz, Chief Investment Officer, lent special help at key moments. The efforts of Todd Bishop, Senior Deputy Director of External Affairs, have been invaluable. The Museum's Board of Trustees, led by Chairman Jerry I. Speyer, has as always been remarkable; we extend special thanks to Marie-Josée Kravis, President, who has provided warm encouragement and support, and to Trustees A. C. Hudgins and Marcus Samuelsson, who have been passionate advocates.

At The Phillips Collection, our heartfelt thanks go to Dorothy Kosinski, Director, for her unstinting belief in furthering the Phillips's longtime commitment to the study and presentation of Jacob Lawrence. Chief Operating Officer Sue Nichols has skillfully guided the project's administrative aspects. Special gratitude to our senior staff for extending their steadfast support and advice. The Phillips Board of Trustees, ably led by Chairman George Vradenburg, has embraced this project with wholehearted commitment and support; we especially thank Trustees A. Fenner Milton, Leo Zickler, Linda Kaplan, and Mary Howell for their leadership in helping to realize the exhibition and related initiatives.

It has been a true pleasure to work with the staff of the Schomburg Center for Research in Black Culture, and we are especially grateful to its Director, Khalil Gibran Muhammad, for his enthusiasm and intellectual generosity.

At The Museum of Modern Art, the exhibition has been made possible by The Ford Foundation, and we especially thank its President, Darren Walker, for his personal involvement. Crucial support for related research initiatives comes from the Museum's Research and Scholarly Publications endowment established through the generosity of The Andrew W. Mellon Foundation, the Edward John Noble Foundation, Mr. and Mrs. Perry R. Bass, and the National Endowment for the Humanities' Challenge Grant Program. The Museum is also grateful for generous funding from The Friends of Education of The Museum of Modern Art, Marie-Josée and Henry Kravis, MoMA's Wallis Annenberg Fund for Innovation in Contemporary Art through the Annenberg Foundation, Karole Dill Barkley and Eric J. Barkley, and the MoMA Annual Exhibition Fund.

The Phillips Collection is grateful to A. Fenner Milton, Judy and Leo Zickler and the Zickler Family Foundation, and the Henry Luce Foundation for their generous support of the museum's Jacob Lawrence microsite launched in conjunction with the exhibition. We are also grateful to Kymber and Bo Menkiti for their support of The Phillips Collection's exhibition and microsite on the occasion of Menkiti Group's tenth anniversary.

The lenders to the exhibitions at both The Museum of Modern Art and The Phillips Collection have our most profound appreciation; their generosity has been essential to this undertaking.

Jacob Lawrence's images appear in this book thanks to the support of the Jacob and Gwendolyn Knight Lawrence Foundation; our great thanks go to the Foundation's President, Walter O. Evans.

At The Museum of Modern Art, the project was shaped in many ways by discussions among participants in our Jacob Lawrence Advisory Committee, which met three times during our preparations. We extend our sincere gratitude to all those who attended these sessions: Elizabeth Alexander, Anthony Appiah, Sara Bodinson, Jim Coddington, Patricia Cruz, Darby English, Henry Finder, Thelma Golden, Farah Griffin, James Grossman, A. C. Hudgins, George Hutchinson, Steffani Jemison, Vernon Jordan, Thomas Lax, Bernard Lumpkin, Shola Lynch, Kerry James Marshall, Terrance McKnight, Julie Mehretu, Khalil Gibran Muhammad, Robert O'Meally, Samuel Pollard, Guthrie Ramsey, Sharifa Rhodes-Pitts, Marcus Samuelsson, Josh Siegel, Elsa Smithgall, and Darren Walker.

The Phillips Collection's presentation of the exhibition and its related programs benefited from thoughtful contributions and expert guidance from an advisory team of leading scholars and practitioners across disciplines: Ira Berlin, Kinshasha Holman Conwill, Leah Dickerman, David Driskell, John Edward Hasse, Jacqueline E. Lawton, Julie L. McGee, E. Ethelbert Miller, James A. Miller, Khalil Gibran Muhammad, Bibiana Obler, Jacquelyne Serwer, Elizabeth Turner, and Brian Williams. We also gratefully acknowledge our warm and fruitful programmatic

collaborations with world-class arts organizations in our community to bring the Migration Series alive by celebrating its strong ties to the performing arts. We thank Jenny Bilfield and Paul Brohan, Washington Performing Arts; Brian Williams, StepAfrika!; Joseph Horowitz and Angel Gil-Ordóñez, PostClassical Ensemble; Shelley Brown, Strathmore; and Anna Celenza and Thomas E. Caestecker, Georgetown University.

Crucial help with research and the securing of images and loans was generously provided by: Ja-Zette Marshburn, Afro-American Newspapers Archives and Research Center; Melissa Barton and Nancy Kuhl, Beinecke Rare Book & Manuscript Library Collection of American Literature; Leah Schlackman, Evergreene Architectural Arts; Aisha M. Johnson, John Hope and Aurelia E. Franklin Library, Fisk University; Albert Henderson; Elizabeth Surles, Institute of Jazz Studies, Rutgers University; Katherine Danalakis and Mason Klein, The Jewish Museum; Corrine Jennings, Kenkeleba House; Christine McKay, independent curator; Susan McNeill; DC Moore Gallery; Kenvi Phillips, Ida Jones, and Joellen El Bashir, Moorland-Spingarn Research Center, Howard University; Nicholas Natanson, National Archives; Paul Karwacki, Penn State University Archives; Joe McCary, Photo Response; the Michael Rosenfeld Gallery; Tamar Dougherty, Tammi Lawson, and Mary Yearwood, the Schomburg Center for Research in Black Culture; Virginia Mecklenburg, Smithsonian American Art Museum; Margaret Z. Atkins, Smithsonian Archives of American Art; Nicole C. Dittrich, Special Collections Research Center, Syracuse University Libraries; Timothy Naftali, Tamiment Library and Robert F. Wagner Labor Archives, New York University; Bill Hooper, Time Inc. Archives; and Harry Weinger, Universal Music Group.

The exhibitions and book result from the work of many individuals throughout our respective institutions. Leah Dickerman's curatorial team at The Museum of Modern Art was led by Jodi Roberts, whose keen mind and thoughtful care are evident throughout both show and book. The team also included Jenny Harris, Rebecca Lowery, and Melinda Lang, whose contributions are vast and whose talent and determination were remarkable. Interns Marta Arenal, Roya Sachs, and Julie Timte also provided great assistance.

In the Department of Publications we thank Christopher Hudson, Chul R. Kim, Matthew Pimm, and Fionnuala McGowan. David Frankel, editor of this book, has our great thanks and admiration. Silas Munro, principal of poly-mode, has crafted an intelligent and exciting design for the volume.

We are also grateful to Cerrie Bamford in Affiliate Programs; Jim Coddington in Conservation; Shannon Darrough, Maggie Lederer, and Fiona Romeo in the Department of Digital Media; Sara Bodinson, Pablo Helguera, Deb Howes, Liz Margulies, and Francesca Rosenberg in the Department of Education; Mack Cole-Edelsack and Lana Hum in Exhibition Design and Production; Randolph Black in Exhibition Planning and Administration; Josh Siegel and Rajendra Roy in the Department of Film; Ingrid Chou and Greg Hathaway in Graphic Design and Advertising; Stuart Comer and Thomas Lax in the Department of Media and Performance Art; Quentin Bajac and Sarah Meister in the Department of Photography; and Maggie Lyko and Melanie Monios in the Department of Special Events.

Our gratitude also goes to the talented and dedicated members of the departments of Art Handling and Preparation; Communications; Development; Imaging and Visual Resources; Library and Archives; Marketing; and Security.

At the Phillips, Elsa Smithgall acknowledges with much gratitude the diligent and intelligent assistance of Liza Strelka, Curatorial. The related initiatives could not have been realized without the dedicated interdepartmental leadership and cooperation of Sarah Schaffer, Marketing and Communications; Darci Vanderhoff, Information Technology; Suzanne Wright, Education; and their teams. The extremely capable and committed members of the Phillips staff deserve special thanks, including Joseph Holbach and Trish Waters, Registration; Elizabeth Steele and Patricia Favero, Conservation; Dale Mott, Development; Christine Hollins, Institutional Giving; Laith Alnouri, Corporate Relations; Andrea O'Brien, Individual Giving and Membership; Cheryl Nichols, Budgeting and Reporting; Karen Schneider, Library and Archives; Bill Koberg, Shelly Wischhusen, and Alec MacKaye, Installations; Angela Gillespie, Human Resources; Dan Datlow and Peter Kinsella, Operations and Security; Caroline Paganussi, Executive Assistant to the Director and the Board of Trustees; and all the devoted curatorial interns who worked tirelessly on research and organizational aspects of this project: Carolyn Bauer, Evelyn Braithwaite, Emily Conforto, James Denison, Genevieve Lipinsky de Orlov, and Anna Walcutt.

While too many to name, our colleagues at both The Museum of Modern Art and The Phillips Collection have allied their efforts and creativity in realizing this project.

The acclaimed poet Elizabeth Alexander conceived of the Migration Series Poetry Suite and solicited the poems by ten outstanding poets that appear in this volume. We are grateful for her work and proud of the result. The poetry suite was supported by MoMA's departments of Publications and Education.

Leah Dickerman
Curator,
Department of Painting and Sculpture,
The Museum of Modern Art

Elsa Smithgall
Curator,
The Phillips Collection

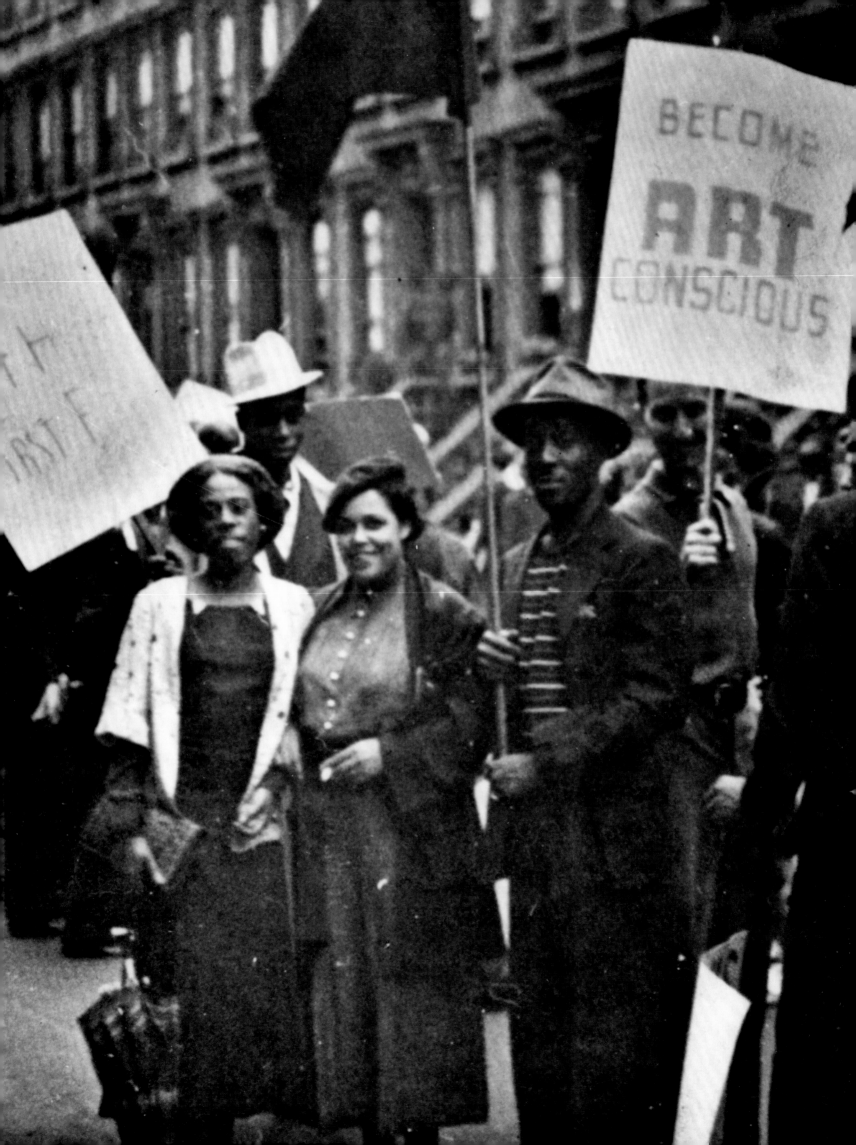

Fighting Blues

Leah Dickerman

"The Spirituals were born on the plantation; The blues were created on the pavements of the city, in saw mills, in lumber camps: in short, wherever the migrant Negro, fresh from the soil, wrestled with an alien reality."[1]

–Richard Wright, Liner notes for Josh White's album *Southern Exposure*

In June 1941, Edith Halpert, a gallerist who represented many of the leading artists of the American avant-garde, arranged to meet the critic and philosopher Alain Locke at the Harlem Community Art Center, on Lenox Avenue and 125th Street in Harlem. Halpert had solicited Locke's advice in shaping an exhibition of work by contemporary black artists for her Downtown Gallery. This outing was very likely when Halpert first saw Jacob Lawrence's newest series of gouache panels.[2] The artist, then just twenty-three, was a rising star; his innovative multipanel narrative series on the lives of Toussaint L'Ouverture, Frederick Douglass, and Harriet Tubman, significant figures in African-American history, had already won praise. This latest series, though—sixty tempera panels, each paired with a caption—dealt in an epic way with a near contemporaneous phenomenon and subject of great topicality: the mass movement of blacks from the South to the North that had begun during World War I, lay in Lawrence's own family background, and had transformed the Harlem community in which he lived. The unusual uptown viewing set off a chain of events that took Lawrence's career to a new level of recognition, unprecedented for a black artist in the United States.

In November 1941, twenty-six of the panels were reproduced in color in *Fortune* magazine. That same month, Halpert showed the series at her Downtown Gallery, and she would also include it in a round-up of work by black artists, selected with Locke, at her gallery a few weeks later. There, although the opening festivities were undercut by the bombing of Pearl Harbor, the show was seen by Duncan Phillips and Alfred H. Barr, Jr., the curator/directors of, respectively, the Phillips Memorial Gallery (now The Phillips Collection), in Washington, D.C., and New York's

Museum of Modern Art, two of the first public institutions dedicated to collecting and showing modern art in the United States. With Halpert brokering the purchase, each institution soon acquired half of the series, dividing the group of sixty panels between them. After the sale, the full series was shown at the Phillips in 1942, then went on a fifteen-stop tour, organized by MoMA, that concluded with a New York presentation at the Museum in 1944 **(p. 42, figs. 15, 16)**. While these events launched Lawrence's national reputation, the artist himself always maintained that in making the Migration Series, "I wasn't thinking of sales or of a gallery."[3] In comments like this, Lawrence suggests that despite its benefits to his career, and some pleasure in his inclusion in these collections, the conversation among institutional arbiters of modern art—among gallerists, collectors, and curators—had not been his primary focus.

WPA Harlem

Lawrence arrived in Harlem around 1930, at about the age of thirteen, with his mother, sister, and brother. He had spent the early years of his childhood first in Atlantic City, New Jersey, where his mother and Lawrence's father had met after moving up from the South, then in resettlement camps in the hardscrabble mining town of Easton, Pennsylvania. His parents soon separated and his mother moved with Lawrence and his siblings to Philadelphia. After some time spent trying to get a foothold, she went to New York City to find work that could better support them, leaving the children behind in foster homes in Philadelphia, and brought them to New York to join her a few years later. By the time Lawrence got there, Harlem had been hit hard by the Great Depression: black workers were often the first to lose jobs—40 percent of black men in New York were registered as unemployed in 1937, compared with 15 percent of whites[4]—and the neighborhood had lost some of the Jazz Age jubilance of the decade or so before, the period often

called the Harlem Renaissance.[5] But despite the sobered atmosphere, in the later 1930s and early '40s, the years in which Lawrence matured as an artist, Harlem saw a second flourishing of cultural activity, this time with a distinctly new tone.

Harlem's vibrancy during the Depression was in many ways incubated by federal-government New Deal support for cultural programs initiated in the mid-1930s. Between 1935 and 1942, the Works Progress Administration (WPA) spent $11 billion and employed 3 million people nationwide, mostly in the construction of the network of bridges, roads, and dams that would provide the country's civil-engineering infrastructure for the next decades.[6] Yet within this overarching relief program, Federal Project Number One was dedicated to cultural work. It was divided by discipline into four parts—Art, Music, Theater, and Writers—and the division for visual artists, called the Federal Art Project (FAP), was run by curator and arts administrator Holger Cahill, who a few years earlier had done a stint as acting director of MoMA while Barr was on a leave of absence. Separate FAP departments were charged with art instruction, research, and the creation of art for nonfederal public buildings (schools, libraries, and hospitals). The FAP also established over 100 community art centers, which offered gallery spaces and tuition-free classes. Although artists accounted for only a small percentage of those on the WPA payroll,[7] their inclusion there not only assured their continued creative activity through these economically disastrous years but also offered a new conceptual model of the artist: an artist-citizen, working for wages to produce not commodities for a market but cultural artifacts for a public. A note that Lawrence wrote to Locke during his own WPA stint suggests the degree to which he had absorbed this ethos:

> **"I think it means much more to an artist to have people like and enjoy his work than it does to have a few individuals purchase his work, and it not have the interest of the masses."[8]**

For white artists, WPA programs were intended to replace sources of employment lost during the Depression; for black artists, however, they provided funding on a level that had not existed before. The Depression, paradoxically, gave significant numbers of African-American artists the new ability to work full-time within their disciplines. But the participation of black artists in these programs was not a passive achievement, a simple move to take advantage of available federal funding; it was the result of organized activism. An artist

1. Left to right: Gwendolyn Bennett, Sarah West, Louise Jefferson, and Augusta Savage with Eleanor Roosevelt at the opening of the Harlem Community Art Center, December 20, 1937. Photographs and Prints Division, Schomburg Center for Research in Black Culture, The New York Public Library, Astor, Lenox and Tilden Foundations

who wanted to join the federal payroll had to document his or her status as a professional, a task made difficult for black artists by their near exclusion from exhibition venues and art-school faculties. "Initially ignorant of African-American artists," wrote the artist Romare Bearden (a friend of Lawrence's from those years) and the art historian Harry Henderson, "WPA administrators refused to hire them until overwhelming evidence from Harmon files, universities, colleges, galleries, and leading white artists demonstrated their existence."[9]

The need to go to the William E. Harmon Foundation—dedicated to championing work by African-American artists through prizes, grants, and Foundation-curated exhibitions, but often patronizing in its policies—rankled many. So too did the relative absence of black artists in supervisory roles on WPA/FAP projects. "We discovered that there was a lot going on in the WPA that we weren't getting the benefits of," recalled Charles Alston, Lawrence's teacher and mentor since his teenage years.[10] Early in 1935, Alston and a handful of others, including the artists Augusta Savage, Gwendolyn Bennett, Aaron Douglas, Norman Lewis, and the bibliophile Arturo Schomburg, founded the Harlem Artists' Guild to champion the interests of black artists, particularly with regard to the new federal programs; Lawrence became a member.[11] The group advocated for WPA commissions and the establishment of a federally supported community art center in Harlem, and protested cutbacks to New York projects (a favorite target of Southern Democrats) and discriminatory practices within the WPA. Guild artists were ready to take to the streets, picketing on a number of occasions **(frontis)**.[12]

The Harlem Artists' Guild could point to important victories. "We succeeded," Alston remembered, "in getting practically everybody who could prove he was somewhat of an artist on the project."[13] The Harlem Community Art Center was the largest of the over 100 art centers built nationwide with federal support;[14] in a sign of its political significance, First Lady Eleanor Roosevelt attended the opening-day ceremonies, on December 20, 1937 **(fig. 1)**, which featured an exhibition of WPA works by Guild artists. The Chairman of the Center's Citizens' Committee, A. Philip Randolph, spoke at the opening.[15] As president

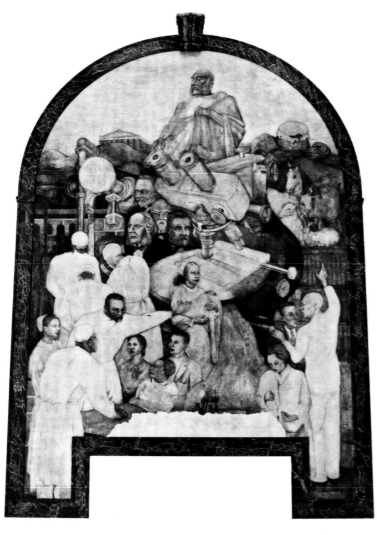

2. Charles Alston. *Modern Medicine*. 1936–40. Oil on canvas, 17 x 9' (5.2 x 2.7 m). Originally installed in the lobby of the Women's Pavilion, Nurses' Residence, Harlem Hospital, New York; now in the hospital's Mural Pavilion. Harlem Hospital Center, New York

of the Brotherhood of Sleeping Car Porters—the first predominantly black labor union, founded in 1925—Randolph served as an important advisor and inspiration for black union-organizing. Douglas was named the Center's first president, Savage the vice-president. The previous year, Alston had also received a major commission for a series of murals for the Harlem Hospital **(fig. 2)**, supervising the work of some twenty other artists, including Lawrence's future wife, Gwendolyn Knight. Though he was not officially on the payroll, Lawrence would remember helping Alston to transfer drawings to walls.[16] The Guild stepped in again in February 1936, when the hospital's superintendent objected that there was "too much Negro subject matter" in the design approved by WPA officials.[17] The Guild and the Artists' Union, a left-leaning voice for unemployed artists led by the painter Stuart Davis, jumped to protest: a joint statement

reported in the *Daily Worker* declared that the superintendent "was eminently unqualified to act either as a judge of the murals or as spokesman for the Harlem community."[18] The WPA reaffirmed Alston's plan. The extraordinary success that Guild lobbying represented is underscored by the fact that the Brotherhood of Sleeping Car Porters would only win its first, unprecedented contract with the Pullman Company in 1937, after more than a decade of organizing. The Guild, significantly, also provided Harlem artists with on-the-ground training in political activism.

In Lawrence's case the advocacy was also personal. After his first solo show, in 1938, at the Harlem YMCA—scenes of people and places in his Harlem neighborhood **(fig. 3)**—he could claim status as a professional artist eligible for the WPA payroll. Savage worried that he was working odd jobs that distracted him from painting; she escorted him downtown to WPA headquarters to enroll him, only to see him turned down because he was not yet twenty-one. A year later she marched him down again, and successfully signed him up, though he was still shy of the mark—a testament to her persuasive insistence.[19] Too young to be entrusted with the supervision of a mural commission, Lawrence was instead assigned to the easel division, a bureaucracy-imposed limitation of scale that he later credited with prompting him to think in a serial format in order "to tell a complete story."[20] From April 27, 1938, until October 27, 1939, the maximum period allowed on the FAP payroll, Lawrence was required to present two paintings every six weeks in return for a paycheck of $95.44 a month.[21] He recognized the importance of Savage's intervention:

"If Augusta Savage hadn't insisted on getting me onto the project, I don't think I would ever have become an artist."[22]

Ultimately, the flow of federal funding into Lawrence's neighborhood across these years and those immediately previous, in which small amounts of pre-WPA New Deal cultural support were in play, was remarkable. Even before the opening of the Harlem Community Art Center, in December 1937, Lawrence could and did spend time (in some combination of working and hanging out) at the workshops held at: 1) Savage's studio, first at 163 West 143rd Street, later at 239 West 135th; 2) the YMCA at 180 West 135th Street, between Lenox and Seventh avenues; 3) the Harlem Art Workshop, which offered classes

in the basement of the branch of the New York Public Library at 103 West 135th Street in Harlem and later in an old nightclub building at 270 West 136th Street, with teachers including Alston and the printmakers James Lesesne Wells and Palmer Hayden; and 4) Alston's and the sculptor Henry "Mike" Bannarn's studio at 306 West 141 Street.[23] Although there was a wide range in the degree of formal instruction these workshops offered, all of them received federal support toward the costs of salaries, rent, and supplies. The result was a dense complex of working spaces within a few blocks, in which young artists could find an array of materials and forms of guidance, with many of them—Lawrence included—moving fluidly between sites. As an infrastructure for artmaking, this complex of black artist-run workshops and organizations stood in stark contrast to the void of exhibition spaces and art schools in Harlem that Savage remembered encountering on her return from Paris at the beginning of the decade.[24]

Moreover, the WPA's four-channel arts structure brought together artists working in different disciplines. The poet Langston Hughes, for example, ran his Suitcase Theater at the Harlem Community Art Center in spaces adjacent to those for art classes and exhibitions; the activist actor Paul Robeson had an office there.[25] While Alston was conducting classes at the 135th Street library, nearby staff on salary from the Federal Writers' Project (FWP) were working on cataloguing Arturo Schomburg's collection of books and printed matter relating to the history of the African diaspora, which the library had acquired in 1926. (This branch of the library would eventually become the Schomburg Center for Research in Black Culture, now at 515 Malcolm X Boulevard.)

Other writers working on FWP projects in the neighborhood included Richard Wright, a Mississippi-born migrant who had come to New York in 1937 after a decade in Chicago. With Claude McKay, Wright wrote on black history and Harlem for a WPA-produced guidebook to New York City, and he was the Harlem editor of the *Daily Worker*. "In summer the sidewalks are crowded with loiterers and strollers," read the 1939 guide, in a description that evokes Lawrence's own early Harlem scenes, and "the unemployed move chairs to the pavement and set up cracker boxes for checker games. On Lenox Avenue soapbox orators draw crowds nightly ... one of the speakers being, inevitably, a disciple of Marcus Garvey, leader of the back-to-Africa movement, now in exile in England."[26] Wright pulled strings to get an FWP position for Ralph

Ellison, who had recently taken a sculpture class with Savage and was hanging out with Bearden. Ellison interviewed Harlem residents for the folklore division of the FWP, part of an ambitious effort to record the life histories of thousands of ordinary Americans. He would later integrate into his fiction elements of the stories and speech patterns he heard in these interviews. Federal theater projects operated nearby; the home base for the New York Negro Unit of the Federal Theater Project was the Lafayette Theater, at 132nd Street and Seventh Avenue. Key productions included the "voodoo" *Macbeth* (1936), an adaptation of Shakespeare's play set in the nineteenth-century Haitian court of King Henri Christophe, directed by the young Orson Welles; *Turpentine* (1936), a social drama, written by J. Augustus Smith and Peter Morell, that focused on the injustice of Southern labor camps; and *Haiti* (1938), by a white Southerner, William DuBois, which in its New York adaption celebrated the revolutionary overthrow of the French government of the country by L'Ouverture.

3. Jacob Lawrence. *Street Orator's Audience*. 1936.
Tempera on paper, 24 1/8 x 19 1/8" (61.3 x 48.6 cm).
Tacoma Art Museum. Gift of Mr. and Mrs. Roger W.
Peck by exchange

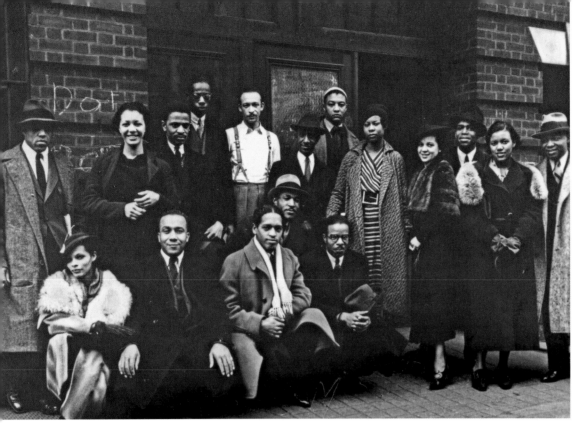

4. Members of the "306" group outside 306 West 141st Street, mid-1930s. Standing, left to right: Addison Bates, Grace Richardson, Edgar Evans, Vertis Hayes, Charles Alston, Cecil Gaylord, John Glenn, Elba Lightfoot, Selma Day, Ronald Joseph, Georgette Seabrooke (Powell), Richard Reid. At front, left to right: Gwendolyn Knight, James Yeargans, Francisco Lord, Richard Lindsey, Frederick Coleman. Photo: Morgan and Marvin Smith. Photographs and Prints Division, Schomburg Center for Research in Black Culture, The New York Public Library, Astor, Lenox and Tilden Foundations

The tutoring provided, as Lawrence's comments suggest, was political as much as artistic.

Harlem-based artists had to go downtown to pick up their paycheck. As Lawrence told the *Chicago Defender* writer Mort Cooper in 1963, "My real education was with the WPA Federal Arts Project. I met people like William Saroyan, just on the edge of fame. They all used to talk about what was going on in the world. All the artists used to go down to project headquarters on King Street in Manhattan to sign in. We'd meet each other, and talk and talk and talk."[28]

Such payday gab-fests enabled a great deal of exchange between artists, writers, actors, and curators across the boundaries of race. Saroyan was at work on his play *The Time of Your Life*, set in a San Francisco bar, for which in 1940, he would win a Pulitzer, then refuse it in the belief that commerce had no right to judge art. He often traveled uptown to join the conversations at 306. It was also at the WPA offices that Lawrence met Jay Leyda, a young film critic and film curator at The Museum of Modern Art.[29] Leyda would end up playing a special role as a champion of Lawrence's work **(p. 37, fig. 7)**, serving as a sometime agent for his picture sales, introducing him to José Clemente Orozco when the Mexican muralist was working onsite at MoMA in 1940, asking Wright if he might mentor Lawrence, and showing the Migration Series to Barr, who would eventually acquire half of the panels for The Museum of Modern Art.[30] One can imagine that Lawrence might have also met Davis, Arshile Gorky, Ad Reinhardt, Ben Shahn, and many others picking up their pay at the WPA— all enrolled in the same time period.[31]

The Painter as Historian

When asked about his early choices of subjects, Lawrence insisted that they reflected the interests of his community.

The impact of the WPA went far beyond tuition-free access to materials, equipment, and training—although that played no insignificant role in allowing someone like Lawrence, a child of migrant parents with little exposure to art at home, to imagine himself as an artist. A broader effect was the creation of a framework for conversational mixing. Savage's studio, the "306" group (of artists frequenting Alston's and Bannarn's studio at 306 West 141st Street; **fig. 4**), and the Harlem Community Art Center provided structures for introducing young artists, often migrants from the South, to members of an established Harlem intelligentsia. Lawrence set himself up in Alston and Bannarn's studio, renting a corner for two dollars a month to give himself a place to paint away from home **(p. 35, fig. 4)**. He would later recall of the space,

> During the '30s there was much interest in black history and the social and political issues of the day—this was especially true at 306. It became a gathering place.... I received not only an experience in the plastic arts—but came in contact with older blacks from the theater, dance, literary and other fields. At sixteen it was quite a learning experience—Katherine Dunham, Aaron Douglas, Leigh Whipper, Countee Cullen, Richard Wright, Ralph Ellison, Alain Locke, William Attaway, O. Richard Reid— hearing them discuss the topics of the day—as well as philosophy and creative processes pertaining to their own fields. Claude McKay was a frequent visitor to 306. He had more than a great interest in Africa, the philosophy of Garvey, U.N.I.A. [The Universal Negro Improvement Association], etc. Augusta Savage was also a strong black Nationalist and champion of black women.[27]

Lawrence seems in retrospect extraordinarily well mentored—especially by Savage, Alston, and Locke, but also by a broader circle that opened itself to promising youth, despite the frequent difference in class.

"People would speak of these things on the street," he recalled. "I was encouraged by the community to do works of this kind; they were interested in them."[32]

Along with the "librarians," "teachers," and "street corner orators" whom Lawrence often mentioned as playing key roles in his education in black history, one crucial figure was Charles Seifert.[33] Lawrence met Seifert across the street from the 135th Street library at the Harlem YMCA, where the artist liked to shoot pool.[34] There, as Bearden and Henderson recount, he would lecture to all who would listen on "the achievements of Black men in Africa, the golden city of Timbuktu, African use of iron when most of Europe was ignorant of it, [and] the elegant bronze casting required to create the superb art treasures of Benin in Nigeria," and would argue that "Black people were never going to get anywhere until they knew their own history and took pride in it."[35] Seifert had a collection of books and artifacts relating to Africa's culture and diaspora, which he opened to young Harlemites including Lawrence, and in 1935 Lawrence joined a trip he organized to an exhibition of African sculpture at MoMA. Lawrence would recall that "one of his projects . . . was to get black artists and young people such as myself who were interested in art . . . to select as our content black history."[36]

Lawrence also spoke of the importance of the "history clubs" that proliferated in the wake of the Migration, part of a movement to document, research, and teach black history.[37] Carter G. Woodson, one of the first professional scholars of African-American history in the United States, encouraged the growth of the clubs by offering any with more than five members a free subscription to *The Journal of Negro History*, which he had founded in 1916.[38] The Negro History Club at the 135th Street library, which Lawrence seems to have attended, had been founded by Ernestine Rose, the enlightened head librarian at the branch since 1920, and Ella Baker, who two decades hence would become one of the most important leaders of youth in the civil rights movement, playing key roles in Martin Luther King's Southern Christian Leadership Conference and the Student Nonviolent Coordinating Committee—one of many links between Lawrence's circles and the mid-century movement.[39] Baker was already developing a profile as a community organizer and activist in the late 1920s. In 1928, soon after arriving in New York after graduation from Shaw University in North Carolina, she organized a Negro History Club at the 135th Street YMCA.[40] In 1930 she joined the Young Negroes Cooperative League, which sought to develop black economic power, then later in the decade found WPA positions both on the Workers' Education Project, which offered classes to enable people to enter the work force, and at the 135th Street library, to help run the Harlem Experiment in Adult Education programs, which focused on black history and culture, and a Young People's Forum that brought in a range of prominent speakers on historical and political topics.

These positions and institutional bases flowed into one another, and Baker coordinated and led classes and workshops in consumer education, labor history, and black history at both the library and the YMCA across the street. These sessions, she would recall, tried to provide the participant with "a more intelligent understanding of the social and political economy of which he is part."[41] Discussions would at times continue outside on the street. At least once, a soapbox orator paid by the library was positioned outside to preach on colonialism, Pan-Africanism, and the struggle for social justice.[42] Baker emphasized the need for political involvement, often leading her protégés to join pickets and signature campaigns. She would recall of these years, "You had every spectrum of radical thinking on the WPA. We had a lovely time. . . . Boy was it good, stimulating."[43] The influence of teachers like Seifert and Baker can be seen in Lawrence's description of his motivation for choosing historical subjects in 1940, when he was occupied with the Migration Series:

> **"Having no Negro history makes the Negro people feel inferior to the rest of the world. . . . I didn't do it just as a historical thing, but because I believe these things tie up with the Negro today."**[44]

With his earlier series on the lives of black leaders, Lawrence had already developed an extensive research protocol unusual for a painter, spending time at the library taking notes on books, journals, and documents **(fig. 5)**. He spoke of choosing both the subjects of his pictures and their captions—at times copied verbatim—from these written sources.[45] Lawrence returned to this process with his Migration Series: in his application for a Julius Rosenwald Fund grant to work on the project when his WPA employment ended, in 1939, he said he needed six months for research. His references for the grant also pointed to his extensive research as a distinguishing and

5. The New York Public Library's 135th Street branch (now the Schomburg Center for Research in Black Culture), 1938. Photographs and Prints Division, Schomburg Center for Research in Black Culture, The New York Public Library, Astor, Lenox and Tilden Foundations

exemplary feature of his work.[46] The Fund had been established by Julius Rosenwald, the Sears, Roebuck magnate, in 1917, when foundations were still a relatively new philanthropic instrument. The endowment—eventually reaching over $70 million—was to be spent down within twenty years of its founder's death.[47] In 1928, it began an ambitious program of "genius" grants to hundreds of black artists, musicians, writers, and other professionals. When Lawrence won a grant, he joined a long list of cultural luminaries who received Rosenwald support including Savage (1929, 1930, 1931), Hughes (1931, 1941), the composer William Grant Still (1939, 1940), and the contralto Marian Anderson (1930).

Lawrence's earlier series, on L'Ouverture, Douglass, and Tubman, had focused on giving visual form to the heroic struggles of an extraordinary historical figure. Each had offered an epic chronicle of its protagonist's transformation from slave to leader in the struggle for the liberation of their people. While the multipanel-plus-caption format that Lawrence created was novel in fine art, and allowed for more narrative development than the traditional portrait or history painting, representation of the lives of great historical figures was a keen imperative in the work of contemporary black painters. Aaron Douglas, for example, painted Tubman in 1931 in an allegorical mode, with arms stretched upward, breaking the shackles of bondage **(fig. 6)**. Hale Woodruff, who had studied with the Mexican muralist Diego Rivera, painted a three-panel mural series marking the centennial of the *Amistad* slave-ship mutiny in 1839.[48] The subject of Charles White's mural *Five Great American Negroes*, made while White was working for the Illinois WPA, was

6. Aaron Douglas. *Harriet Tubman*. 1931. Oil on canvas, 54 x 72" (137.1 x 182.9 cm). Bennett College, Greensboro, North Carolina

a pantheon of black heroes chosen by a poll conducted by the *Defender* in October 1939: Anderson, Sojourner Truth, Frederick Douglass, George Washington Carver, and Booker T. Washington **(fig. 7)**.[49]

With the Migration Series Lawrence changed tack: rather than choosing a subject set in the distant past, he picked an ongoing historical phenomenon that had begun just two decades or so before. The flow of Southern blacks to the North had started in the first years of World War I as a small stream; the numbers jumped dramatically in 1916, becoming noticeable to many observers. As early as February 5 of that year, the *Defender* spoke of the "steady movement of race families" out of the South.[50] By the end of 1917, Chicago's three major dailies (the *Tribune*, the *Daily News*, and the *Examiner*) had written no less than forty-five articles on the exodus.[51] More than 437,000 black southerners moved North in the course of the 1910s, and at least 810,000 more relocated in the 1920s, effecting a demographic transformation of the country that thoroughly changed its cities and its political, cultural, and economic life.[52] Moreover, the dual influx of migrants from the Caribbean and the South in the first decades of the twentieth century had turned Harlem, Lawrence's neighborhood, into the country's "race capital," as Locke described it in the introduction to *Harlem: Mecca of the New Negro* (1925): a geographic center that gathered and intensified the aspirations of a people. The migration, like the preceding waves of European immigration, was for Locke "a mass movement toward the larger and the more democratic chance," and Harlem the stage for the "resurgence of a race."[53]

Not only was the subject contemporary, but Lawrence also shifted from recounting the lives of great heroes to giving image to the experience of ordinary people. There was precedent for this in the writing of Hughes and McKay, both of whom he had met at 306. Hughes, for example, in his 1940 autobiography *The Big Sea*, described the protagonists of his poetry as

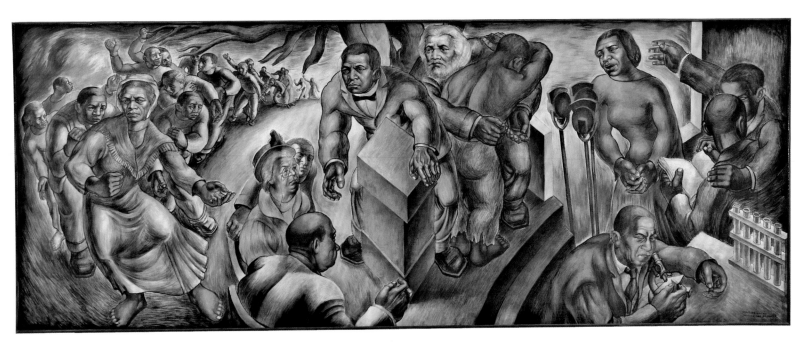

7. Charles White. *Five Great American Negroes*. 1939–40. Oil on canvas, 5 x 12' (1.5 x 3.7 m). Howard University Gallery of Art, Washington, D.C.

"workers, roustabouts, and singers, and job hunters on Lenox Avenue in New York, or Seventh Street in Washington or South State in Chicago— people up today and down tomorrow, working this week and fired the next, beaten and baffled, but determined not to be wholly beaten."[54]

Certainly this change in approach also had something to do with how Lawrence learned about the Migration, through stories told by family, friends, and neighbors. "I grew up hearing tales about people coming up, another family arriving," he recalled. "Out here people who'd been in the North who'd migrated … would say, 'Another family came up.'"[55] Lawrence's intimate connection to the subject matter is suggested in panels such as **no. 33**, showing a woman seen in foreshortened perspective from the crown of the head, reading a letter in bed. "Maybe it represents my mother reading a letter or my sister," Lawrence later said.[56] Yet his use of a collective subject in the Migration Series, and the many, mostly faceless figures depicted, may also have something to with the nature of the event: the Migration has been described from early on as the first leaderless liberation movement in African-American history.[57] In 1917, during its first years, Adam Clayton Powell, Sr., the powerful pastor of Harlem's Abyssinian Baptist Church, declared, "The masses have done more to solve the Negro problem in fifty weeks without a leader than they did in fifty years with certain types of leaders."[58] The panels of Lawrence's series offered

a new kind of history, attentive to the role of ordinary people as actors on the historical stage— akin in many ways to the oral-history projects of the FWP. In images of people reading and receiving information (**panels 20, 33, 34**), talking (**panels 26, 30**), taking action by deciding to leave, often in the face of opposition (**panels 41, 42**), and enduring hardships in order to do so (**panel 27**), they focus on the many repeated acts of agency that the migrants undertook.[59]

In his Rosenwald application, Lawrence defined his approach carefully, outlining an eight-part structure that largely survives in the finished work. The series would address in turn:

I. *Causes of the Migration*
II. *Stimulation of the Migration*
III. *The Spread of the Migration*
IV. *The Efforts to check the Migration*
V. *Public Opinion Regarding the Migration*
VI. *The Effects of the Migration on the South*
VII. *The Effect of the Migration on various parts of the North*
VIII. *The Effects of the Migration on the Negro*[60]

Lawrence's presentation of the causes and effects of the Migration closely follows early writing on the phenomenon—the type of book Lawrence read at the library, such as those by Woodson, Emmett J. Scott (most of his eight sections mirror chapters in Scott's book *Negro Migration during the War*, 1920), Charles S. Johnson, and W. E. B. Du Bois.[61] So do the push-and-pull forces he notes. Writing in the National Association for the Advancement of Colored People's *Crisis* magazine in 1917, for example, Du Bois had cited the almost biblical accounting of the Migration's seven causes given by the African Methodist Episcopal Ministers' Alliance of Birmingham, Alabama:

"prejudice, disfranchisement [*sic*], Jim Crow cars, lynching, bad treatment on the farms, the boll weevil, the floods of 1916."[62] These plagues are essentially those Lawrence presents. He also read literature that grappled with the experience of the Migration: a copy of Jean Toomer's *Cane* (1923)—a novel composed of vignettes whose settings move from the South to the North and back again—was found among the artist's possessions after his death, checked out of the library in 1939 and never returned.[63]

A key aspect of the Migration Series' shift away from Lawrence's presentation of the lives of great leaders in his earlier narratives is the move from a historical perspective, in which the significance of events is read in relation to a greater principle such as nation-building, to a sociological mode, an attempt to understand the collective social behavior of a group. The Migration and its impact on Northern cities were perhaps the key topics for a generation of black sociologists emerging in the 1920s and '30s. Many of these thinkers had studied with Robert E. Park, who had helped to establish the field of sociology in the United States and had been a major force in stimulating and shaping the direction of research on race relations since his arrival in Chicago in 1914. In the aftermath of the widespread racial violence that erupted in the urban North during the Migration, black researchers and reformers developed a new approach to the politics of race, deploying statistical evidence to define racial disparities in the management of crime, labor, and housing. The study of the Chicago race riot of 1919 that Charles S. Johnson, who had trained with Park, prepared for the city's Commission for Race Relations is one example.[64] Wright spoke of a sociological turn in his own work: in his introduction to *Black Metropolis: A Study of Negro Life in a Northern City* (1945), a landmark study of Chicago's South Side written by Park students Horace R. Cayton, Jr., and St. Clair Drake, he wrote that Chicago School sociology

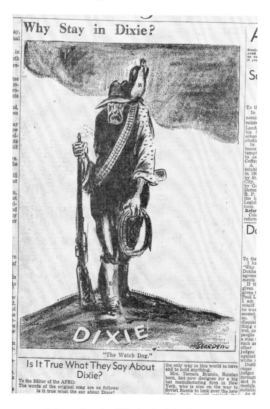

8. Romare Bearden. "Why Stay in Dixie? The Watch Dog." Cartoon published in the *Baltimore Afro-American*, June 20, 1936, p. 4

had given him a way of understanding and imagining in his fiction the relationship between his characters and their environment.[65]

Media Consciousness

At the 135th Street library Lawrence inhabited a papery world full of printed matter—books, newspapers, journals, sociological tracts, historical ephemera. That domain shaped far more than the subject matter and textual components of his work: Lawrence also showed himself to be a keen connoisseur of the visual idiom of modern media culture—of graphic illustration, mechanically reproduced photographs, and cinema.

Lawrence declared his allegiance to the modern print world first of all in his choice of medium. Rather than the oil paint associated with fine art, he chose a tempera paint, a product often used by commercial illustrators because it was fast drying, matte, and opaque—good for producing pictures quickly and creating flat planes of color that would photograph well in reproduction.[66] Lawrence used a relatively small range of colors, leaving them unmixed in order to keep them consistent from panel to panel. Like a printmaker, he layered them in one at a time across all sixty panels, beginning with black, then moving on, color by color, to lighter values.[67] The results—spare images made up of large flat planes of unmixed colors with defined edges—also had the graphic impact of a color print.

Lawrence's use of captions for each panel also intimately linked his work to the picture-plus-text formula of images in print. This kind of pairing could be seen in graphic illustrations and political cartoons such as those produced by Alston, Bearden, E. Simms Campbell, and others **(fig. 8)**. Yet perhaps most significant as a model were the illustrated weeklies that had appeared in the 1920s and '30s—magazines like *Fortune*, *Life*, and *Look*. In contrast to newspapers

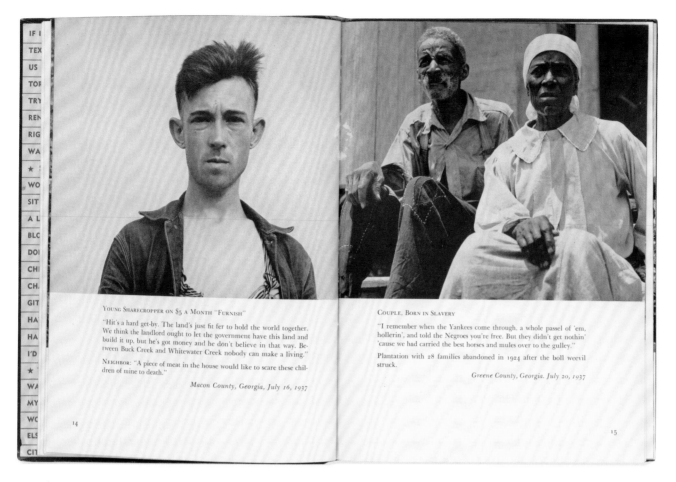

Within the book spread image:

YOUNG SHARECROPPER ON $5 A MONTH "FURNISH"

"Hit's a hard get-by. The land's just fit fer to hold the world together. We think the landlord ought to let the government have this land and build it up, but he's got money and he don't believe in that way. Between Buck Creek and Whitewater Creek nobody can make a living."

NEIGHBOR: "A piece of meat in the house would like to scare these children of mine to death."

Macon County, Georgia. July 16, 1937

COUPLE, BORN IN SLAVERY

"I remember when the Yankees come through, a whole passel of 'em, hollerin', and told the Negroes you're free. But they didn't get nothin' 'cause we had carried the best horses and mules over to the gulley."

Plantation with 28 families abandoned in 1924 after the boll weevil struck.

Greene County, Georgia. July 20, 1937

9. Spread from Dorothea Lange and Paul Schuster Taylor. *An American Exodus: A Record of Human Erosion*. New York: Reynal & Hitchcock, 1939. The Museum of Modern Art Library, New York

like the *New York Times*, and its use of single images, the photo-magazines offered orchestrated, quasi-cinematic sequences of pictures and text—a word-picture hybrid in which the image was dominant but its meaning was directed by a caption. *Flash* magazine, a picture magazine dedicated to black experience, had had a short-lived run from 1937 to 1939—its founding an implicit recognition of both the importance of the medium and the exclusions of its coverage.

In the late 1930s, some of the leading photographers who had worked for the illustrated magazines began to produce a variant genre: the photo book. In books, photographers could assert more authorial control over their images than they could within the collective corporate structure of the photo magazine, and could work in a longer format, often with the aim of creating a more coherent and sustained political argument. Several key early examples of this nontraditional image-based reporting—Erskine Caldwell's and Margaret Bourke-White's *You Have Seen Their Faces* (1937), Dorothea Lange's and Paul Taylor's *American Exodus* (1939; **fig. 9**), and James Agee's and Walker Evans's *Let Us Now Praise Famous Men* (1941), all of which address a nexus of themes of poverty, disenfranchisement, migration, and itinerancy—found huge trade distribution.

In response to the newly voracious demand for pictures, photo magazines,

10. Ben Shahn. *Picking Cotton, Pulaski County, Arkansas*. 1935. Gelatin silver print, 7 5/8 x 9 3/16" (19.4 x 25 cm). The Museum of Modern Art, New York, New York. Purchase

Fortune especially, became the patrons of ambitious photographic and documentation projects. The federal government did too; the Farm Security Administration (FSA), one of several New Deal agencies designed to help farmers impoverished by the economic and agricultural disasters of the decade, launched an ambitious initiative through its Historical Section, directed by Roy Stryker, to send photographers into the field to create

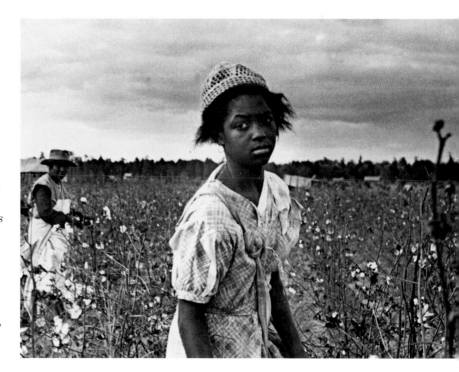

images that would document and explain the plight of farmers to various constituencies. FSA photographers took over 270,000 photos.[68] "There had never to my knowledge . . . been photography underwritten that actually tried to create the portrait of a country in a given period," reflected Edwin Rosskam, Stryker's deputy and a photographer and picture-editor with the FSA.[69] The FSA also shaped a new conception of the way a documentary photograph should look. FSA photographers self-consciously avoided elegant compositions and stylized formal devices in pursuit of what they saw as straight, honest photography **(fig. 10)**. For captions they often used quotations taken directly from conversations with the photographs' subjects, or written to appear so—an effort to give voice to the experience of ordinary citizens that echoes the documentary strategies of other federal agencies, such as the oral-history projects of the FWP. Rosskam described the FSA's goal as "documentation with humanity, rather than documentation that had a certain numerical quality to it."[70]

Although FSA images of rural Americans—often on the move as a result of drought, flood, or economic loss—were produced by a federal agency, they permeated the mass media. An extraordinary number of the photographs that appeared in corporate publications such as *Fortune*, *Look*, and *Life* between 1935 and 1940 were drawn directly from FSA photo archives; by 1940, the FSA's Historical Section was placing some 1,406 images a month in such publications, free of charge.[71] As important as the saturation of the media world with pictures of impoverished and often itinerant rural Americans was the way this image stream reflected a mainstream embrace of a new, socially engaged documentary approach.

That enthrallment with FSA photo-culture was strong in Lawrence's circles is suggested by Alston's course of action. Inspired by conversations at 306 about the plight of Southern blacks, he applied for a Rosenwald grant to travel to the South—which he had not seen since his family's own move north in 1915, when he was a small child—to work on a project contrasting "the Northern industrial and metropolitan Negro with his Southern and rural brother."[72] Arriving there in early 1940, he joined up with Giles Hubert, a sociologist and two-time Rosenwald grant-holder now working as an FSA inspector, and accompanied him on his rounds, playing the role of FSA photographer. "We both wore khakis, and I had a camera, so I was never questioned whether I was official or not," Alston would remember. "We went into all of these rural places and I took photographs, hundreds of photographs, and I really saw the South." Alston used the photos he brought home with him as the basis for a series of paintings of black Southerners **(fig. 11)**.[73]

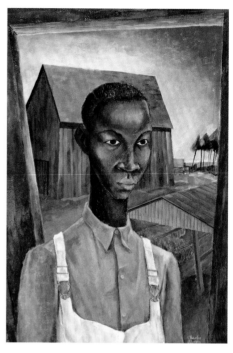

11. Charles Alston. *Tobacco Farmer*. 1940. Watercolor and gouache on paper, 21 x 15" (53.3 x 38.1 cm). Private collection, New York

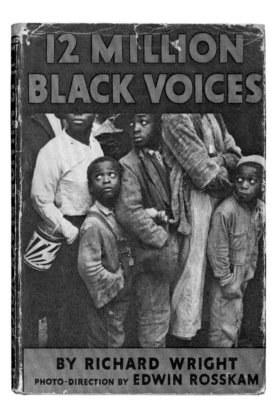

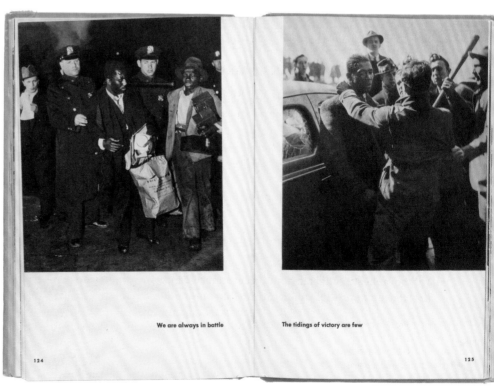

We are always in battle

The tidings of victory are few

124

125

The logic of FSA documentation of the lives of rural Americans led North to urban centers--to show, as Rosskam understood it, "where migration went to. Migration went to the city."[74] He enlisted Wright as a partner in preparing a photo book that would contrast black life in the South and in the North, and the two spent time in Washington, poring over photographs in the FSA archive. Then Rosskam, Wright, and FSA photographer Russell Lee traveled to Chicago together, along with Rosskam's and Wright's wives, to photograph the South Side. Wright's sociologist friend Cayton served as their guide. The final book, *12 Million Black Voices: A Folk History of the Negro in the United States* (1941), showcased large photographic reproductions—images taken largely by FSA photographers but also a few drawn from news agencies or taken by Wright himself—in spreads with simple captions **(figs. 12, 13)**. Wright's text addressed an implicitly white reader in prose that took on the cadence of speech:

> ## "Each day when you see us black folk upon the dusty land of the farms or upon the hard pavement of the city streets, you usually take us for granted and think you know us, but our history is far stranger than you suspect, and we are not what we seem," he began.[75]

That *12 Million Black Voices* was seen as an important corollary for Lawrence's Migration Series would soon be made explicit in the design for the traveling exhibition, organized by MoMA, that followed the acquisition of the series by MoMA and The Phillips Collection: five of the photographs reproduced in *12 Million Black Voices* were shown enlarged along with Lawrence's panels at all the venues.[76]

Yet the orchestrated sequence of images and captions in Lawrence's work—like those of the photo stories in the picture magazines themselves—is also inherently cinematic. Leyda recognized the affinity: Lawrence said that the film curator had taken to his work

because of the cinema-like development of its serial panels. "I thought of doing it that way for that reason," Lawrence quietly confirmed.[77] Lawrence's friendship with Leyda seems key in this regard. In 1933, Leyda had traveled to the Soviet Union to study with the Russian filmmaker Sergei Eisenstein; returning to New York three years later, he joined the staff of The Museum of Modern Art and helped to acquire prints of *Battleship Potemkin* for its collection in 1938 and 1939. He would soon become one of the first and most important scholars of Russian avant-garde cinema: when he met Lawrence at the WPA, he was translating Eisenstein's theoretical writings, which would be published as the book *Film Sense* in 1942. Significantly given Lawrence's relationship with Leyda, the structure of the sixty panels of the Migration Series differs markedly from the continuous flow of his earlier historical narratives—images of trains, railway cars, train stations and their waiting rooms, and people arriving at or departing from them with their bags appear again and again, serving as a repetitive motif. There are fourteen such images in total across the sixty panels of the series. This rhythmic intersplicing of congruent bodies of images, the juxtaposition producing both aesthetic and ideological meaning, resembles nothing so much as Eisenstein's montage: the Soviet filmmaker's cutting back again and again to the baby carriage in the thrilling Odessa Steps sequence of *Battleship Potemkin* is the most famous example **(fig. 14)**. The analogy with cinema in Lawrence's work offered a way of representing time: while his early series suggest historical development and resolution, the temporal mode of the Migration Series is continuous. The measured reappearance of the train image implies constancy—a motion that will not stop. "And the migrants kept coming," reads the final panel. In the Migration Series Lawrence joins such avant-garde structural strategies with a keen consciousness of popular mass-media forms to rework traditional models of history painting.

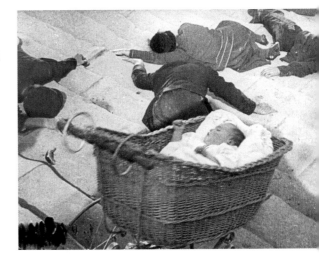

14. Still from Sergei Eisenstein. *Battleship Potemkin*. 1925. Black and white, silent, 75 minutes. The Museum of Modern Art Film Stills Archive

Our Struggle

Lawrence's choice of the Migration as a subject—and his representation of racial injustice in both the North and the South—was bound up with a key shift in political mindset. In the years around 1939 to 1941, when Lawrence began his deep study of the Migration and conceptualized and worked on the series, figures in his orbit were testing new forms of protest politics in the cause of racial justice. They were turning, as Randolph put it, "from industrial to political action."[78] Before and after taking over the Abyssinian Baptist Church from his father, in 1937, for example, Adam Clayton Powell, Jr., used it as a base for community organizing, conducting crusades against lynching, and for employment equity and affordable housing, with an arsenal of tactics that included pickets, mass meetings, rent strikes, and company-specific leafletings and boycotts **(fig. 15)**. His activities reached new levels of attention with a series of high-visibility

"Don't Buy Where You Can't Work"

campaigns conducted after the U.S. Supreme Court reaffirmed the right to picket establishments with discriminatory hiring practices in 1938, overturning the decisions of the lower courts. Then, in early 1941, after failing to win concessions from President Franklin Delano Roosevelt toward ending discrimination in the defense industries and armed forces, Randolph called for 10,000 black citizens—the number committed to going was subsequently upped to

15. Adam Clayton Powell, Jr., with a group of shop workers on strike, Harlem. 1940. Photo: Morgan and Marvin Smith. Photographs and Prints Division, Schomburg Center for Research in Black Culture, The New York Public Library, Astor, Lenox and Tilden Foundations

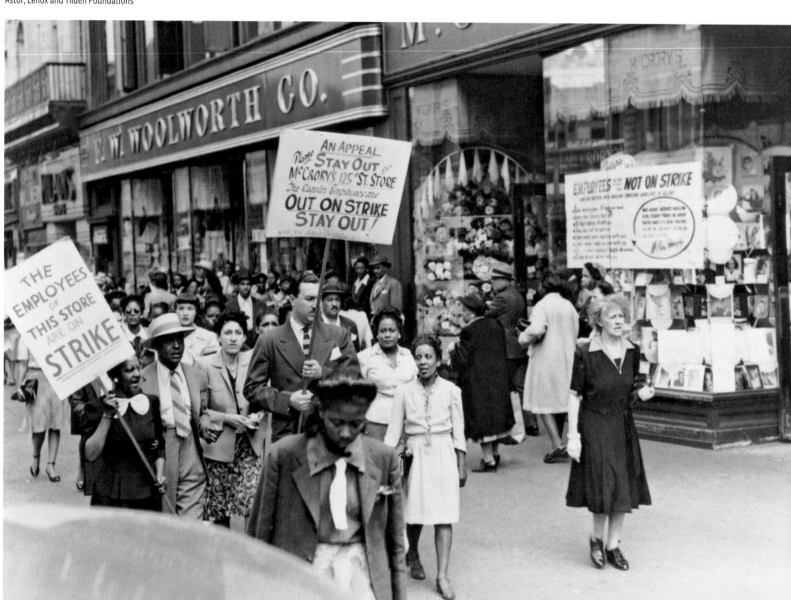

A. PHILIP RANDOLPH
National Director

B. F. McLAURIN
National Secretary

ALDRICH TURNER
National Treasurer

BEATRICE E. PARRISH
Acting Executive Secretary

- -

MARCH-ON-WASHINGTON MOVEMENT

2084 Seventh Avenue New York City, N. Y.
 MOnument 2-3350

Enclosed please find $1.00 for membership to the MARCH-ON-WASHINGTON
MOVEMENT — Also I hereby contribute

 $ ($1) ($5) ($10) ($25)

 or Pledge $ for the $100,000 Fund

 440

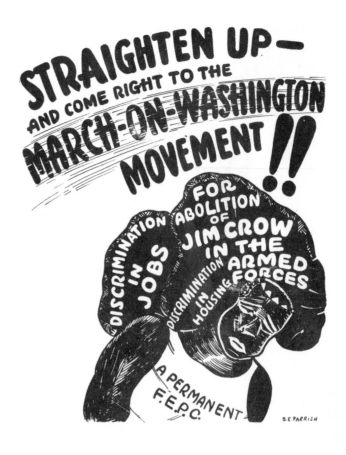

16. B. E. Parrish. Flyer for March-on-Washington
Movement. 1941. Library of Congress,
Washington, D.C.

50,000—to join a March on Washington on July 1, 1941 **(fig. 16)**.
Late in the game—on June 25, less than a week before
the planned march—Roosevelt issued an executive order
establishing the Fair Employment Practices Committee,
leading to the action's cancellation. The emergence of these
new tools for political organizing, predicting the tactics
of the mid-century Civil Rights Movement, may well have
been the ultimate legacy of the Migration itself: as the
black Department of Labor official George Edmund
Haynes had written in 1919, not only had the Migration
served to "break down much of [the black population's]
timidity," but had also generated "the united demand . . .
for the removal of race discriminations in public courts,
public conveyances and for provision in city and country for
the same facilities of community improvement for them
as for others."[79] The Migration led, such thinking suggests,
to mass political consciousness.

In the cultural sphere too, a sequence of events took place
in these years that signaled a new willingness to use
the most visible stages for daring statements of social
protest. One bold act followed another in short order. In
1939, the Daughters of the American Revolution (DAR)
refused to allow Anderson to sing before an integrated
audience at Constitution Hall, in
Washington, D.C., and the city's
Board of Education declined a request to move the concert
to a white public high school. The Marian Anderson
Citizens Committee—composed of several dozen organi-
zations, including Randolph's Brotherhood of Sleeping
Car Porters, the Washington Industrial Council–CIO, the
American Federation of Labor, and the National Negro
Congress, as well as church leaders and others—picketed
the Board of Education on February 20, organized petitions,
and planned a mass protest at the next Board of Education
meeting. The furor caused by these protests attracted the
attention of Eleanor Roosevelt, who resigned from the DAR,
writing in a public letter,

**"You had an opportunity to
lead in an enlightened way
and it seems to me that your
organization has failed."**[80]

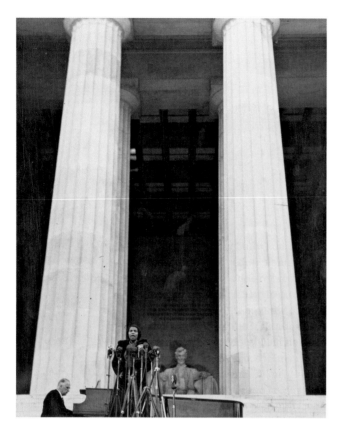

17. Marian Anderson singing at the Lincoln Memorial, April 9, 1939. Marian Anderson Collection of Photographs, 1898–1992, Kislak Center for Special Collections, Rare Books and Manuscripts, University of Pennsylvania

With the First Lady's support, Anderson instead took the stage in the open air, performing on the steps of the Lincoln Memorial before an audience of 75,000 and millions more listening by radio at home **(fig. 17)**.[81]

That same year in New York, Alston's great friend Billie Holiday debuted "Strange Fruit" as her signature song at the close of her regular sets at Café Society. The place was a special one: it was New York's first interracial night club. Both performers and audiences were integrated, and anyone displaying prejudice was quickly shown the door. Habitués ranged from Robeson to Franklin D. Roosevelt, Jr., and sometimes his mother, Eleanor, too. While lynching is not mentioned explicitly in the lyrics of Holiday's set piece—which first appeared in the union magazine *The New York Teacher* as a poem written by a Bronx high school teacher, Abel Meeropol—the metaphor in lines like "Southern trees bear a strange fruit/ Blood on the leaves and blood at the root" was clear. When Holiday's label, Columbia Records, refused to record the song, fearing the retribution of Southern distributors, she persisted, negotiating a one-time release to record it with her friend Milt Gabler at Commodore (a label associated with the left-wing magazine *New Masses*) in 1939 **(fig. 18)**. The disk went on

to sell over a million copies and played an influential role in inaugurating the genre of civil rights protest songs. Jazz composer and critic Leonard Feather has called "Strange Fruit" "the first significant protest in words and music, the first unmuted cry against racism."[82]

In 1941, the blues singer Joshua White (today better known as Josh White) recorded *Southern Exposure: An Album of Jim Crow Blues*, a disk of six songs written by White in collaboration with the poet Waring Cuney, all attacking Jim Crow segregation and racial injustice in terms that were perhaps more forthright about the facts than anything yet recorded **(figs. 19, 20)**. The liner notes were written by Wright—the most famous black writer of the time, given the recent acclaim for his novel *Native Son* (1940). The title track, set to the tune of "Careless Love," offers a Southern sharecropper's lament that resonates with Lawrence's Migration Series:

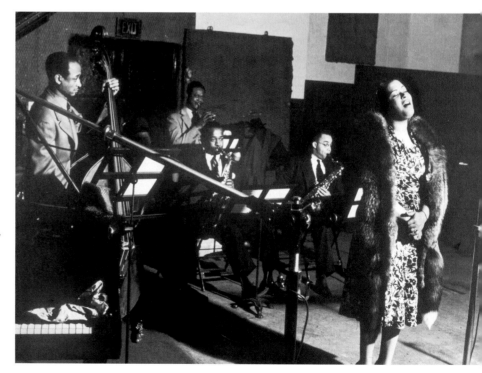

Lord, I work all the week in the blazin' sun, [three times]

Can't buy my shoes, Lord, when my payday comes.

I ain't treated no better than a mountain goat, [three times]

Boss takes my crop and poll tax takes my vote.

I'm leaving here 'cause I just can't stay, [three times]

I'm goin' where I can get more decent pay.

Wright introduced White's songs with the idea that "the blues, contrary to popular conception, are not always concerned with love, razors, dice and death. *Southern Exposure* contains the blues, the wailing blues, the moaning blues, the laughing-crying blues, the sad-happy blues. But it also contains the fighting blues."[83] The release party celebrating these "fighting blues," held at the Harlem hangout Ralph's Bar and Grill that September, was attended by several hundred members of the black cultural world: Lawrence's friend Bearden was there, and it is easy to imagine that Lawrence himself could have been too—he would recall listening to White in interviews.[84] The record's impact was far-reaching: President Roosevelt himself—struck by the song "Uncle Sam Says," with its refrain "Let's get together and kill Jim Crow today"—invited White to play all six of its songs at a special concert for a select group

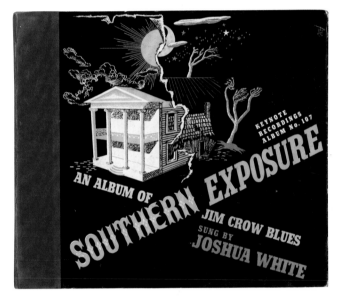

of guests. This was the first command performance at the White House by a black artist. When Halpert sat down to plan the December 8 opening of the Downtown Gallery exhibition that was to feature Lawrence's Migration Series, the First Lady was to be the honored guest and White was to perform. "Joshua Whyte [*sic*] will be grand!," Locke wrote to Halpert.[85] The bombing of Pearl Harbor on December 7 preempted this coming together of cultural and political power.

These events and others, including the publication of Wright's own, phenomenally successful *Native Son*, suggest the degree to which something markedly new was happening as the decade turned from the 1930s to '40s: a form of concerted testing of the power of culture to address issues of race on the national stage. To some degree this involved a linking—implicit

18. Billie Holiday in a Commodore Records recording session, April 20, 1939. With bassist Johnny Williams, trumpeter Frankie Newton, and saxophonists Stan Payne and Kenneth Hollon. Photo: Charles Peterson

19 & 20. Cover of Josh White's album *Southern Exposure: An Album of Jim Crow Blues*, with interior liner notes by Richard Wright and design by E. Simms Campbell. New York: Keynote Recordings, 1941. Institute of Jazz Studies, Rutgers University Libraries

or explicit—of art with political action: the refusal to allow Anderson to sing, for example, led to marches and petitions that prompted the involvement of Eleanor Roosevelt, and President Roosevelt's interest in the song "Uncle Sam Says," and his invitation to White to play at the White House, came just months after Randolph had readied thousands to march on Washington. Such correspondences speak to the media savvy shown by these artists in their use of publicity, radio, and recordings, and perhaps to a new receptivity on the part of their audiences as well. The words of Anderson, Holiday, White, and Wright reached millions— truly mass audiences—and played a key role in moving attention to racial injustice out of the black press and into broad consciousness.

Lawrence was certainly aware of these models, and during the period when he was working on the Migration Series, he too participated in a grand display of the political power of culture. In December 1940, White and the Golden Gate Quartet appeared together in a concert at the Library of Congress to celebrate the seventy-fifth anniversary of the Thirteenth Amendment, which had abolished slavery in the United States. Locke, the poet Sterling Brown (former national editor of Negro affairs at the FWP), and Alan Lomax (the musicologist who ran the Library's folk-song program) offered wry and often pointed commentary from the stage. White closed the concert with his song "Trouble."

"Well, I always been in trouble," he sang to the gathered crowd, "'cause I'm a black skinned man/Said I hit a white man, locked me in the can."

Just a year after Anderson had been denied the stage at Constitution Hall, the event offered an ambitious, federally supported showcase of contemporary black cultural achievement. In addition to White's concert it included classical music, the display of historical documents related to the emancipation from slavery and other key events in black history, and an exhibition of contemporary art by black artists selected by Locke and Cahill. Among the works exhibited were five panels from Lawrence's Tubman series.[86]

Both Halpert and Locke, it seems, saw that Lawrence's work too might be positioned to address a mass audience. In a telegram of June 1941, Halpert asked Locke to phone Deborah Calkins, the assistant art editor at *Fortune*.[87] Within the month, *Fortune* had offered to publish a group of the Migration panels. Alston, who drew illustrations for *Fortune*, *The New Yorker*, and other magazines in these years, would recall that he worked with Calkins on the selection of images.[88] The appearance of panels from the Migration Series in the November issue put Lawrence's work before a vast audience. It also set it adjacent to the photo stories and graphic art that had shaped his approach to painting; his media consciousness must have made his integration into the pages of a picture magazine seem natural. *Fortune*, a notable part of Henry Luce's media empire, was an expensive magazine, selling for a dollar a copy during the Depression, and had become an important venue for the publication of both photo stories and modern graphic art by artists such as Davis, Rivera, and Fernand Léger.[89] Nevertheless, the inclusion of twenty-six full-cover images over four spreads **(pp. 38–39, figs. 9–12)**—at a time when color reproduction was still luxurious—was extraordinary, unheard of for a young black artist. Even years later, Lawrence would say, "I don't think I've had anything bigger than that."[90]

Perhaps more startling still was the text, in which America's best-known business magazine took the country's industrialists to task for race-based labor discrimination. Despite the title *Fortune*, and a distribution aimed at captains of industry, the magazine had often chosen to play the role of capitalism's conscience, supporting liberal social ideals such as New Deal remedies, unionism, civil liberties, and antifascism. The short essay that accompanied Lawrence's images was unsigned; like most pieces in the magazine's pages, it had been written collectively by *Fortune*'s editorial team, but it seems to have been shaped by Locke. The philosopher wrote with great pleasure to his friend Peter Pollack, the director of the South Side Community Center in Chicago,

I have seen the Lawrence Fortune lay-out. It is one of the most imposing things I have seen. The story, stressing social significance of the migrations is a masterpiece. Was done by the whole staff at several of our suggestions. The new masses [the journal New Masses*] couldn't have done this thing better, and in this plutocratic magazine. I just can't believe it.*[91]

The *Fortune* essay put forth a strong indictment: in the South that the migrants left behind, "an average of fifty-six Negroes were being lynched every year," and America's treatment of the Negro was used by Hitler "as prime

propaganda to convince people that U.S. democracy is a mockery."[92] And this was just ramping up: the final paragraph was the clincher, setting Lawrence's images in relation to a specific set of political demands.

> *A few months ago the Negro A. Philip Randolph, head of the Pullman porters union, announced plans for "A March on Washington" to protest against discrimination facing Negroes in the army, in industry, in every phase of the defense program. Fifty thousand Negroes pledged themselves ready to march July 1st. Then on June 25 President Roosevelt issued an executive order to end discrimination and to implement it the [Office of Production Management] established its Committee on Fair Employment Practice with two Negro members. Randolph's 50,000 marchers primarily wanted jobs, of course, but they also wanted more—the chance to belong. The reasons for their hunger in both respects are elaborated in the captions accompanying the pictures.*[93]

In this context Lawrence's panels were linked not only to political goals but also to a larger willingness to mobilize collectively—an elaboration of rationale, but also of future threat.

While Lawrence cannot have anticipated the presentation of the Migration Series in the pages of *Fortune*, this definition of a new activist consciousness served as an extension of his own thinking. The series was conceived as an ingenious form of political speech—a call for action. Explaining his motivations as an artist in 1940, Lawrence said,

"We don't have a physical slavery, but an economic slavery. If these people, who were so much worse off than people today, could conquer their slavery, we certainly can do the same thing. . . . I'm an artist, just trying to do my part to bring this thing about."[94]

Notes

Many specific intellectual debts are acknowledged in the footnotes, but I would like to express my particular gratitude to Henry Louis Gates, Jr., Patricia Hills, Elizabeth Hutton Turner, and Ellen Harkins Wheat for the foundation they have provided—it has shaped this essay in many ways—and for their insistence on the historical significance and continuing relevance of Lawrence's Migration Series. Isabel Wilkerson's magisterial history *The Warmth of Other Suns: The Epic Story of America's Great Migration* (New York: Random House, 2010) prompted me to turn my attention to Lawrence's work—her book balances a sense of the macro-phenomenon with the intimacy of individual experience as Lawrence's series does. Jodi Roberts, Jennifer Harris, Rebecca Lowery, and Christine McKay all made important contributions to the research for this essay.

1. Richard Wright, liner notes for Joshua White, *Southern Exposure: An Album of Jim Crow Blues* (New York: Keynote Recordings), album no. 107, shellac recording, 1941.

2. Edith Halpert, telegram to Alain Locke, n.d. Folder 37, box 164-33, Alain Leroy Locke Papers, Manuscript Division, Moorland-Spingarn Research Center, Howard University, Washington, D.C. See also Patricia Hills, *Painting Harlem Modern: The Art of Jacob Lawrence* (Berkeley: University of California Press, 2009), p. 48, and Diane Tepfer, "Edith Gregor Halpert and the Downtown Gallery Downtown, 1926–1940: A Study in American Art Patronage," PhD diss., University of Michigan, 1989, pp. 131, 139.

3. Jacob Lawrence, interview with Henry Louis Gates, Jr., June 1992, quoted in Elsa Smithgall, Gates, and Elizabeth Hutton Turner, *Jacob Lawrence and the Migration Series from The Phillips Collection* (Washington, D.C.: The Phillips Collection, 2007), p. 3. A similar statement appears in a taped interview with Turner, Seattle, Washington, October 3, 1992. Transcript in The Phillips Collection Archives, Washington, D.C.

4. See Cheryl Lynn Greenberg, *Or Does it Explode: Black Harlem in the Great Depression* (New York: Oxford University Press, 1991), p. 66.

5. Some scholars have drawn attention to problems inherent in the term "Harlem Renaissance," a period generally seen to have come to a close either with the Crash of 1929 or the Harlem Riots of 1935. They stress instead a greater geographic terrain, the significance of interracial conversations, and a broader periodization. See for example George Hutchinson, *The Harlem Renaissance in Black and White* (Cambridge, Mass.: Harvard University Press, 1995), esp. pp. 1–28.

6. See Marlene Park and Gerald E. Markowitz, *New Deal for Art* (Hamilton, N.Y.: Gallery Association of New York State, 1977), p. 8.

7. Ibid., p. 5.

8. Lawrence, letter to Locke, n.d. Folder 26, box 164-44, Alain Leroy Locke Papers.

9. Romare Bearden and Harry Henderson, *A History of African-American Artists from 1872 to the Present* (New York: Pantheon Books, 1993), p. 174. Bearden and Henderson's book is based on both extensive interviews and Bearden's own memory and experience; it is full of contextual details often absent from other scholarly accounts.

10. Charles Henry Alston, in an oral-history interview with Harlan Phillips, September 28, 1965. Archives of American Art, Smithsonian Institution, Washington, D.C.

11. Ibid.

12. See **frontis.** An article and accompanying photograph by Morgan and Marvin Smith also ran in the *New Amsterdam News* showing Harlem Guild artists Vertis Hayes, Ronald Joseph, and Gwendolyn Knight picketing Federal Art Project headquarters on December 19, 1936: "WPA Rehires 96 Strikers; New Plan On: Relief Workers Must Show Need to Stay on Roll." *New Amsterdam News*, December 19, 1936, p. 24. See Hills, *The Art of Jacob Lawrence*, p. 34.

13. Alston, in an interview with Camille Billops and Ivie Jackman, January 27, 1975, in *Arts and Influence 1996*, vol. 15, ed. Hatch, Hamalian, and Judy Blum (New York: Hatch-Billops Collection, 1996), p. 32.

14. See Terry Gips, entry on Augusta Savage in "Narratives of African-American Art and Identity, The Driskell Center, University of Maryland: http://www.driskellcenter.umd.edu/narratives/exhibition/sec3/sava_a_02.htm. For the number of art centers see Francis V. O'Connor, "Introduction," in O'Connor, ed., *Art for the Millions: Essays from the 1930s by Artists and Administrators of the WPA Federal Art Project* (Greenwich, Conn.: New York Graphic Society Ltd, 1973), p. 20.

15. A list of members of the committee is provided in a group interview with Walter Christmas et al., "Harlem Artists' Guild and Harlem Community Art Center," *Artist and Influence 1987*, vol. 5, ed. Leo Hamalian and James V. Hatch (New York: Hatch-Billops

Collection, 1987), p. 47. Randolph's speech is reported in "Harlem's Art Center," *Art Digest*, January 1, 1938, p. 15.

16. See Hills, *Painting Harlem Modern*, p. 34.

17. See "Harlem Hospital Rejects Murals by Negro WPA Artists," *Daily Worker*, February 24, 1936, later quoted in *Art Front* 2 (April 1936):3, and in Hills, *Painting Harlem Modern*, p. 34.

18. Ibid.

19. The story is told in several places, including Lawrence, in an oral-history interview with Carroll Greene, October 26, 1968, Archives of American Art.

20. Lawrence, in the interview with Turner, p. 22. The passage is partially published in Smithgall, Gates, and Turner, *Jacob Lawrence and the Migration Series* , p. 32.

21. Hills, *Painting Harlem Modern*, p. 38, citing the Jacob Lawrence file, box 16, Francis O'Connor Papers, Archives of American Art.

22. Lawrence, quoted in Bearden and Henderson, *A History of African-American Artists*, p. 297.

23. Lawrence was not a student in Savage's workshop, but as the story of her marching him down to enroll in the WPA suggests, she was a strong presence in his life. His interviews mention the importance of her studio as a gathering place in this period, and it was through her that he met Knight, a young artist working there whom he would later marry. Lawrence studied under Alston first at the Utopia Children's House, then at the Harlem Art Workshop in 1932–34. Funding for the Harlem Art Workshop ended after January 1, 1936, but the library continued efforts to support the program and Lawrence seems to have continued his involvement: his work was included in a group show of work by Harlem Art Workshop artists sent by the 135th Street library to the Pearl Street Neighborhood House in Waterbury, Connecticut, in 1936. Program description for Harlem Art Workshop and exhibition checklist, February 13, 1936, folder 6, box 7, 135th St. Branch Records, Schomburg Center for Research in Black Culture, Manuscripts, Archives, and Rare Books Division, New York Public Library. Alston and Lawrence would stay in close association for some time, with Lawrence renting a corner of Alston's and Henry Bannarn's studio at 306 West 141st Street and unofficially assisting Alston on his WPA mural commission at the Harlem Hospital in 1936. The 135th Street YMCA was a favorite haunt of Lawrence's, a place to play pool, attend Charles Seifert's lectures on African history, and, in 1938, stage his first solo show. For more on these institutions, their activities, and the government and private funds that supported them see Hills, *Painting Harlem Modern*, pp. 17–23.

24. Savage's recollection is noted in "Mrs. Roosevelt Feature Guest at Art Center, New York," *New Amsterdam News*, December 25, 1937.

25. See Deborah Cullen, "Robert Blackburn: American Printmaker," PhD diss., City University of New York, 2002, p. 67.

26. Federal Writers' Project, *New York City Guide: A Comprehensive Guide to the Five Boroughs of the Metropolis—Manhattan, Brooklyn, the Bronx, Queens, and Richmond*, 1939, reprinted as *The WPA Guide to New York City: The Federal Writers' Project guide to 1930s New York*, with an introduction by William H. Whyte (New York: New Press, 1992), p. 263.

27. Lawrence, in an interview with Jeff Donaldson, January 8, 1972, in Donaldson, "Generation '306,'" PhD diss, Northwestern University, 1974, quoted in Hills, *Painting Harlem Modern*, p. 87. Alston recalled of conversations in his studio, "We'd meet and have just bull sessions, knockdown, drag out. Some of them were pretty rough. But it was sort of a forum. . . . I don't think any of us realized the value of these things but there was a tremendous exchange of ideas." Alston, in the interview with Phillips.

28. Lawrence, quoted in Mort Cooper, "Portrait of a Negro Painter," *Chicago Defender*, May 18, 1963, p. 9.

29. See Bearden and Henderson, *A History of African-American Artists*, p. 297.

30. Lawrence discusses Jay Leyda's introducing him to José Clemente Orozco in the interview with Turner, p. 14. Leyda, letter to Wright, April 18, 1941. Folder 21, box 5, Jay Leyda Papers, Tamiment Library and Robert F. Wagner Labor Archives, New York University. In *A History of African-American Artists*, p. 301, Bearden and Henderson note that it was Leyda who first showed Barr the Migration Series.

31. Lawrence recalled, "When I went on the Project I had the good fortune to meet many more people, not just the Negro people but other artists as well." Lawrence, in the oral-history interview with Greene. Alston similarly said, "Artists like Gorky and Stuart Davis. . . . I'd stand in line for my check with them. . . . That's the way it was for everybody." Alston, in the interview with Phillips.

32. Lawrence, in conversation with Ellen Harkins Wheat, February 3, 1984, quoted in

Wheat, *Jacob Lawrence: American Painter* (Seattle: Seattle Art Museum, 1986), p. 42.

33. See Lawrence, in the interview with Turner, quoted in Smithgall, Gates, and Turner, *Jacob Lawrence and the Migration Series*, p. 30; Lawrence, in an oral-history interview with James Buell and David Driskell, February 4, 1982, Amistad Research Center, Museum Services Files, Tulane University, p. 1; and Lawrence, in the oral-history interview with Greene.

34. See Bearden and Henderson, *Six Black Masters* (New York: Zenith Books, 1972), p. 104.

35. Ibid.

36. Lawrence, quoted in Wheat, *Jacob Lawrence: American Painter*, p. 35.

37. "There was quite a bit of interest in black history at that time—street corner orators talking about social issues and things of that kind. . . . We had Negro history clubs in the schools and the libraries." Lawrence, in the interview with Buell and Driskell. In an unpublished manuscript written in conjunction with an exhibition of his John Brown series at the Detroit Institute of Arts in 1971, Lawrence recalled, "It was in a Negro history club and our nearly all black schools that I first heard the stories of Frederick Douglass, Harriet Tubman, Toussaint L'Ouverture, Nat Turner, Denmark Vesey and John Brown and many others." Quoted in Ellen Sharp, "The Legend of John Brown and the Series by Jacob Lawrence," *Bulletin of the Detroit Institute of Arts* 67, no. 4 (1993):21.

38. See *Journal of Negro History* 4, no. 2 (April 1919):237.

39. See Barbara Ransby, *Ella Baker and the Black Freedom Movement: A Radical Democratic Vision* (Chapel Hill: The University of North Carolina Press, 2003), p. 69, and J. Todd Moye, *Ella Baker: Community Organizer of the Civil Rights Movement* (Lanham, Md.: Rowman and Littlefield, 2013), pp. 36–37.

40. "The Negro History Club was organized at the 'Y' branch October 23 [1928], with fourteen members." *New Amsterdam News*, October 31, 1928, p. 9. "Miss Ella Baker, who gives a course in Negro Life and History at the Y.M.C.A. was guest of honor Monday evening at the regular meeting of the Chi Tau Upsilon Girls' Club," "Club Chats," *New Amsterdam News*, March 13, 1929, p. 4.

41. Ella Baker, quoted in Ransby, *Ella Baker and the Black Freedom Movement*, p. 95.

42. See Ransby, *Ella Baker and the Black Freedom Movement*, p. 69.

43. Baker, quoted in ibid., p. 94.

44. William E. Harmon Foundation, "Jacob Lawrence Biographic Sketch," November 12, 1940, p. 2. Reel 5577, frame 390, Downtown Gallery Records 1824-1974, bulk 1926-1969, Archives of American Art.

45. Requesting a renewal of his Rosenwald grant in March 1941, Lawrence writes, "The explanatory notes, to be selected from my research notes, will, I feel, take me about a month to get in shape." Jacob Lawrence file, folder 1, box 429, Rosenwald Collection, Franklin Library Special Collections, Fisk University, Nashville, Tenn. A press release put out by the Harmon Foundation on February 25, 1941, recounts, "Most of [Lawrence's] research has been done at the Schomburg Library in New York where he reads books and takes notes. He often goes through his notes two or three times to eliminate unimportant points. From these notes he blocks out the whole series he is working on in pencil. . . . This is later elaborated in paint." Jacob Lawrence file, folder 1, box 429, Rosenwald Collection. Hills speaks of Lawrence's use of phrases taken verbatim from John R. Beard's biography of Toussaint L'Ouverture; see Hills, *Painting Harlem Modern*, p. 61.

46. Helen Grayson, for example, offered that Lawrence's "extensive research in his subject matter is quite remarkable considering his lack of training." Charles Rogers spoke of "scholarship so sound," and Locke praised Lawrence's "careful library reading and research." See Grayson, "Confidential Report on Candidate for Fellowship," January 26, 1940; Rogers, "Confidential Report on Candidate for Fellowship," n.d.; and Locke, "Confidential Report on Candidate for Fellowship," January 23, 1940. Jacob Lawrence file, folder 1, box 429, Rosenwald Collection.

47. See Daniel Schulman, ed., *A Force for Change: African American Art and the Julius Rosenwald Fund* (Evanston: Northwestern University Press, 2009). An exh. cat. for the Spertus Museum, Chicago.

48. The mural was made for and remains at the black liberal-arts college Talladega College, in Alabama.

49. See Andrea D. Barnwell, *Charles White* (San Francisco: Pomegranate Communications, Inc., 2002), p. 3. Originally made for the George Cleveland Hall Library on Michigan Boulevard in Chicago, the mural is now installed in the Law Library at Howard University.

50. *Chicago Defender*, February 5, 1916, quoted in James R. Grossman, *Land of Hope:*

Chicago, Black Southerners and the Great Migration (Chicago: at the University Press, 1989), p. 168.

51. Grossman, *Land of Hope*, p. 168.

52. James N. Gregory, *The Southern Diaspora: How the Great Migrations of Black and White Southerners Transformed America* (Chapel Hill: The University of North Carolina Press, 2005), p. 15.

53. Locke (signed A.L.), "Harlem," *Harlem: Mecca of the New Negro, Survey Graphic* 6, no. 6 (special issue; March 1925): 629, 630. This essay was published in revised form in *The New Negro: An Interpretation* (New York: A. and C. Boni, 1925), p. 7.

54. Langston Hughes, *The Big Sea*, 1940 (reprint ed. New York: Hill and Wang, 1993), p. 264.

55. Lawrence, in the interview with Gates, quoted in Smithgall, Gates, and Turner, *Jacob Lawrence and the Migration Series from The Phillips Collection*, p. 3.

56. Ibid. p. 19.

57. See Grossman, *Land of Hope*, and Ira Berlin, *The Making of African America: The Four Great Migrations* (New York: Viking, 2010).

58. "Hold Big Migration Meeting in New York," *New York Age*, July 5, 1917, quoted in Arnesen, *Black Protest and the Great Migration: A Brief History with Documents*, (Boston: Bedford, and New York: St. Martin's, 2003), p. 11.

59. Lawrence's focus on such acts of agency was noted in the discussions of our exhibition's advisory committee, and especially by James Grossman and Sharifa Rhodes-Pitts. (The advisory committee was a group of artists, writers, historians, and others who met at the Museum three times in conjunction with our preparations for the show.) Grossman's history of the Great Migration, *Land of Hope*, emphasizes the choice to leave home as a self-conscious and politically significant act.

60. Lawrence, "Plan of Work," January 3, 1940. Folder 1, box 429, Rosenwald Collection.

61. Among the books that Lawrence read, as Hill demonstrates, were Carter G. Woodson, *A Century of Negro Migration* (Washington, D.C.: The Association for the Study of Negro Life and History, 1918) and Emmett J. Scott, *Negro Migration during the War* (New York: Oxford University Press, 1920). Six of Lawrence's section headers, as Hills points out, are quotations from Scott's *Negro Migration during the War*. See Hills, "Jacob Lawrence Migration Series: Weaving of Pictures and Texts," in Turner, ed., *Jacob Lawrence: The Migration Series* (Washington, D.C: The Rappahannock Press in association with The Phillips Collection, 1993), pp. 144, 148. In the oral-history interview with Greene, Lawrence describes his research at the Schomburg: "And this is where I think I read many of the books, like books of Du Bois, books of—well, he was one of my favorites—and many books like this. And this is how this story developed." In 1941, Mary Beattie Brady, Director of the Harmon Foundation; Edwin R. Embree, Director of The Rosenwald Fund; and the sociologist Charles S. Johnson attempted to broker a collaboration between Lawrence and Johnson; their correspondence from October of that year, as well as the fact that Johnson was included in the famous *New Negro* anthology (1925), compiled by Lawrence's champion Locke, suggests that the artist was probably familiar with Johnson's work as well. Jacob Lawrence file, folder 1, box 429, Rosenwald Collection. See also Locke, ed. *The New Negro*, pp. 278–98.

62. W. E. B. Du Bois, "The Migration of Negroes," *Crisis* 14, no. 2 (June 1917):63–66.

63. See Hills, *Painting Harlem Modern*, p. 141.

64. Chicago Commission on Race Relations, *The Negro in Chicago: A Study of Race Relations and a Race Riot* (Chicago: at the University Press, 1922).

65. Wright, "Introduction," in *Black Metropolis: A Study of Negro Life in a Northern City* (Chicago: at the University Press, 1993), pp. xvii–xxxiv.

66. See Elizabeth Steele, "The Materials and Techniques of Jacob Lawrence," in Peter T. Nesbett, Michelle DuBois, and Hills, eds., *Over the Line: The Art and Life of Jacob Lawrence* (Seattle: University of Washington Press in association with Jacob Lawrence Catalogue Raisonné Project, 2000), p. 248.

67. Ibid., p. 250.

68. See Park and Markowitz, *New Deal for Art*, p. xii.

69. See Edwin and Louise Rosskam, in an oral-history interview with Richard Doud, August 3, 1965. Archives of American Art.

70. Ibid.

71. See Sara Blair, *Harlem Crossroads: Black Writers and the Photograph in the Twentieth Century* (Princeton and Oxford: Princeton University Press, 2007), p. 7.

72. See Schulman, "African-American Art and the Julius Rosenwald Fund," in Schulman, ed., *A Force for Change*, p. 60.

73. Ibid. See also Bearden and Henderson, *A History of African-American Artists*, p. 264.

74. Edwin Rosskam, in the interview with Doud. Rosskam is speaking of the photographer Russell Lee, who had been working for the FSA: "he couldn't do migration without showing, finally, where migration went to. Migration went to the city."

75. Wright, *Twelve Million Black Voices: A Folk History of the Negro in the United States*, photo direction by Edwin Rosskam (New York: Viking Press, 1941), p. 10.

76. See Hills, *Painting Harlem Modern*, p. 131. See also Lonnie G. Bunch III and Spencer R. Crew, "A Historian's Eye: Jacob Lawrence, Historical Reality, and the Migration Series," in Turner, ed., *Jacob Lawrence: The Migration Series*, p. 27.

77. Lawrence, in the interview with Turner, p. 22, says, "I thought of [the series form] because it was the only way I could tell a complete story, you deal with Toussaint L'Ouverture, or Frederick Douglass and Harriet Tubman, their lives are so big, so all encompassing that I couldn't see a way to do this in one or two paintings so I thought of the series form and I guess that's why Jay Leyda took to my work because he thought of doing it in terms of a film where you do, you carry it on like a person would develop a film and I thought of doing it that way for that reason, I wasn't going to be given a wall." Passage published in partial form in Smithgall, Gates, and Turner, *Jacob Lawrence and the Migration Series*, p. 32.

78. Randolph, "Why Should We March?," *Survey Graphic* 31 (November 1942):488.

79. George Edmund Haynes, "Effect of War Conditions on Negro Labor," *Proceedings of the Academy of Political Science in the City of New York* 8, no. 2 (February 1919), quoted in Arnesen, *Black Protest and the Great Migration*, p. 23.

80. Eleanor Roosevelt, letter to Mrs. Henry M. Robert, Jr., president general of the Daughters of the American Revolution, February 26, 1939. Eleanor Roosevelt Papers, Franklin D. Roosevelt Library, Hyde Park, New York.

81. See Edward T. Folliard, "Ickes Introduces Contralto at Lincoln Memorial; Many Officials Attend Concert," *The Washington Post*, April 10, 1939.

82. Leonard Feather, liner notes for *Billie Holiday: Strange Fruit*, Atlantic Records SD 1614, 1972. As early as 1939, *New York Post* writer Samuel Grafton wrote of the song, "If the anger of the exploited ever mounts high enough in the South, it now has its Marseillaise." Quoted in Dorian Lynskey, "Strange Fruit: the first great protest song," *The Guardian*, February 15, 2011. See also Edwin Moore, "Strange Fruit Is Still a Song for Today," *The Guardian*, September 18, 2010, and David Margolick, *Strange Fruit: The Biography of a Song* (New York: HarperCollins, 2001).

83. Wright, liner notes for White, *Southern Exposure*.

84. On Bearden see Ellen Harold and Peter Stone, "Josh White," available online at www.culturalequity.org/alanlomax/ce_alanlomax_profile_josh_white.php (consulted October 19, 2014), and Elijah Ward, *Josh White: Society Blues* (New York: Routledge, 2002), p. 87. Lawrence mentions White in an interview with Turner, April 2000, location 3:22:21; 14, The Phillips Collection Archives, Washington, D.C. The transcript gives the name as "Josh Lee (ph.)," which seems to be a mistake given the context.

85. Locke, letter to Edith Halpert, n.d. Folder 37, box 164-33, Alain Leroy Locke Papers.

86. Library of Congress, *75 Years of Freedom: Commemoration of the 75th Anniversary of the Proclamation of the 13th Amendment to the Constitution of the United States* (Washington, D.C.: U. S. Govt., 1943). This show offered an important precedent for Halpert's show a year later at the Downtown Gallery, including her choice of Locke as an advisor.

87. Halpert, telegram to Locke, n.d. Folder 37, box 164-33, Alain Leroy Locke Papers.

88. See Bearden and Henderson, *A History of African-American Artists*, p. 264.

89. In the meetings of our exhibition advisory committee, Henry Finder, the editorial director of *The New Yorker*, discussed the important role *Fortune* played as a patron of and platform for a socially conscious modern graphic art.

90. Lawrence, in the oral-history interview with Greene.

91. Locke, letter to Peter Pollack, n.d. ("Tues"). Folder 4, box 164-78, Alain Leroy Locke Papers. See also Hills, *Painting Harlem Modern*, p. 129.

92. "'. . . And the Migrants Kept Coming': A Negro Artist Paints the Story of the Great American Minority," *Fortune* 24 (November 1941):102, 108.

93. Ibid., p. 109.

94. William E. Harmon Foundation, "Jacob Lawrence Biographic Sketch."

One
Series,

Two Places:

Jacob Lawrence's Migration Series
at The Museum of Modern Art and
The Phillips Collection

Elsa Smithgall

"Are we not both experimenting in the same problem, though you are far advanced where I am just beginning?"

—Alfred H. Barr, Jr., to Duncan Phillips, January 10, 1927[1]

In January 1927, Alfred H. Barr, Jr., a determined young Wellesley College professor of art history **(fig. 1)**, brazenly reached out to an equally passionate devotee of modern art with a museum of his own, Duncan Phillips **(fig. 2)**. "The Art Department is poor," Barr wrote, "so shamelessly we go begging." The teaching, Barr explained, was suffering from its lack of resources, including original artworks as well as books and quality reproductions. Could Phillips possibly help by supplying photographs of works in his collection? Could he send to Wellesley an exhibition of masterworks from the Phillips Memorial Gallery in Washington, D.C., similar to the one that he had recently sent to the Baltimore Museum of Art?[2] Before asking pardon for his bold requests, Barr expressed how much he "looked forward with pleasure to writing about your delightful book for the Saturday Review of Literature."[3] Released just the previous year, Phillips's book *A Collection in the Making* represented his first effort to document the artists in his burgeoning collection and to share the founding principles guiding its direction. Barr would begin his review by noting the book's extensive illustrations; he was struck by the fact that 150 out of its 200 images illustrated the work of American artists. While not hesitating to differ with Phillips's enthusiastic estimations of certain painters, Barr readily dismissed these as insignificant lapses in a book that he called "the most comprehensive and valuable anthology of the last fifty years of American painting thus far produced."[4]

1. Alfred H. Barr, Jr., first director of The Museum of Modern Art, New York. 1929–30. The Museum of Modern Art, New York

Frontis Jacob Lawrence's Migration Series installed at the Downtown Gallery, New York. December 1941. Harmon Foundation Collection, National Archives and Records Administration, College Park, Md.

Within two years, the nature of Barr's relationship with Phillips was transformed as Barr became the founding director of The Museum of Modern Art and Phillips one of its founding trustees. "Anxious to serve" and "tremendously interested in the great enterprise," Phillips began his tenure fully expecting "to find ways in which our Museum can cooperate with yours for mutual benefit," he told the board's secretary, Frank Crowninshield.[5] He wasted no time in asserting his opinions and advice about which artists and works to include in the newly inaugurated series of loan exhibitions at MoMA, and his vocal counsel at times tested his relationship with Barr.[6] Yet even as Phillips's engagement with MoMA waned after 1935, when his status changed from trustee to honorary trustee for life, he and Barr continued to enjoy a warm friendship and professional collegiality by seeking each other's advice, supporting each other's projects, and socializing together in the company of their spouses.[7]

2. Duncan Phillips, founder and director of the Phillips Memorial Gallery (now The Phillips Collection), Washington, D.C. 1940s. The Phillips Collection Archives, Washington, D.C.

In January 1941, Barr stopped in at the Phillips Memorial Gallery: "It was lucky I happened to be there when you came.... We see you all too seldom," Phillips wrote with evident sincerity.[8] That spring, Barr and his wife paid Phillips another visit, this time having dinner with him and his wife, Marjorie, at their home on Foxhall Road in Washington, surrounded by works from their personal collection. A subsequent letter from Barr suggests that during the visit, Phillips pointed out several works by one of his favorite artists—Arthur Dove—and, more important, tried to gauge Barr's interest in accepting one as a gift to MoMA. Once back in New York, Barr hastened not only to

confirm that he would welcome such a gift but also to name the work he favored: "We would be very interested in having a fine Dove painting for our collection. Of all those that you showed me it seems to me the one called *Willows* is the finest."[9] *Willows* entered MoMA's collection later that year as a gift from Phillips—a sign of ties between the Phillips Memorial Gallery and MoMA that were to grow stronger in the coming year, when these two experimenters would join in the cause of Jacob Lawrence's Migration Series.[10]

"A storybook success"

"The show opened on the day of Pearl Harbor and was nevertheless a storybook success. The Museum of Modern Art and the Phillips Memorial Gallery fought to buy the whole series and at last reluctantly divided it between them." –Aline B. Louchheim, "An Artist Reports on the Troubled Mind," 1950[11]

Since The Museum of Modern Art and The Phillips Memorial Gallery (today known as The Phillips Collection) acquired Lawrence's Migration Series, in 1942, the story of the two institutions supposedly battling over his master-piece has become legendary—particularly because it ends in the splitting of the series, despite the artist's wish to keep the paintings together. But the actual circumstances, even including the dramatic unfolding that precipitated the split purchase, suggest that from the beginning neither museum actually fought to acquire the series in its entirety, and that the main point of negotiation concerned precisely which half of it each museum would claim.

The making of the Migration Series, and its journey to the collections of MoMA and The Phillips Collection through Edith Halpert's Downtown Gallery in Manhattan, began with a boy who never imagined that he would one day earn a living as a professional artist.[12] From the age of thirteen, Lawrence showed artistic promise at an after-school arts-and-crafts program at Utopia Children's House in Harlem **(fig. 3)**, where his family, participants in the Great Migration, had arrived around 1930. There, under the direction of the African-American artist Charles Alston, he enjoyed making stage sets out of cardboard boxes and conjuring up abstract geometric designs out of tempera poster paints. What started as a productive outlet assuring his mother that her son was off the streets became a portal for Lawrence's

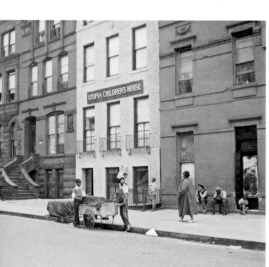

3. Utopia Children's House, where Lawrence took art classes in the early 1930s with the artist Charles Alston. Summer 1938. Library of Congress Prints and Photographs Division, Washington, D.C.

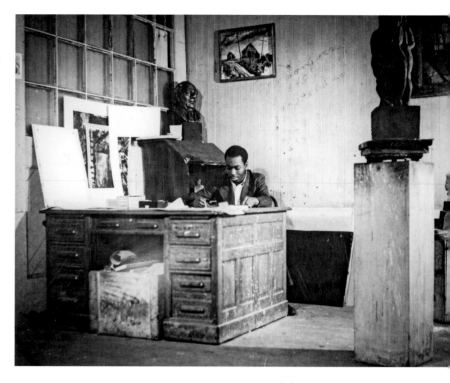

4. Lawrence in the space he rented in Charles Alston's and Henry Bannarn's studio at 306 West 141st Street, Harlem. c. 1935. National Archives and Records Administration, Harmon Foundation Collection, College Park, Md.

creative imagination. In 1932, encouraged by Alston, he began studies at the Harlem Art Workshop, which was based at the 135th Street branch of the New York Public Library. Then, beginning in 1934, he continued his training in Alston's and Henry Bannarn's studio at 306 West 141st Street, off Frederick Douglass Boulevard, an art center funded by the federal government's Works Progress Administration (WPA). Here, through Alston, Lawrence gained the confidence that

"what I was doing, the way I was seeing, had validity"

(fig. 4).[13] The space that was known as "306" would become a cultural crossroads for the artists of the Harlem Renaissance; Lawrence soaked in its vitality, and in the spirited exchanges among its artists, musicians, writers, critics, dancers, actors, and playwrights.[14] One of the many pivotal encounters he had there was with Alain Locke, professor of philosophy at Howard University in Washington, D.C. **(fig. 5)**.

In late 1939, after completing two major series on historical African-American figures, Toussaint L'Ouverture (1938) and Frederick Douglass (1939), and starting a third on Harriet Tubman, Lawrence contemplated a new subject. More ambitious than the rest, this idea would serve as the basis for a grant

5. Alain Leroy Locke at the South Side Community Art Center, Chicago. 1940. Photo: Gordon Parks. Moorland-Spingarn Research Center, Howard University, Washington, D.C.

6. Lawrence's series The Life of Toussaint L'Ouverture (1938) installed in the exhibition *Contemporary Negro Art* at The Baltimore Museum of Art. 1939. Photograph Collection, Archives and Manuscripts Collections, The Baltimore Museum of Art

application he was submitting to the Julius Rosenwald Fund. "My proposed plan," he wrote to Locke, "is to interpret in a sufficient number of panels (40–50—18 x 12) the great Negro migration north during the World War."[15] In consulting Locke on the application, Lawrence was turning to the person who "had faith in what I am doing."[16] Locke had not just had faith in what Lawrence was doing, he had proven a devoted champion: as an advisor to the William E. Harmon Foundation, he had worked tirelessly with its director, Mary Beattie Brady, to promote Lawrence's work in both publications and exhibitions. Among these was an exhibition earlier that year that the Harmon Foundation had helped to organize with the Baltimore Museum of Art: *Contemporary Negro Art* included an entire room dedicated to all forty-one panels of Lawrence's Toussaint L'Ouverture series **(fig. 6)**.[17] The artist's works had caught the attention of *Newsweek* magazine, whose writer proclaimed Lawrence "the likeliest discovery" in the show.[18]

"It had the feeling of a filmmaker"

As Lawrence garnered both critical and popular attention throughout 1939 for the Toussaint L'Ouverture series, his circle of supporters began to extend beyond the black community. It was around this time that his work attracted the attention of Jay Leyda, an assistant film curator at MoMA **(fig. 7)**. Leyda was one of "the people [who] came up to Harlem and took an interest in what was going on," Lawrence would recall.[19] He would also surmise that Leyda found his work appealing because "he thought it ... had the feeling of a film maker by the progression of working in the series form."[20]

A note in Leyda's hand from early February 1940 reads,

> Jacob Lawrence
> Negro boy (thru Jay Leyda) 2/5/40
> 1. Series of gouaches: Story Touissant [sic] L'Ouverture
> 2. Series in temperas on panel: Story of Harriet Tubman[21]

An informal property pass of sorts, the note suggests that the two series had been delivered to The Museum of Modern Art care of Leyda. It probably relates to a letter a month later from Brady to George Reynolds, director of the Rosenwald Fund's fellowships program, telling him that she had "sent [Lawrence's work] up to the Museum of Modern Art ... several of the men there are very eager to have the material shown in one of their exhibitions a few months hence."[22] A few days earlier, Reynolds, having heard rumors that someone at MoMA had "interest in [Lawrence's] paintings," had reached out to the Museum for input on the artist's pending grant application. Addressing his letter to "Gentlemen," Reynolds noted that he was "seeking further critical judgment on Mr. Laurence's [sic] ability" and a "frank appraisal of his work and his promise as you see it."[23] Within a week of receiving Reynolds's query, Leyda, the Lawrence aficionado in MoMA's ranks, had written to Holger Cahill, director of the Federal Art Project (a division of the WPA) and a former curator at MoMA. Hoping to enlist a respected authority in supporting Lawrence's fellowship application but uncertain of Cahill's feelings about Lawrence, Leyda phrased his request in the form of a question:

"If you enjoyed his paintings that you saw—or found enough quality in them— would you say so to the Rosenwald people?"

A supplementary letter from you would be enormously important."[24] The very next day, Leyda's MoMA colleague Dorothy Miller, assistant curator of American art and Cahill's wife, dashed off a letter to Reynolds, with a copy to Leyda, expressing both her and Cahill's assessment of Lawrence:

> I have seen the Toussaint L'Ouverture series of gouaches and the Harriet Tubman series of gesso panels and thought them extremely promising. Mr. Holger Cahill, who happened to be in the Museum when the paintings were here, also looked them over and has authorized me to say that he feels the work has promise and that he shows a very interesting reaction to racial subject matter. Laurence [sic] is very young and probably should be allowed the opportunity for further art study.

For her summary of Cahill's opinion, Miller seems to have almost exactly transcribed her own handwritten notes on the bottom of Reynolds's letter, which Cahill must have dictated to her.[25] Her letter landed on Reynolds's desk just days after Brady's, which had offered glowing support of "one of the very first of the Negro artists I would consider for scholarship."[26]

On April 17, 1940, Reynolds wrote to Lawrence with good news: "You have been selected by the Committee on Fellowships of the Julius Rosenwald Fund to receive a grant of One thousand five hundred dollars to assist you in carrying forward your painting for one year, beginning May 1, 1940."[27] Lawrence wrote to Locke to share the news and thank him for "all that you did in helping me win this award."[28] Leyda, too, wrote to Locke on hearing the "marvelous news": "I feel positive," he predicted, "that his will be one grant that the Rosenwald Fund will be hugely proud of some day."[29]

Meanwhile Leyda and Locke were hard at work on another attempt to support Lawrence by getting his Tubman series included in a major exhibition, *The Art of the American Negro (1851–1940)*.[30] The show, in a hall of the Chicago Coliseum, was part of a much larger event, the American Negro Exposition, on whose national committee on art both Leyda and Locke served. In the same letter of April 11, Leyda asked whether Locke had heard from Claude Barnett (the chairman of the Art Committee for the Exposition) about including Lawrence's Tubman series in the show.[31] Their efforts were evidently successful, since that July, Lawrence's forty-one-panel Toussaint L'Ouverture series (having won out over Tubman) made a notable appearance in Chicago, earning Lawrence the exhibition's second prize in watercolor painting.[32] Beside reproductions of two panels from the series, the exhibition catalogue declared that the series was painted "in a remarkable manner" by a young Lawrence at only "the age of sixteen."[33]

7. Lawrence with Jay Leyda, assistant curator of film at The Museum of Modern Art, in Brooklyn. 1941. Photographs and Prints Division, Schomburg Center for Research in Black Culture, The New York Public Library, Astor, Lenox and Tilden Foundations

By the time the Chicago exhibition ended, in September 1940, a then twenty-three-year-old Lawrence was deeply engaged in his work on The Migration of the Negro. With the benefit of the Rosenwald grant, he had for the first time been able to establish his own studio, at 33 West 125th Street, a space large enough to spread out all sixty hardboard panels at once.[34] As his practice had been in the Toussaint and Tubman series, he began not by putting a brush to the panels but by immersing himself in the history, studying the Migration at the Schomburg Center for Research in Black Culture at the 135th Street branch of the New York Public Library. In the months to come, Lawrence would undertake a process of "careful selection, simplification and distillation" to crystallize his ideas for the series into the words of the caption phrases and then into preparatory drawings.[35] Assisted by the artist Gwendolyn Knight, whom he would marry the following year, he brushed several layers of a rabbit-skin-glue gesso onto each hardboard panel and sanded them smooth once they were dry. Then, after transferring his drawings onto the gesso, he filled the panels with bold color, building up forms and rhythmic cadences in alternating vertical and horizontal compositions.[36] To unify the color throughout, he applied one color at a time to all sixty panels, moving from dark hues to light. In this way he conveyed a sense of the series as one unit rather than as sixty separate panels.[37]

"So much of this was news to me"

Later in 1940, Lawrence took a break from painting to write to thank Locke for sending him a copy of the philosopher's latest book, *The Negro in Art*.[38] "As an artist," Lawrence wrote, "I find the book very interesting, as it is very good to see and to know what your fellow contemporaries are doing in the art field, and also to know what the Negro artists have done in the past. I find the book a very complete and thorough study."[39] Locke wrote in the book that Lawrence had at this point executed "three brilliantly original series," including the Toussaint L'Ouverture series, which was generously represented with eight reproductions.[40]

In June of 1941, Locke received a letter about *The Negro in Art* from Edith Halpert **(fig. 8)**, owner of Manhattan's Downtown Gallery, who said she was "enjoying [her] copy immensely and everyone who has seen it has been equally enthusiastic." She continued, "I was woefully ignorant of the background material, although my W.P.A. contacts kept me informed about the contemporary painters and sculptors. Because so much of this was news to me, and to other persons in the art world, it occurred to me to introduce Negro art in a large inclusive exhibition."[41] If the material in Locke's book was a revelation to Halpert, she knew it was equally unknown to most Americans. Before proceeding with her idea, she was eager to know whether Locke liked it and would consult with her on the project. Responding

8. Edith Halpert, art dealer and, as of 1927, director of the Downtown Gallery, New York. 1921. Downtown Gallery Records, Archives of American Art, Smithsonian Institution, Washington, D.C.

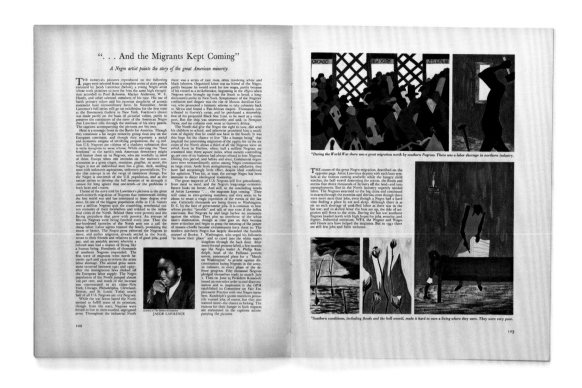

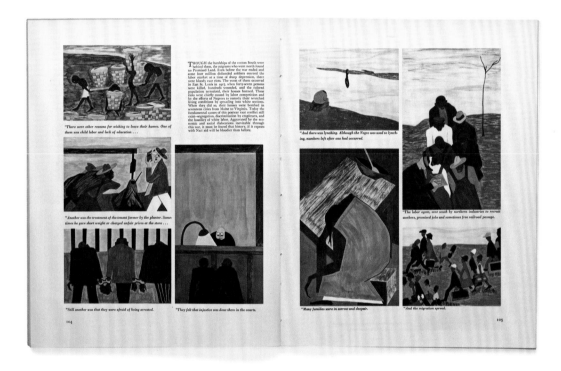

a week later, on June 16, Locke wrote that he would be pleased to collaborate and would be in New York the following week, when he could help her track down works in private collections. Then he posed the question:

"Have you seen the work of Jacob Lawrence?"[42]

Days later, on June 18, Halpert confirmed a meeting with Locke the following week, noting how eager she was to "make some definite decision about artists and other possibilities" for the exhibition. Among these decisions was one on Lawrence, whose Migration Series she would soon see with Locke, most likely at the Harlem Community Art Center.[43] Halpert must have decided quickly to include it in her exhibition, for by the end of the month she had arranged for the panels to travel to the Time & Life Building, midtown at Rockefeller Center, where they were seen by Deborah Calkins, assistant art editor at *Fortune* magazine,

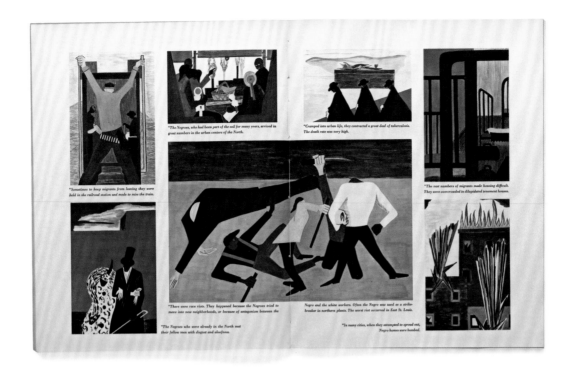

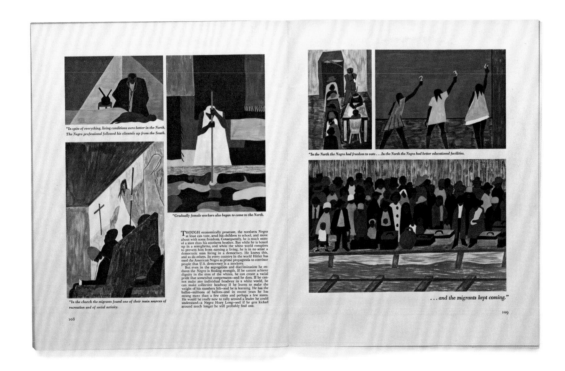

9—12. Spreads from the November 1941 issue of *Fortune* magazine featuring twenty-six panels from Lawrence's Migration Series.

and others on staff. Halpert knew that publication of the series in the country's leading business journal would bring it to the attention of a global upper-middle-class readership—and, in turn, draw prospective clients to her gallery when she showed the work later in the year. "The editors of FORTUNE who have seen your panels are, as I suspected they would be, immensely interested in them," Calkins wrote to Lawrence on July 1, shortly after telephoning Halpert to give her the good news. Calkins spared Lawrence the possibility that the war situation could upend the plan entirely.[44] Once *Fortune* confirmed that

it would include twenty-six panels from the Migration Series, along with a text, in the November 1941 issue **(figs. 9–12)**, Halpert moved quickly to organize a special viewing of the series at the Downtown Gallery during the week of November 3. But the "real fireworks," as Halpert would later tell Lawrence, were to come in December, when the series would make its debut in her exhibition *American Negro Art*.[45]

"Have you set a price?" A Sales Proposal

A month before Lawrence's November solo exhibition at the Downtown Gallery, while he was on an extended trip to New Orleans with Gwendolyn (the couple had recently married), Halpert wrote to ask the essential question, "Have you set a price?" Halpert also asked whether he would "consider breaking up the set, if important institutions are interested in individual items."[46] In creating the Migration Series, Lawrence had not been thinking about sales or a gallery, and now he needed some time to think over the question.[47] After reflection, he responded to Halpert that he "finally decided not to break up the series. I have reached this conclusion because the complete story was conceived within the sixty paintings therefore to sell any one painting out of the set would make it an incomplete story."[48] He set his price at $2,000, but realized that selling the complete set at that price could be challenging and ultimately deferred to his seasoned dealer: "If you have any other ideas as to disposing of the paintings or the price, will you please write and let me know? Your experience puts you in a much better position than myself to make decisions of this kind."[49]

13. Adele Rosenwald Levy with First Lady Eleanor Roosevelt. c. 1940s. Courtesy David and Stephanie Deutsch

In early November, on the closing day of the show, Halpert wrote back. Mentioning neither the price nor the splitting up of the series, she instead assured Lawrence that the panels "look remarkably well" and were being met with "a great deal of enthusiasm."[50] Over the few weeks leading up to the opening of the larger show, on December 9, the series, relocated to Halpert's office, continued to draw visitors. In the second fortnight of November, a review of the Migration Series in *Artnews* magazine, praising Lawrence's "exceptional flair both for the most direct means of expression and for a fine vigorous color pattern," seemed to poise the young artist for success in the imminent *American Negro Art* show.[51]

"A labor of love"[52]

Halpert's plans for *American Negro Art* continued apace, including an opening on the evening of December 8 with entertainment by the blues singer Joshua White and the band the Harlem Highlanders. With Locke's help, Halpert had assembled an impressive sponsorship committee,

ranging from leading figures of the Harlem Renaissance such as, Countee Cullen, Katherine Dunham, Paul Robeson, Carl Van Vechten, Ethel Waters, and Richard Wright to political and social luminaries such as Eleanor Roosevelt, Mr. and Mrs. John D. Rockefeller, and Dr. David Levy and his wife, Adele Levy, a trustee of MoMA **(fig. 13)**. In the invitation to a preview of the show, Halpert announced two objectives for it: "to inform the public of the contribution made to native art by American negro artists," and "to inaugurate a special Negro Art Fund for the purchase of paintings, sculpture, and graphics by contemporary American Negro artists, such works to be presented to museums and other public institutions."[53] Another objective that Halpert worked behind the scenes to achieve was to prompt more New York dealers to add an African-American artist to their roster. On December 7, however, before the exhibition welcomed its first visitors, the United States was attacked by Japan at Pearl Harbor. Although public attention was consumed by the crisis, Halpert moved forward with her opening on December 8 and continued the exhibition through January 3, 1942.

Nor were her efforts completely in vain. As the exhibition drew to an end, Locke wrote to Lawrence to report on the reception of his Migration Series. Lawrence, who was still in New Orleans and experiencing the culture of the South for the first time, had missed the activity surrounding both his one-person exhibition in November and his inclusion in the larger exhibition that followed **(fig. 14)**.

"I wish you could have seen the exhibit," Locke told Lawrence enthusiastically, "it was beautifully set up, and was quite an artistic success."

The same could not be said for the monetary returns: "Financially it was only a fair success owing to the war situation," he said tellingly.[54] Sales had indeed been disappointing—hardly surprising, as Locke suggested, given the uncertain economic outlook. (Nevertheless, Halpert had succeeded in selling two new paintings, *Catholic New Orleans* and *Bar and Grill*, that Lawrence had sent up from New Orleans.)[55] Locke also told Lawrence that there were "several interested sources for the Migration Series," and assured him that "with patience I believe they will be sold intact." Among those who had visited the exhibition was Alfred Barr. According to Locke, "Mr. Barr of the Modern Museum was in three or four times, and liked the whole show, but particularly your work."[56]

14. Lawrence's Migration Series installed at the Downtown Gallery, New York. December 1941. Harmon Foundation Collection, National Archives and Records Administration, College Park, Md.

Meanwhile Duncan Phillips was arranging to visit Halpert and the Downtown Gallery. His visit was prompted by the desire to see works by two artists in her stable, Raymond Breinin and Bernard Karfiol, that he hoped to borrow for an exhibition of contemporary American art he was planning for March.[57] But he also expressed interest in seeing *American Negro Art*, and in particular the work of Horace Pippin, a black painter who was older and better-known than Lawrence. "I note that your American Negro Art will still be on when we get to New York and I am looking forward to the work of Pippin," Phillips wrote to Halpert in early January.[58] When he finally made it to the gallery, by the middle of the month, his admiration for the Migration Series led to a new plan to bring the complete series to Washington for an exhibition at the Phillips Memorial Gallery.[59] Knowing Phillips often tested out possible new acquisitions by living with them, Halpert may have masterminded the idea of an exhibition to help seal a future purchase.[60] The exhibition also promised to give the artist exposure in Washington, D.C., where Lawrence's story would resonate among the city's large population of Southern migrants.

On January 17, however, just days after Phillips's visit and with the promise of an exhibition at the Phillips Memorial Gallery looming, Halpert began simultaneously pursuing the possibility of placing the Migration Series at MoMA. Her key was Adele Levy, the MoMA trustee who had also served on the sponsorship committee of Halpert's *American Negro Art* exhibition. Moreover, as Halpert would remind her, the series had been made possible by a Julius Rosenwald fellowship—and Julius Rosenwald was none other than Levy's father. Writing to Levy, Halpert claimed "tremendous success" for the exhibition and singled out the Migration Series as a work that

"many authorities in the art world consider . . . one of the most important contributions to contemporary art."

She continued, "While institutions and artists were eager to buy single panels from the group (amounting to about forty in the number of requests) we all agreed that it would be an unfortunate idea to break up this extraordinary series. We are considering dividing it into two groups of thirty each."[61] Given Lawrence's absence from New York and his stated preference for keeping the series together, it seems most likely that it was Halpert who devised the idea of dividing the series into two groups of thirty as a sensible alternative to selling off the panels individually.[62] Making the case to Levy, Halpert further invoked the consensus of members of The Museum of Modern Art, who "agree with me that at least thirty of these panels should be in the collection of the Museum of Modern Art. Mr. Barr has expressed his enthusiasm for these panels and I have reasons to believe that they will be accepted with great appreciation."[63] To entice her further, Halpert wrote that she and Lawrence had set a "ridiculously low price" of "one thousand dollars, or at an average of $33 per panel."[64] This was in fact the price that had been established by Lawrence the previous October.

On February 5, the day after the panels were to have been shipped to the Phillips in preparation for the exhibition there, Halpert telegramed Marjorie Phillips, Duncan Phillips's wife and the assistant director of the museum, with word of their sudden detour to The Museum of Modern Art: "I am so sorry that there has been a delay in the

shipment of the Jacob Lawrence panels," Halpert explained.

"The Museum of Modern Art had requested that we send them up on approval and would not permit us to remove them during the negotiation. Mrs. David Levy has purchased thirty of the panels to present to MoMA at the urgent request of Mr. Barr."[65]

With MoMA's half of the series secured, Halpert now had leverage to persuade the Phillips Memorial Gallery to make an acquisition. Seeing no need to even mention price, she proposed to Marjorie two possible scenarios acceptable to Barr: to take either numbers 1 to 30, or alternate, odd numbers from 1 to 60. Why not **panels 31** to **60**, and why odd numbers, not even? Barr was intent that his group of thirty should include **panel 46**, "Industries attempted to board their labor in quarters that were oftentimes very unhealthy. Labor camps were numerous," since it was one that his donor, Adele Levy, particularly liked. Ultimately, Halpert insisted, "since both series contain equally fine examples, it really does not matter how the distribution is made." What mattered was that by deciding to acquire the other thirty, Marjorie and Duncan would ensure that the entire series be "preserved for the future."[66]

Two weeks later, on February 21, as Duncan Phillips was enjoying his latest show, *Exhibition of Tempera Paintings by Jacob Lawrence*, Halpert wrote to apologize for "rushing you into a decision regarding the Lawrence panels." Barr was to blame, she said, as he had asked her to call Phillips "immediately" because "his announcements were being sent out." Halpert conveyed her great pleasure in Phillips's decision to "have half of this remarkable series of paintings."[67] She did not mention which half of the series Phillips had finally settled on, but in May, Phillips telegramed Barr, "Our Lawrence set the odd numbers.

You made decision saying you would take the set which included picture of stairs leading up to a window. This you said was condition imposed by donor who had specified gift of that subject."[68]

By splitting the series between even- and odd-numbered panels rather than dividing it down the middle, Barr and Phillips had arrived at a solution that allowed each museum to maintain the integrity of the south-to-north progression of the narrative, where, beginning in **panel 31**, the migrants arrive in the North, the so-called promised land. At the same time that Halpert secured Phillips's commitment to purchase half of the series, she also obtained his agreement to "permit the Museum of Modern Art to exhibit [all the panels] as a unit" in a traveling exhibition. By March, however, Phillips had grown concerned about parting with his new acquisition, which had just returned from the bedside of the distinguished poet and civil rights advocate Katherine Garrison Chapin.[69] Chapin had been "very ill and asked if they could be sent to her room as she had heard much about them and [was] deeply interested in the character of the negro and his wrongs," Phillips reported, but they returned from her home severely scratched. Realizing "how very perishable they are," Phillips withdrew his consent for the MoMA show.[70] Finally, in May, Barr and Elodie Courter, MoMA's director of circulating exhibitions, persuaded Phillips to lend them his thirty panels with the assurance that they would all be framed under glass before going out on tour. That October Lawrence's Migration Series embarked on a two-year, fifteen-venue tour around the country, culminating in an exhibition at MoMA in October 1944 **(figs. 15 and 16).**[71]

So what had become of the artist while his Migration Series was caught up in all these negotiations? The Lawrences had retreated from New Orleans to a farm

in Lenexa, Virginia, when reports of the disposition of the series reached him in two waves: first, that MoMA had acquired half the series through the generosity of a donor, and then that Phillips had "finally agreed to purchase the other thirty."[72] Halpert must have felt satisfaction in brokering this outcome, but how did Lawrence feel about it, having originally hoped for the series to remain together? "I was also very glad to hear that the other half of the series has been sold," he wrote Halpert.[73] Lawrence's positive though understated expression of his pleasure over the split acquisition raises the question of how he really felt about the series' future fate in two places. As his later recollections suggest, the then twenty-four-year-old artist, who had painted the series without thought of the commercial market, had yet to grasp its full implications for his future career.[74] For the moment, however, the chance to divide the series equally between two places far outweighed the alternative: the individual sale and displacement of each panel to as many as sixty different collections. Lawrence later credited Halpert with having the strength and determination not to sell the panels off individually: "Had I not had Edith Halpert's encouragement in keeping it together, I don't know what would have happened.... Had it been another dealer maybe they would have been sold individually and just completely lost."[75]

In a matter of seven months, Lawrence had enjoyed a rise to national fame that was nothing short of meteoric. In the process he came to learn something about the inner workings of the commercial art market and the acquisition practices of museums; this formative experience no doubt left a lasting impact on his subsequent approach to artmaking. Lawrence never abandoned the narrative serial format that had secured his place in the art world, as evidenced by such later series as: Struggle: From the History from the American People (1954–56), Harriet and the Promised Land (1967), Hiroshima (1983), and Eight Studies for the Book of Genesis (1989). Yet never again would the artist complete a narrative cycle as large in scale or scope as the one he deemed "one of the highpoints of my creative life."[76] In 1992, a half century after the series had been acquired by both MoMA and The Phillips Collection, Lawrence offered his own answer to the ever beguiling question of why the series was broken up:

"It wasn't. It's in two places, two very prestigious places: The Phillips Collection and The Museum of Modern Art."[77]

Notes

Thanks to my curatorial interns Anna Walcutt and James Denison, and to Jodi Roberts, Curatorial Assistant, Department of Painting and Sculpture, MoMA, for their invaluable research assistance. I am grateful to Myra Shulman for her thoughtful reading of this manuscript.

1. Alfred H. Barr, Jr., letter to Duncan Phillips, January 10, 1927. Reel 1934, frames 1088–89, The Phillips Collection Records 1920–60, The Phillips Collection Archives, Washington, D.C.

2. Barr told Phillips he had read "a short while ago that you had lent a fine exhibition of your pictures to the Baltimore Museum." He was probably referring to *Exhibition of Paintings by American Artists*, which traveled to the Baltimore Museum of Art from November 6 to 30, 1924.

3. Ibid. Phillips later did send Barr photographs of his collection and books for Wellesley's library.

4. Barr, "American Painting," *The Saturday Review of Literature* 4, no. 7 (September 10, 1927):99.

5. Phillips, letter to Frank Crowninshield, November 4, 1929. Reel 1937, frames 1136–37, The Phillips Collection Records 1920–60.

6. In a letter to Barr of November 10, 1930, Phillips threatened to resign from the board if Barr did not honor his desire that Augustus Vincent Tack be included in the Museum's exhibition *Painting and Sculpture by Living Americans*. Tack's omission would have represented a second slight for Phillips, who had strongly urged Barr to include the artist in the 1929 show *Nineteen Living Americans*, to no avail. Barr immediately appeased Phillips by adding several Tacks to the 1930 exhibition. See Phillips, letter to Barr, November 10, 1930, reel 1939, frames 0994–95, The Phillips Collection Records 1920–60, and Barr, letter to Phillips, November 11, 1930, reel 1939, frame 0996, The Phillips Collection Records 1920–60.

7. The relationship between the two men continued into the last decade of Phillips's life. In 1962, on the occasion of Barr's sixtieth birthday, Phillips wrote to him, "You are known ... for your own illuminating interpretations of the fascinating diversities of art in our time ... You have connected your fellow Americans with vital currents of creative innovation everywhere.... Collectors have taken courage from your courage. Your understanding has aided interracial understanding." Phillips, letter to Barr, January 22, 1962. Folder 11, box 2, The Phillips Collection Records 1920–79.

8. Phillips, letter to Barr, January 10, 1941. Reel 1957, frame 0303, The Philips Collection Records 1920–60.

9. Barr, letter to Phillips, April 1, 1941. Reel 1957, frame 0448, The Phillips Collection Records 1920–1960. MoMA had one Arthur Dove in its collection, the collage *Grandmother* (1925). For their research on the early acquisition history of Dove's work at MoMA, I thank Jennifer Harris and Jodi Roberts.

10. Jacob Lawrence admired Dove early in his career, and one can imagine that Phillips and Barr could have seen an affinity between Dove's organic abstraction and some of the nature-based abstract forms in the Migration Series. See Elizabeth MacCausland, "Jacob Lawrence," *Magazine of Art* 38, no. 7 (November 1945):254.

11. Aline B. Louchheim, "An Artist Reports on the Troubled Mind," *New York Times Magazine*, October 15, 1950.

12. Of his early years at Utopia Children's House, Lawrence said, "I never thought of being a professional artist at that time. I didn't even know what it was about." Lawrence, in an oral-history interview with Carroll Greene, October 26, 1968. Archives of American Art, Smithsonian Institution, Washington, D.C. Lawrence also said, "Until the time that I was hired by the Federal Art Project ... I had no idea that I would be selling works." In a tape-recorded interview with Elizabeth Hutton Turner, Seattle, Washington, October 3, 1992. P. 11 of a transcript in The Phillips Collection Archives.

13. Lawrence, in the interview with Turner. P. 21 of a transcript in The Phillips Collection Archives.

14. Lawrence relished talking about the incredible mix of people whom he encountered in the "university without walls" at 306. For one account see ibid., p. 13.

15. Lawrence, letter to Alain Locke, n.d. Folder 26, box 164-44, Alain Leroy Locke Papers, Moorland-Spingarn Research Center, Howard University, Washington, D.C.

16. Ibid.

17. See *Contemporary Negro Art* (Baltimore: The Baltimore Museum of Art, 1939). Locke wrote the foreword to this catalogue. Bridget D. Cooks considers the exhibition's origin and purpose in *Exhibiting Blackness: African Americans and the American Art Museum* (Amherst: University of Massachusetts Press, 2011), pp. 33–44. For more on Locke's and Mary Beattie Brady's role in advancing Lawrence's career between 1939 and 1941, see Patricia Hills, *Painting Harlem Modern: The Art of Jacob Lawrence* (Berkeley: University of California Press, 2009), pp. 40–47.

18. "Baltimore Museum Becomes the First in the South to Stage Large Show of Negro Art," *Newsweek* 13, no. 6 (February 6, 1939):26.

19. Lawrence, in a tape-recorded interview, of himself and Gwendolyn Lawrence at their home in Seattle, Washington, with Paul J. Karlstrom, November 18, 1998. P. 26 of a transcript in Curatorial Records, The Phillips Collection Archives. Lawrence tells Karlstrom, "I think it's very important . . . the people that came up to Harlem and took an interest in what was going on, and when Gwen mentions a filmmaker, I think of a person like Jay Leyda."

20. Lawrence, in the interview with Turner, p. 14.

21. Jay Leyda, handwritten note, February 5, 1940, Museum Collection Files, Jacob Lawrence (General—Biographical Material), Department of Painting and Sculpture, The Museum of Modern Art. I am grateful to Jodi Roberts for uncovering this note and the other documents cited below in the MoMA Archives.

22. Mary Beattie Brady, letter to George M. Reynolds, March 25, 1940. Julius Rosenwald Fund Archives, Fisk University Library, Nashville, Tenn.

23. Reynolds, letter to "Gentlemen," at MoMA, March 20, 1940. Museum Collection Files, Jacob Lawrence (General—Biographical Material), Department of Painting and Sculpture, The Museum of Modern Art.

24. Leyda, letter to Holger Cahill, March 26 [1940]. Museum Collection Files, Jacob Lawrence (General—Biographical Material), Department of Painting and Sculpture, The Museum of Modern Art.

25. Dorothy Miller, letter to Reynolds, March 27, 1940. Julius Rosenwald Fund Archives. There is also a copy in the Museum Collection Files, Jacob Lawrence (General—Biographical Material), Department of Painting and Sculpture, The Museum of Modern Art. The handwritten notes in the right margin of Reynolds's letter read, "has promise very int. work/int reaction to racial/subject matter/Prob sh. be allowed/ further study."

26. Brady, letter to Reynolds.

27. Reynolds, letter to Lawrence, April 17, 1940. Reel 4571, frame 554, Jacob Lawrence Papers, 1937–92, Special Collections Research Center, Syracuse University Library. Microfilmed reel on deposit at the Archives of American Art.

28. Lawrence, letter to Locke, n.d. Folder 26, box 164-44, Alain Leroy Locke Papers.

29. Leyda, letter to Locke, May 3, 1940. Folder 5, box 164-45, Alain Leroy Locke Papers.

30. *Exhibition of The Art of the American Negro* (1851–1940), with a foreword by Locke (Chicago: American Negro Exposition, 1940). The exhibition, curated by Alonzo J. Aden, was on view from July 4 to September 2, 1940. Both Lawrence and Leyda retained a copy of the catalogue in their papers; see reel 4572, frames 455–459, Jacob Lawrence Papers, and folder 17, box 22, Jay and Si-Lan Chen Leyda Papers and Photographs, Tamiment Library and Robert F. Wagner Labor Archives, New York.

31. Locke, Cahill, James V. Herring, Richmond Barthe, Daniel Catton Rich, and others were members of the jury making the selection for the exhibition. Claude A. Barnett, who served as the chair of the Art Committee for the exposition, was the founder and director of the Chicago-based Associated Negro Press (1919–1964).

32. Locke no doubt advocated for Lawrence as a member of the five-person jury on the awards.

33. While the catalogue gave the correct date of the series, 1938, the writer's boast that it was done by a sixteen-year-old was in error. Lawrence completed the series at the age of twenty-one. *Exhibition of The Art of the American Negro*, n.p.

34. Other artists renting studios in 33 West 125th Street at the time included Romare Bearden, Robert Blackburn, Ronald Joseph, Claude McKay, and William Attaway.

35. Lawrence, in a memo accompanying his Julius Rosenwald fellowship application, 1940. Julius Rosenwald Fund Archives. The archive also contains letters of support for Lawrence. (While the application names the Mexican artist and illustrator Miguel Covarrubias as a reference, the archives shows no record of a letter from him.)

36. For a description of Lawrence's technical process, see Elizabeth Steele and Susana M. Hapine, "Precision and Spontaneity: Jacob Lawrence's Materials and Techniques," in Turner, ed., *Jacob Lawrence: The Migration Series* (Washington, D.C.: The Rappahannock Press in association with The Phillips Collection, 1993), pp. 155–59. See also Lawrence, interview with Steele, Hapine, et al., June 4, 1992, transcript in the The Phillips Collection Archives.

37. Lawrence, in the interview with Turner, p. 17.

38. Lawrence probably wrote soon after receiving Locke's book, which was released late in the year (his foreword is dated November 1, 1940).

39. Lawrence, letter to Locke, n.d. Folder 26, box 164-44, Alain Leroy Locke Papers. The book was Locke, ed., *The Negro in Art: A Pictorial Record of the Negro Artist and the Negro Theme in Art* (Washington, D.C.: Associates in Negro Folk Education, 1940, reprint ed. New York: Hacker Art Books, 1979). Interestingly, the Carnegie Corporation, reviewing a request from Locke for support for his work on the book, sought the opinion of Barr to assess its merits. See Rudolph Alexander Kofi Cain, *Alain Leroy Locke: Race,*

Culture, and the Education of African American Adults (New York: Rodopi, 2004), pp. 60–62.

40. Most artists were represented by only one to four images. In the number of images devoted to Lawrence he was surpassed only by Hale A. Woodruff and Richmond Barthé. See Locke, ed., *The Negro in Art*, p. 133.

41. Edith Halpert, letter to Locke, June 9, 1941. Folder 37, box 164-33, Alain Leroy Locke Papers.

42. Locke, letter to Halpert, June 16, 1941. Folder 37, box 164-33, Alain Leroy Locke Papers.

43. Halpert, letter to Locke, June 18, 1941, and Halpert, telegram to Locke, n.d. Both folder 37, box 164-33, Alain Leroy Locke Papers. The telegram in which Halpert asks Locke to "join her at the Arts Center" does not explicitly mention that they would be seeing the Migration Series at the Harlem Community Arts Center, but the context, as Hills has argued, supports this likelihood. It remains unclear, however, whether Lawrence's Migration Series was on exhibition there at that time or whether it was brought there expressly to show Halpert. See Hills, *Painting Harlem Modern*, p. 48, n. 84. For earlier accounts see Turner, "Introduction," in *Jacob Lawrence: The Migration Series*, p. 14, and Diane Tepfer, "Edith Gregor Halpert: Impresario of Jacob Lawrence's Migration Series," in ibid. p. 131, n. 11.

44. Deborah Calkins, letter to Lawrence, July 1, 1941. Reel 4571, frame 560, Jacob Lawrence Papers. Also on July 1, Halpert wrote to Locke to share the contents of her phone conversation with Calkins, explaining that she had advised her of *Fortune*'s plans to publish the series "unless the war situation makes publication obsolete." She closed by noting, "I am particularly delighted in this connection, as it promises well for our idea in December. There is a possibility of touring the exhibition to an important organization in New England, and of course to many museums." The latter plan never materialized. See Halpert, letter to Locke, July 1, 1941. Folder 37, box 164-33, Alain Locke Papers.

45. Halpert, letter to Lawrence, November 8, 1941. Reel 5549, frame 390, Downtown Gallery Records 1824–1974, bulk 1926–1969, Archives of American Art.

46. Halpert, letter to Lawrence, [October 7, 1941]. Reel 4571, frame 489, Jacob Lawrence Papers. Microfilmed reel on deposit at the Archives of American Art.

47. See Lawrence, tape-recorded interview with Henry Louis Gates, June 1992, p. 10 of a transcript in The Phillips Collection Archives.

48. Lawrence, letter to Halpert, n.d. [after October 7, 1941]. Reel 5549, frames 384–86, Downtown Gallery Records.

49. Ibid.

50. Halpert, letter to Lawrence, November 8, 1941. Reel 5549, frame 390, Downtown Gallery Records. Several weeks later, Halpert wrote to tell Lawrence that she had "hung the series in my office and a great many people are coming in to see them." Halpert, letter to Lawrence, November 24, 1941. Reel 5549, frame 395, Downtown Gallery Records.

51. "Art News of America: Picture Story of the Negro's Migration," *Artnews* 40, no. 15 (November 15–30, 1941):8–9.

52. Locke, letter to Halpert, n.d. [c. December 4, 1941]. Folder 37, box 164-33, Alain Leroy Locke Papers. Locke told Halpert, "This is a good place while you are still in the throes of this labor of live [sic], to tell you how deeply I appreciate your work and interest and sacrifice through it all."

53. "Invitation for Preview and Formal Opening of Exhibition of American Negro Art: 19th and 20th Centuries." Reel 4572, frame 358, Jacob Lawrence Papers. See press release, reel 5495, frames 1219–20, Downtown Gallery Records.

54. Locke, letter to Lawrence, n.d. [early January 1942]. Folder 26, box 164-44, Alain Leroy Locke Papers. Locke expressed his hope that "some day I too want to own one of your canvasses [sic]."

55. *Catholic New Orleans* was sold to the artist Charles Sheeler for $35, *Bar and Grill* to O'Donnell Iselin for $50. See Sales Records, Artwork: Sales Slips, 1941, reel 5624, frames 236 and 245, Downtown Gallery Records.

56. Locke, letter to Lawrence, n.d. [early January 1942]. It is possible that by this time Barr had been introduced to Lawrence's work by Leyda, or that he had encountered it in one of the artist's solo or group exhibitions.

57. *Cross-Section Number One of a Series of Specially Invited American Paintings and Watercolors with Rooms of Recent Work by Max Weber, Karl Knaths, Morris Graves*, March 15–31, 1942, extended to April 15. PMG 1942.6. See Exhibition History File, The Phillips Collection Archives. Phillips had been acquiring works from Halpert since the early 1920s. By this point he already owned several works by Bernard Karfiol but none by Raymand Breinin.

58. Phillips initially planned to visit Halpert's gallery in early December, in time to see her Bernard Karfiol exhibition, but a letter of January 2 explained that his trip was delayed due to the "pressure of plans I am making for the safeguarding of our pictures

against war risks." See Phillps, letter to Halpert, December 4, 1941, reel 5495, frame 1231, Downtown Gallery Records, and Phillips, letter to Halpert, January 2, 1942, reel 5496, frame 10, Downtown Gallery Records. Technically *American Negro Art* closed on January 3, the day after this second letter was written and before Phillips would have arrived in New York, but Halpert must have maintained some form of it for him to see: on January 8, detained again in Washington, Phillips telegramed Halpert indicating that he now planned to visit the following Thursday or Friday (January 13 or 14). See Phillips, telegram to Halpert, January 8, 1942. Reel 5496, frame 16, Downtown Gallery Records. Halpert acted as a New York agent for Horace Pippin's Philadelphia dealer, Robert Carlen. "Both Duncan Phillips and the Museum of Modern Art are interested in getting an important Pippin," she wrote to Carlen in mid-January 1942. See Halpert, letter to Carlen, January 14, 1942. Reel 5496, frame 27, Downtown Gallery Records. In 1938, MoMA had shown Pippin's work in their exhibition *Masters of Modern Painting*, and in 1946 he would be included with Lawrence and Richmond Barthe in the *Three Negro Artists* exhibition at the Phillips Gallery. The Phillips acquired its first Pippin, *Domino Players*, in 1943, while MoMA acquired its first Pippin, *Abe Lincoln, The Great Emancipator* (1942), in 1977.

59. It remains unclear whether Phillips knew Lawrence's work before he saw the Migration Series in *American Negro Art*. Just over a year earlier, two of the artist's narrative cycles, Frederick Douglass (1939) and Harriet Tubman (1940), had been featured in the Library of Congress's landmark group exhibition commemorating the seventy-fifth anniversary of the Thirteenth Amendment—the kind of exhibition that one can imagine Phillips attending.

60. Although she does not indicate her source for the information, Lindsay Pollack posits that Halpert suggested the idea that Phillips exhibit the Migration Series during his visit to the Downtown Gallery. See Pollack, *The Girl with the Gallery: Edith Gregor Halpert and the Making of the Modern Art Market* (New York: Public Affairs, 2006), p. 251. The idea for the exhibition may also have been prompted by either Phillips or his wife, Marjorie, who served as the assistant director of the Phillips Memorial Gallery and was a key advisor to her husband. See note 65 for her involvement in Halpert's negotiations on the sale.

61. Halpert, letter to Mrs. David H. Levy, January 17, 1942. Reel 5496, frames 38–39, Downtown Gallery Records.

62. Just two days after her letter to Adele Levy, Halpert wrote to Lawrence saying nothing about the idea of splitting the works into two groups of thirty or about showing the complete series at the Phillips Memorial Gallery. She merely noted, "We are also making some progress with the Migration series and I shall give you more information when we have something concrete [to] report." See Halpert, letter to Lawrence, January 19, 1942. Reel 5549, frame 403, Downtown Gallery Records.

63. Halpert, letter to Mrs. David H. Levy, January 17, 1942. While Barr had no doubt been enthusiastic about the series, as Locke had reported earlier, it is unclear whether he knew of Halpert's plan to solicit it as a gift for the Museum from Adele Levy.

64. The figures, adjusted for inflation, would be roughly $500 per panel, or $15,000 for the thirty.

65. Halpert, telegram to Marjorie Phillips, February 3, 1942. Reel 1958, frame 1179, The Phillips Collection Records 1920–1960. See also Marjorie Phillips, telegram to Halpert, February 3, 1942, reel 5496, frame 85, Downtown Gallery Records. A subsequent letter from Barr to Adele Levy indicated that the panels left for Washington within hours of coming to MoMA. See Barr, letter to Levy, March 7, 1942. Alfred H. Barr, Jr. Papers (AAA: 2167; 0819), The Museum of Modern Art Archives, New York.

66. Halpert, letter to Mrs. Phillips, February 5, 1942. Reel 5496, frame 86, Downtown Gallery Records.

67. Halpert, letter to Duncan Phillips, February 21, 1942. Reel 1958, frame 120, The Phillips Collection Records 1920–1960. Both before and after the acquisition of the Migration Series, Phillips had been adding large numbers of works by living American artists to his growing collection, in greater quantity than those by Europeans. Lawrence's Migration Series was one of over forty works that entered his collection in 1942, at prices that peaked at $12,000 for Jean-Baptiste-Camille Corot's *View from the Farnese Gardens* (1826). Other acquisitions included two by Lawrence's contemporaries Allan Rohan Crite (*Parade on Hammond Street*, 1935; $85) and Raymond Breinin (*The Maestro*, 1940; $250), as well as a painting by the American modernist Marsden Hartley (*Wood Lot, Maine Woods*, 1939; $1,000) at a price equal to that of all thirty panels from the Migration Series. The following year, Phillips acquired Horace Pippin's *Domino Players* (1943) for $500. See ledger, The Phillips Collection Archives, pp. 267–68, 281. Considering this buying pattern, it is unlikely that price weighed significantly in Phillips's decision to acquire the Migration Series. The fact that he treasured his newly acquired panels is clear from his later expression of grave concern over their safety; see note 70.

68. Phillips, telegram to Barr, May 27, 1942. Reel 1959, frame 0204, The Philips

Collection Records 1920–1960. Phillips was replying to a telegram from Barr: "Regret cannot remember your decision re Lawrence gouaches. Please wire collect whether you want odds or eves." Barr, telegram to Phillips, May 27, 1942. Alfred H. Barr, Jr. Papers [AAA: 2168; 0156], The Museum of Modern Art Archives.

69. The wife of attorney general Francis Biddle, Katherine Garrison Chapin maintained close ties with Locke (from whom she likely first learned about Lawrence) and other prominent black artists and musicians of the day. Her interest in the African-American experience found expression in her celebrated poems set to music: "And They Lynched Him from a Tree" (1938) and "Plain Chant for America" (1941). According to a conversation with Phillips conservator Steele on July 14, 2014, many of the Phillips panels still bear extensive scratch marks that must have occurred before they were glazed for MoMA's tour.

70. Phillips, letter to Elodie Courter, March 21, 1942. Reel 1959, frame 0273, The Phillips Collection Records 1920-60, The Phillips Collection Archives. That Phillips was firmly resistant to the loan, even if the works were framed under glass, is clear from a flurry of correspondence. See ibid.; Courter, letter to Phillips, April 2, 1942, reel 1959, frame 0291, The Phillips Collection Records 1920-60; [Elmira Bier], letter to Courter, April 21, 1942, reel 1959, frame 0198, Duncan Phillips Papers; Memorandum from Miss Courter to Mr. Barr, April 29, 1942, Alfred H. Barr, Jr. Papers [AAA: 2167; 0967], The Museum of Modern Art Archives; and Memorandum from Mr. Barr to Miss Courter, May 6, 1942, AHB [2167; 0966], The Museum of Modern Art Archives.

71. On March 10, 1942, MoMA sent out a questionnaire to other museums to gauge their interest in a tentative list of proposed circulating exhibitions in 1942–43. Of the solo exhibitions, Migration of the Negro is listed at a fee of $40 for three weeks. See Courter, letter with questionnaire to C. Law Watkins, March 10, 1942. Reel 1959, frame 0268, The Phillips Collection Records 1920-60. Given the presence of the letter and questionnaire in Phillips's papers, it is likely that Watkins, who directed the Phillips Memorial Gallery's art school, shared them with him, and that seeing the Migration Series tour on the list precipitated Phillips's March 21 letter to Courter. The responses to the questionnaire showed seventeen exhibitors interested in the Migration Series tour (with twelve being the minimum required for MoMA to move forward with the exhibition) See annotated questionnaire, AHB [2167; 0974], MoMA Archives. MoMA originally planned a one-year tour but extended it to accommodate significant demand. See Courter, letters to Phillips, June 9 and 21, 1943, reel 1961, frame 25, and reel 1961, frame 28, The Phillips Collection Records 1920–1960; and Phillips, letter to Courter, June 18, 1943, reel 1960, frame 1338, The Phillips Collection Records 1920–1960: "they might as well be away a little longer and give pleasure on their way back to the east. I am delighted to hear that they are still in good condition as you remember I feared for their safety . . . I will breathe a sigh of relief if they return to us without scratches."

72. Halpert, letter to Lawrence, February 12, 1942. Reel 5549, frame 405, Downtown Gallery Records. Halpert, letter to Lawrence, March 12, 1942. Reel 5549, frame 408, Downtown Gallery Records.

73. Lawrence, letter to Halpert, n.d. [after March 12, 1942]. Reel 5549, frames 413–414, Downtown Gallery Records. In his final interview before his death, Lawrence responded to the often-repeated question of how he felt about the split purchase of The Migration Series: "I was asked by Edith Halpert again, did I want her to break up the series, which meant selling one, two, three, like that, and it would no longer be in existence, or she had these two possible clients, Phillips and the Museum of Modern Art. So I had this choice. And, of course, I selected the two galleries or museums, which turned out to be a very wise choice." See Lawrence, in an interview with Jackson Frost, 2000, p. 27 of a transcript in The Phillips Collection Archives.

74. "I didn't realize the importance of this show. I didn't realize the importance of the Downtown Gallery. I had no idea about the commercial art market whatsoever." Lawrence in the interview with Greene, p. 30.

75. Lawrence, in the interview with Turner, p. 4.

76. Lawrence, in ibid., p. 29. On only one other occasion did Lawrence conceive of a series comprising sixty works. In 1956, more than a decade after the Migration Series, he began work on another ambitious historical epic, Struggle: From the History of the American People. This series, which Lawrence abandoned in mid-course, was initially sold to one private collector but later dispersed into several collections, suffering the fate he had happily avoided in the case of the Migration Series.

77. Lawrence, in the interview with Gates, p. 23.

The Migration Series

Panels 1-60

Jacob Lawrence began preparations for The Migration of the Negro (now known as the Migration Series) long before the work's debut, in 1941: he started research at the 135th Street branch of the New York Public Library (now known as the Schomburg Center for Research in Black Culture) sometime in mid-1939. By January 1940, when the young artist submitted his application for a Julius Rosenwald Fund Fellowship, his studies had already led him to a selection of the series' overarching themes, and he proposed another six months of work at the Schomburg, followed by several months for formulating and then painting the panels.

The Rosenwald Fund granted Lawrence $1,500, which he began to spend by securing a studio for himself in a small building at 33 West 125th Street. Work on the captions came first. With the help of the artist Gwendolyn Knight,

A segregated railroad-depot waiting room in Jacksonville. Florida. 1921. State Archives of Florida

Lawrence combed through notes he had taken on a wide variety of sources—books, newspapers, pamphlets, illustrated magazines—and drafted captions for each panel. Once he had decided on the panels' subjects, he began to sketch, creating several variations for each image. After he decided on the final compositions, he and Knight laid out the panels side-by-side on the studio floor, taking advantage of the new space to gain a view of the series as a whole. They covered the panels in gesso, then pinned preparatory drawings to the corners of the works. Lawrence traced each composition with a graphite pencil and then began to paint. As a final step, he and Knight edited the captions to eliminate all but the most essential information. The process went quickly: in early 1941, Lawrence informed the Rosenwald staff that he planned to finish the work in the late spring.

The sixty panels in the Migration Series are painted in casein tempera on hardboard. Each measures approximately 18 by 12 inches (45.7 x 30.5 cm). The even-numbered panels are in the collection of The Museum of Modern Art, New York, gift of Mrs. David M. Levy. The odd-numbered works are in the collection of The Phillips Collection, Washington, D.C., acquired 1942. In preparation for a 1993–95 exhibition organized by The Phillips Collection, Lawrence changed the work's title from The Migration of the Negro to the Migration Series and rewrote his original captions from 1941. Both sets of captions are included in the following pages.

with notes by Jodi Roberts

Panel 1

During the World War there was a great migration North by Southern Negroes. (1941)

During World War I there was a great migration north by southern African Americans. (1993)

Lawrence opens his sixty-panel Migration Series with this image of a chaotic crowd in a train station, pushing toward three ticket windows marked "CHICAGO," "NEW YORK," and "ST. LOUIS." Images of train stations and waiting rooms, railroad cars and people arriving and leaving, weighted with bags, recur throughout the series; their measured reappearance provides a rhythmic marker of time, like the sound of the train itself. The three cities named were key destinations for the hundreds of thousands of black Southerners who began to leave their homes during World War I in what is called the Great Migration, searching for economic opportunity and social equality in the North. The cities are not ordered geographically, but Chicago and New York, the latter named at bold center and Lawrence's own home, received more migrants than any other American cities, and would flourish as the twin centers of African-American culture in the coming century; and Saint Louis, as an important stopping point on the railroad line north from Louisiana and Mississippi, was one of the first places to feel the massive impact of the Migration. Each of this trio of cities received its own chapter in Emmett J. Scott's book *Negro Migration during the War* (1920), one of the first scholarly efforts to come to grips with the population shifts spurred by the Migration, as well as with its causes and implications. Scott shared the sense of surprise that many felt in seeing thousands of blacks decamping from their homes: "They left as if they were fleeing some curse," he wrote.[1] The book was crucial for Lawrence, who read it during his own extensive research for the series at Harlem's 135th Street library. He returned to it again and again, at times using its words verbatim in his captions.

The Migration constituted one of the greatest demographic transformations in U.S. history, recasting an overwhelming rural Southern population as a largely urban Northern one. Over the next six decades, more than 6 million African-Americans decided to seek better lives far from the farms and small towns that had been their homes, forever changing the nation's racial profile, political priorities, and cultural landscape.

1. Emmett J. Scott, *Negro Migration during the War*, 1920 (reprint ed. New York: Arno Press, 1969), p. 44.

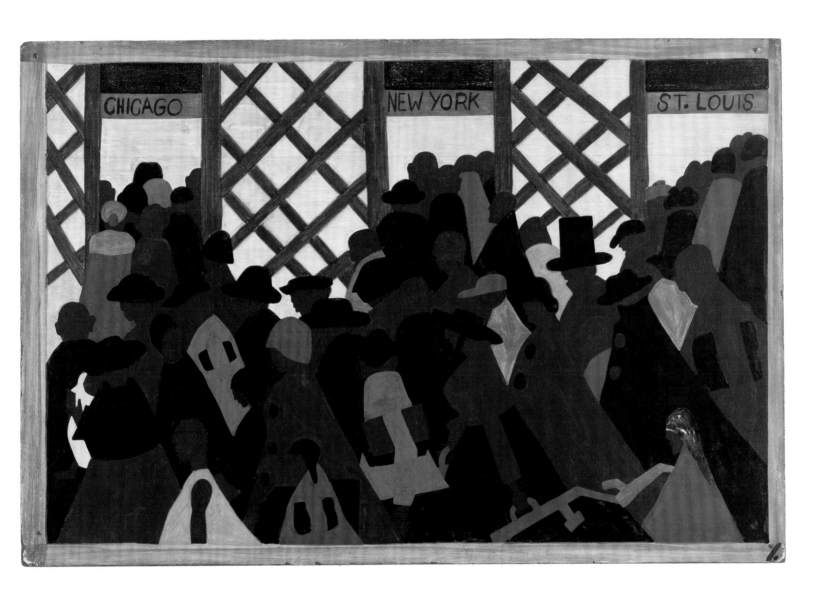

Panel 2

The World War had caused a great shortage in Northern industry and also citizens of foreign countries were returning home. (1941)

The war had caused a labor shortage in northern industry. Citizens of foreign countries were returning to their native lands. (1993)

Only two panels in the series feature a lone white figure. The world of industrial labor had been largely inaccessible to black workers before 1914, yet white workers, like the man Lawrence places in the cab of the vehicle in this panel, could not satisfy the expanding American market after the outbreak of World War I, in 1914. From its start, the conflict sparked new demand in Europe for American industrial goods, but as U.S. companies tried to keep up with increases in orders, they found their usual pool of workers drying up. The war made passage from Europe's interior to its western ports difficult and expensive, slowing the flow of immigrant labor to the United States. Meanwhile changes in U.S. policy—the Immigration Act of 1917, for example, which imposed more-demanding entry requirements on new arrivals—further stemmed arrivals from abroad. That same year, the United States both entered the war and introduced military conscription, eventually drafting almost 3 million men. Industrialists were forced to turn to labor sources they had previously ignored, including African-Americans and women.

The new availability of jobs in the North was a spark of opportunity that spurred many black Southerners to leave home. Beginning as a steady stream around 1915, the numbers of migrants rose steeply the following year, and close to half a million had traveled north by the end of the decade. The movement was announced in newspapers and magazines across the country and celebrated in the black press. As early as 1917, the historian and activist W. E. B. Du Bois described the Migration as a "social evolution working itself out before our eyes."[1]

1. W. E. B. Du Bois, "The Economics of the Negro Problem," in Alexander Trachtenberg, ed., *The American Yearbook 1917–18* (New York: Rand School of Social Science, 1918), p. 181.

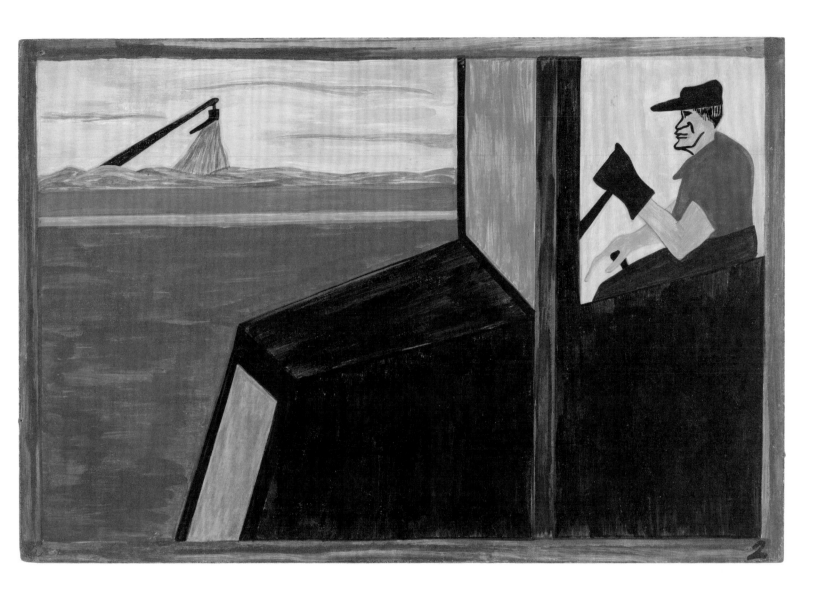

Panel 3

In every town Negroes were leaving by the hundreds to go North and enter into Northern industry. (1941)

From every southern town migrants left by the hundreds to travel north. (1993)

Weighed down with bags and boxes, a dense crowd pushes north, their bodies making a triangular shape that echoes the V formation of the migratory birds in flight above their heads. The birds' easy movement through the air draws attention to the difficulty of the human travelers' journey, restricted to slow, earthbound routes and hindered by the need to carry unwieldy packages. The panel illuminates Lawrence's search for different ways to visually convey the enormous cumulative impact of the Great Migration. "We think of birds migrating," he explained, "I guess we are very much like other kinds of animals in that we move for different reasons."[1]

The image of a flight of birds underscores Lawrence's interest in the Migration as a mass movement. Where his earlier series had been multipanel narratives of the lives of outstanding individuals—Toussaint L'Ouverture, Frederick Douglass, and Harriet Tubman—the portrait here is collective. The people on the move throughout the Migration Series are largely anonymous, and are often condensed into a tightly packed mass. They are rarely differentiated by particularized faces or other physical traits, though details of clothing and accessories hint at the period and at their economic status. Lawrence's parallel between birds and African-Americans as a group had cultural precedents: after "Jim Crow laws"—legislation codifying the unequal treatment of blacks—took hold in the South at the turn of the century, stories, songs, films, and imagery in the popular press began to caricature black men and women as blackbirds and crows.

1. Jacob Lawrence, quoted in Elsa Smithgall, Henry Louis Gates, Jr., and Elizabeth Hutton Turner, *Jacob Lawrence and the Migration Series from The Phillips Collection* (Washington, D.C.: The Phillips Collection, 2007), p. 4.

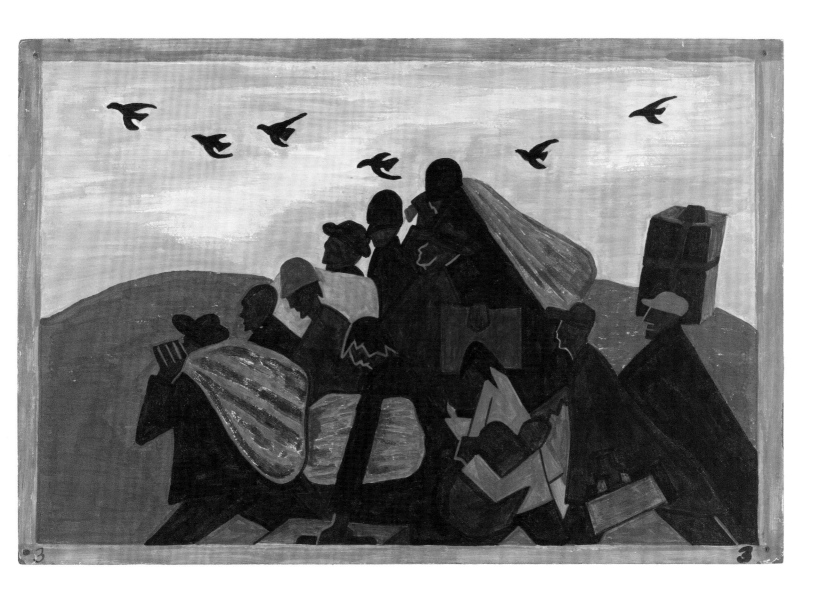

Panel 4

The Negro was the largest source of labor to be found after all others had been exhausted. (1941)

All other sources of labor having been exhausted, the migrants were the last resource. (1993)

With spindly arms and a protuberant torso, back bent under the weight of his hammer, this black worker offers a stark contrast to the sturdy, muscled men seen in countless images generated by the cultural programs of the federal government's New Deal. In public murals and widely distributed posters, as well as in the press images and advertising of the period, burly workers happily swung hammers, drilled rocks, and built dams. During the Depression years, there was also renewed interest in the tireless African-American folk hero John Henry, the "steel-driving man" said to have worked on the railroads in the nineteenth century. Henry was the subject of a Broadway musical of 1940 starring the activist actor Paul Robeson, the blues singer Josh White, and the civil rights activist Bayard Rustin.

Lawrence's figure, however, is far more equivocal than the workers pictured by his left-leaning social realist peers. This ambivalence may stem from the actual conditions of industrial labor for black men. It was only during World War I that blacks had access to industrial jobs on a large scale. After the armistice, though, when white soldiers began to return from duty overseas, blacks were often relegated to the most dangerous and demeaning jobs, usually earning a fraction of the wages paid to their white co-workers. The historically troubled relationship between black workers and white-led labor unions was fraught with cultural misunderstandings and outright racism. Some unions did try to organize black industrial workers, but in construction and other major sectors, African-Americans remained excluded.

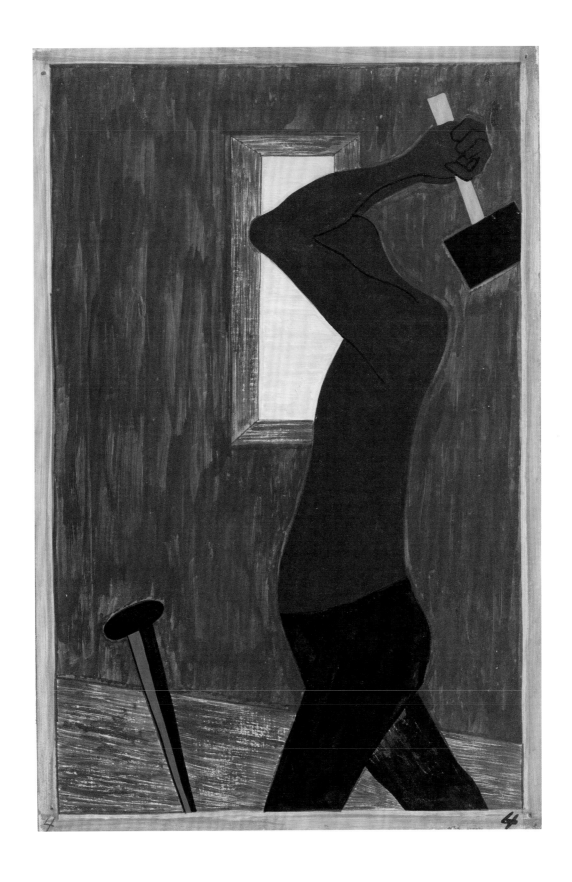

Panel 5

The Negroes were given free passage on the railroads which was paid back by Northern industry. It was an agreement that the people brought North on these railroads were to pay back their passage after they had received jobs. (1941)

Migrants were advanced passage on the railroads, paid for by northern industry. Northern industry was to be repaid by the migrants out of their future wages. (1993)

Lawrence's train—black smoke billowing from its smokestack, a large bell evoking the clamor of a rushing locomotive, a shining headlight cutting through the dark night—is an emblem of progress through space and time and a beacon of new opportunities. Throughout the Migration Series, Lawrence returns to trains and railroads as both symbolic reminders of black Southerners' will to search for better lives and a literal representation of the means by which they moved. The "free passage" mentioned in the 1941 caption, however, was largely a myth, circulating in the press and by word of mouth: while it may have been offered in a few early cases, potential employers soon found paying for transport unnecessary, so strong was black Southerners' drive to escape the region, even at great financial cost.

Lawrence's use of railroad imagery built on a tradition that took root well before the promise of industrial jobs began to catch Southerners' attention. In the nineteenth century, a clandestine network of travel routes and safe houses emerged to help escaped slaves in the South make their way to the Northern states and Canada. This system came to be known as the "Underground Railroad," and railroad terms, such as "conductor" and "station," served as coded speech for its users and for those who shepherded them to freedom, both groups risking their own lives. The subject had been on Lawrence's mind: in 1940, when he began the Migration Series, he had just finished a multipanel narrative cycle on the life of Harriet Tubman, one of the Underground Railroad's most successful "conductors."

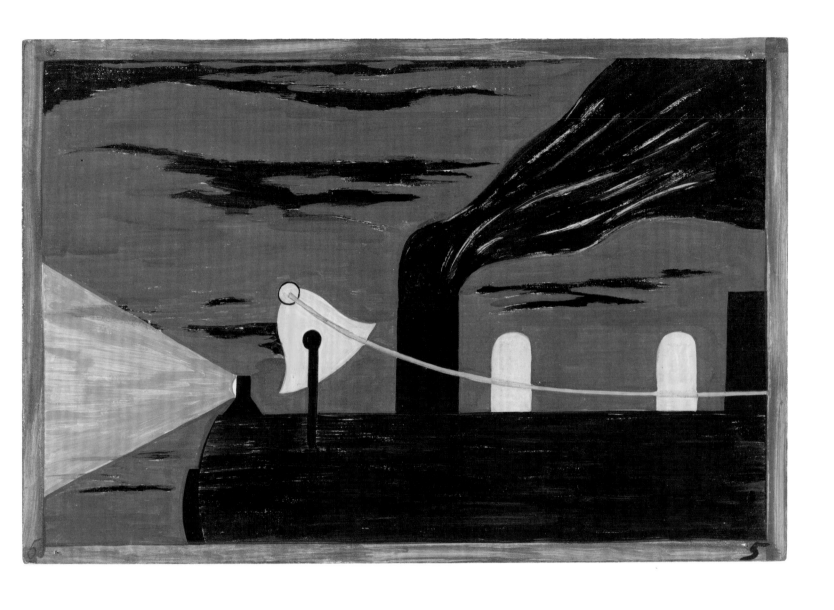

Panel 6

The trains were packed continually with migrants. (1941)

The trains were crowded with migrants. (1993)

Filled with African-Americans squeezed tightly together, this train car captures some sense of the experience of the journey north. The car is crowded with mainly sleeping forms. Wrapped in brightly colored clothes and blankets, a suitcase spilling open on the floor, the passengers have settled in for a ride that might last days. A woman at the left nurses her child, an indication of the car's cramped conditions but also a reminder of black Southerners' hopes for future generations. For Lawrence, images of packed railroad compartments and train stations were powerful assertions of the migrants' pioneering spirit. "That's what migration is," he would later recall of panels like this one. "You think in terms of people on the move, people moving from one situation to another."[1]

Lawrence was far from alone in seeing the railroad as a symbol of freedom: many songs and poems of the period use railroad imagery in relation to the Migration. In 1925, the protagonist of blues singer Maggie Jones's hit song "Northbound Blues" declared, "Got my ticket in hand/And I'm leaving Dixieland." Two years later, the folk singer Henry Thomas traced the train stops between East Texas and Chicago in "Railroadin' Some," his guitar and reed pipe evoking the rumble and whistle of a train. In 1949, in "One-Way Ticket," the New York–based poet Langston Hughes described a train ticket as a pass to freedom:

> *I pick up my life*
> *And take it away*
> *On a one-way ticket—*
> *Gone up North*
> *Gone out West*
> *Gone!*

Inspired by the thematic overlap between Lawrence's Migration Series and his own work, Hughes asked Lawrence to illustrate the poem for a book published in 1949, giving the painter the chance to revisit the metaphor for migration he had developed nearly a decade earlier.

1. Jacob Lawrence, quoted in Elsa Smithgall, Henry Louis Gates, Jr., and Elizabeth Hutton Turner, *Jacob Lawrence and the Migration Series from The Phillips Collection* (Washington, D.C.: The Phillips Collection, 2007), p. 4.

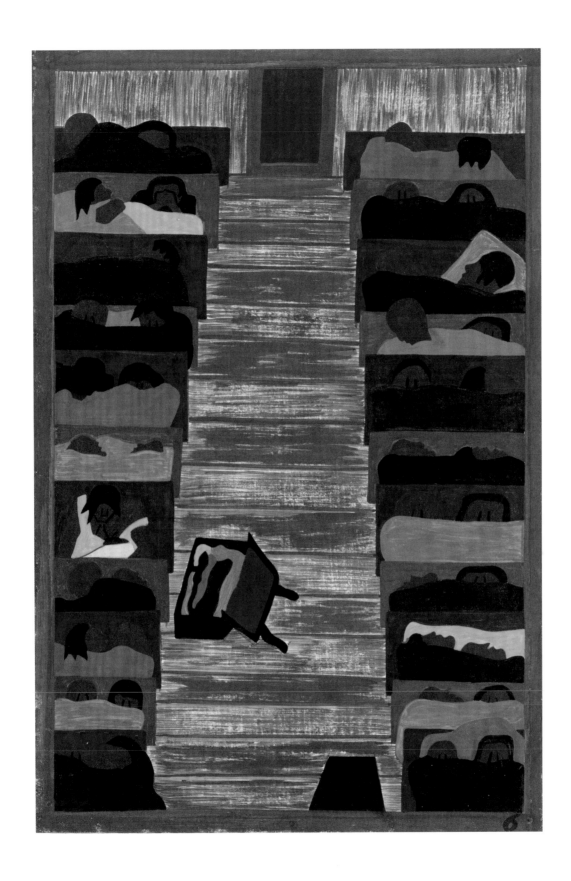

Panel 7

The Negro, who had been part of the soil for many years, was now going into and living a new life in urban centers. (1941)

The migrant, whose life had been rural and nurtured by the earth, was now moving to urban life dependent on industrial machinery. (1993)

In this panel, alternating leafy green shapes and striated bands of brown, orange, and green extend across the entire surface in a pattern that approaches abstraction while evoking the carefully maintained rows of a cultivated field. The composition's vertiginous sweep from bottom to top pulls the viewer tightly into the painting, as though he or she were a farmworker moving through the fields. This close-up, allover view marks a sharp shift from the sequence so far; changes in perspective from one panel to the next recur through the series, and resemble the montage cuts of cinema, a medium that fascinated Lawrence.

During the early years of the Great Migration, black Southerners made personal decisions about leaving their homes in the face of public appeals for them to stay. Fields emptied of workers were the Southern planters' greatest fear. White writers argued that the region's warm weather, and the physical demands of agricultural work, were suited to African-American habits and personalities. Some black leaders also emphasized the benefits of staying home and battling Southern racism at close range. The young teacher Percy H. Stone, for example, argued in 1917 that while he and other African-Americans "resent most bitterly some treatment accorded us," they also "understand the soil, the climate, and the life in the South; and, being by nature a race of peaceful people, we prefer to remain in the South and solve our problems by industry, thrift, and education."[1] To leave the South was to abandon the dream of self-sufficiency through landownership, a key aspiration for black Americans since Emancipation.

1. Percy H. Stone, "Negro Migration," *Outlook* 116, no. 14 (August 1, 1917):520–21.

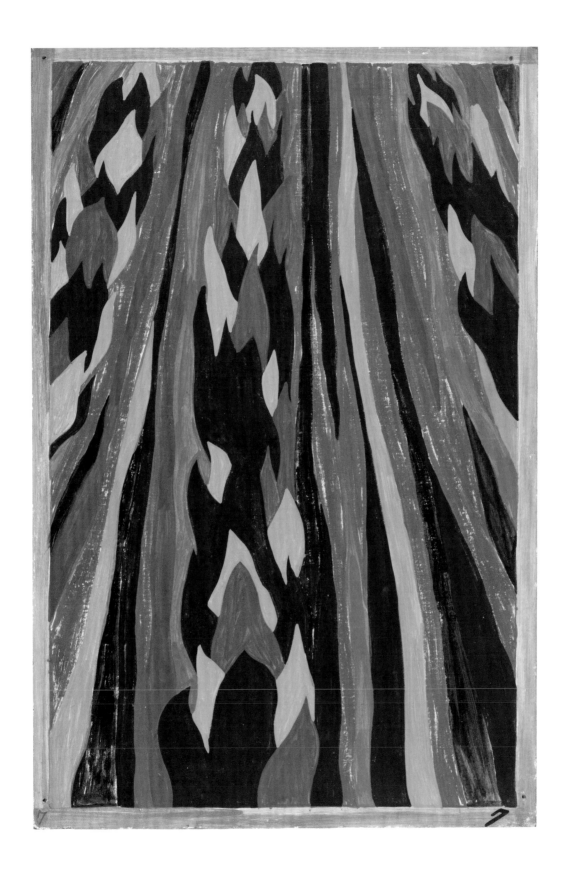

Panel 8

They did not always leave because they were promised work in the North. Many of them left because of Southern conditions, one of them being great floods that ruined the crops, and therefore they were unable to make a living where they were. (1941)

Some left because of promises of work in the North. Others left because their farms had been devastated by floods. (1993)

Covering this panel almost entirely in shades of blue, Lawrence separates sky from water with only a thin strip of brown to represent the bank of a river so swollen it has overtaken the neighboring trees. In offering only this meager hint of safe dry land, Lawrence evokes a deluge of biblical proportions, a paradigm for the overwhelming force of the floods that ravaged several major agricultural regions in the South during the first decades of the twentieth century. Emmett J. Scott's *Negro Migration during the War*, which Lawrence read, highlights the devastating floods of 1915 and 1916 as a motivating force behind the Migration, but the Great Mississippi Flood of 1927, the most destructive river flood in U.S. history, was no doubt also on Lawrence's mind. That spring, after months of heavy rain, the Mississippi River and its tributaries began to break through levees from Illinois to Louisiana. They flooded 27,000 square miles of land, leaving countless farms and towns under water and displacing up to a million people, most of them black. The flood was memorialized in multiple cultural forms, including the blues singer Bessie Smith's "Homeless Blues" of 1927 and, closer to the making of Lawrence's Migration Series, William Faulkner's 1939 novel *The Wild Palms*.

As bad as nature could be, men could be worse: the calamity exposed the exploitative practices of many Southern landowners. In Greenville, Mississippi, for example, LeRoy Percy, one of the Delta's "cotton kings" and a former U.S. senator, thwarted efforts to evacuate the town's African-American residents, worried about losing his cotton plantation's labor force. Relief rations were often distributed on the basis of race, and many black men were held at gunpoint by the National Guard and forced to perform life-threatening work on the levees. Mistreatment of this kind inspired tens of thousands of black men and women to abandon the area for the cities of the North.

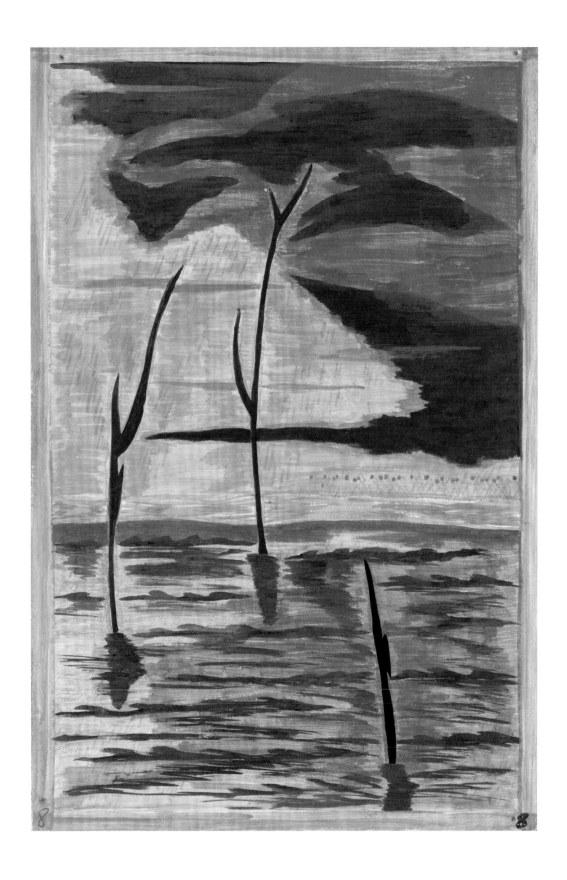

Panel 9

Another great ravager of the crops was the boll weevil. (1941)

They left because the boll weevil had ravaged the cotton crop. (1993)

In an image born equally of research and imagination, Lawrence uses pink-and-yellow bulbs and peculiar four-legged creatures to represent insect-infested cotton plants. His version of the boll weevil, a beetle that feeds on and destroys cotton bolls, realistically describes the pest's long proboscis but also features incongruously mammalian legs and feet. When asked about the panel, Lawrence confessed that when he was working on the Migration Series he had never seen a boll weevil nor even visited the South, but he certainly knew of their devastating effects on cotton crops there. He probably constructed his image from tales told by friends and neighbors and from references in popular culture. In one folk song recorded by Lead Belly, Woody Guthrie, Tex Ritter, and others, a destitute farmer moans, "We's in an awful fix; de boll weevil et all de cotton up, an' lef' us only sticks."

Traveling north from Mexico, boll weevils began to attack Texas cotton fields at the turn of the twentieth century. By the mid-1920s, the infestation had spread throughout the cotton-growing regions of the South, destroying millions of acres of crops and gravely damaging the cotton industry, a cornerstone of the national economy. The boll weevil's capacity for annihilation made it an emblem of hard times in the South. Depression-era newsreel footage and documentary photographs carried news of infestations to audiences in the North.

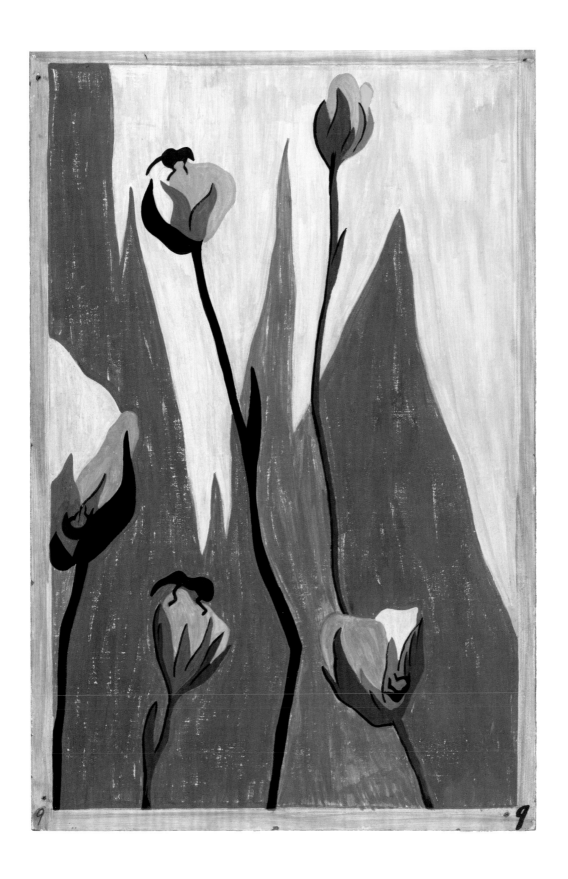

Panel 10

They were very poor. (1941)
They were very poor. (1993)

This panel is a study in sparseness. Against a blue background that fills most of the space, two figures sit at a table, their heads bowed in a prayer of grace. Before them are two simple vessels, with spoons their sole utensils. Underscoring the slim inventory of the couple's possessions, the only other culinary tool is an empty pot or basket hanging on a nail-and-board rack. Poverty was extreme for tens of thousands of African-Americans in the South, where agricultural jobs typically paid half or even a third of the wages earned for industrial jobs in the North. Meeting the most basic of needs was often a struggle. "[Only] reason families survived they put their money together . . . five or six of us children that were working and all of us were working for twenty-five cents a day," James Hall, a farmer and carpenter from Albany, Georgia, would recall. "When the week come we'd pool that money and my daddy, they would go into town and buy enough groceries . . . but they didn't have nothing to buy clothes with."[1] Lawrence's quiet restraint in this image provides a sense of pause in the flow of the series, a counterpoint to the bustle of color and form in his many images of hurried packs of travelers. Importantly, it also frames the Migration as a pursuit of basic human dignity and need.

1. James Hall, in an oral history interview with Gregory Hunter, June 17, 1994, available online at http://library.duke.edu/digitalcollections/behindtheveil_btvct01005/ (consulted October 2014).

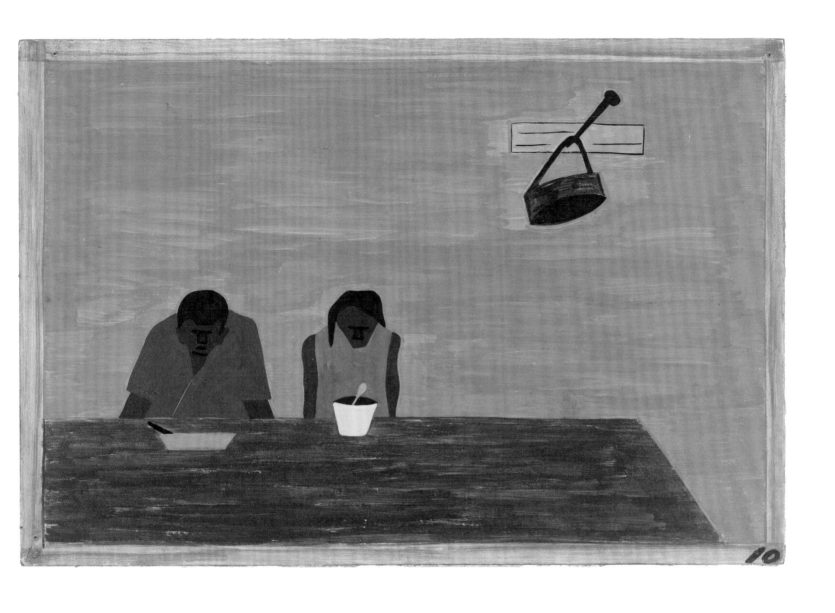

Panel 11

In many places, because of the war, food had doubled in price. (1941)

Food had doubled in price because of the war. (1993)

A woman cuts thin layers from a large slab of fatback as her thin child looks on with wide eyes. Pork was a staple of Southern cuisine, served on its own or cooked with vegetables and other dishes to season them. Yet many poor black families could not afford the choicest meat. Instead, they inventively incorporated cheaper cuts of the pig—fatback, feet, ears, intestines, and other flavorful parts—into recipes old and new. Lawrence knew the resourcefulness of black cooks firsthand. Looking at this panel, he recalled, "This is the fatback. . . . This was our salvation: we ate everything but the squeal."[1]

Migrants' taste for Southern food survived the trip north. Their injection of Southern ingredients and cooking techniques into the culinary traditions of Northern neighborhoods transformed the eating habits of black and white residents alike. In places like Harlem, restaurants and street vendors serving Southern food found a growing customer base and could become booming businesses. In March 1925, the African-American writer James Weldon Johnson published a profile in the magazine *Survey Graphic* on one of Harlem's star street-corner merchants, a woman known locally as Pig Foot Mary. An early migrant to New York from Mississippi, Mary—her real name was Lillian Harris—first found work in the city as a domestic but soon took to selling pigs' feet, chitterlings, and other Southern classics on a West Side street corner. Recognizing a shift in the makeup of Harlem, Mary moved her business uptown around 1917, setting up a stand at the corner of Lenox Avenue and West 135th Street. That same year, she used her considerable earnings from selling Southern specialties to buy an apartment building in the area. Her success manifested both black migrants' business acumen and their enduring appetite for the foods of home.

1. Jacob Lawrence, quoted in Elsa Smithgall, Henry Louis Gates, Jr., and Elizabeth Hutton Turner, *Jacob Lawrence and the Migration Series from The Phillips Collection* (Washington, D.C.: The Phillips Collection, 2007), p. 9.

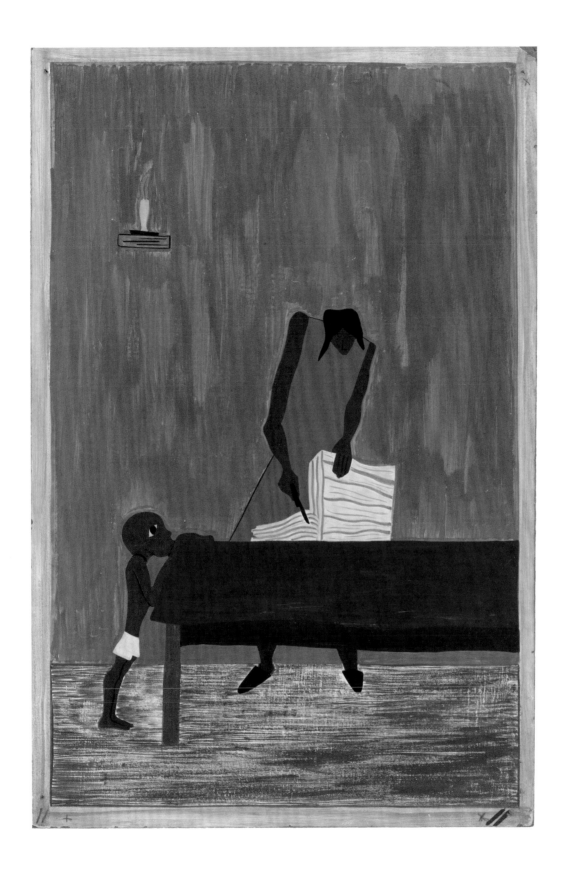

Panel 12

The railroad stations were at times so over-packed with people leaving that special guards had to be called in to keep order. (1941)

The railroad stations were at times so crowded with people leaving that special guards had to be called to keep order. (1993)

In the foreground of this panel, two uniformed white men, nightsticks in hand, stand watch over a crowd of African-American men, women, and children, lining up to buy tickets for their train. The guards surveying these all-black lines regulate every move the hopeful migrants make even as they prepare to leave the South. The painting captures not only the migrants' impatience to get moving but also their inability to move without constraints: under the segregated railroad system of the South, they were funneled into all-black waiting rooms and then into train compartments known as "Jim Crow cars." Once on board, to minimize their contact with white passengers, they were prohibited from moving freely through the train. While train travel signaled escape for black Southerners, the restrictions it forced on them also encapsulated the day-to-day humiliations they were trying to flee. "I looked about to see if there were signs saying: FOR WHITE—FOR COLORED. I saw none," wrote the Mississippi-born writer Richard Wright of his arrival in the Chicago train station in 1927. "It was strange to pause before a crowded newsstand and buy a newspaper without having to wait until a white man was served."[1]

The "Jim Crow train" was a potent cultural symbol. In 1941, the same year Lawrence finished his Migration Series, the blues singer Josh White took on Jim Crow travel regulations on the landmark album *Southern Exposure: An Album of Jim Crow Blues*. With extraordinary guitar runs that evoke train whistles and the rhythm of wheels on rails, the song "Jim Crow Train" is a black man's lament about finding only segregated trains to ride. His hope is to one day find "black and white folks ridin' side by side." A bold statement of political protest with many fans in Lawrence's circle, the album was also a popular hit. Wright wrote the album's liner notes.

1. Richard Wright, *American Hunger* (New York: Harper & Row, 1977), pp. 1–2.

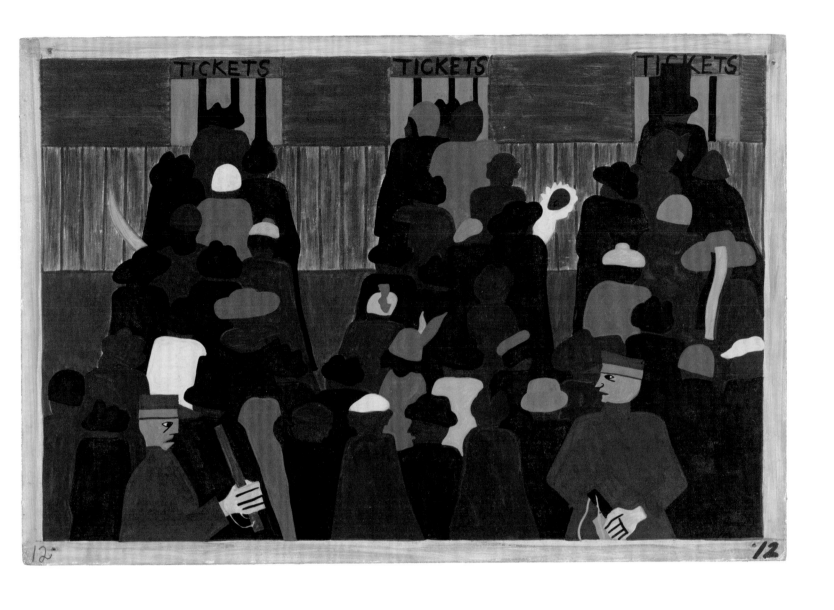

Panel 13

Due to the South's losing so much of its labor, the crops were left to dry and spoil. (1941)

The crops were left to dry and rot. There was no one to tend them. (1993)

This panel, which depicts abandoned fields baking under a hot sun, reveals key aspects of Lawrence's technique in its rough, thinly painted surface. In 1940, the artist secured an unheated studio on West 125th Street specifically to work on the Migration Series. With the help of the artist Gwendolyn Knight, his future wife, he covered all sixty of the series' hardboard panels with gesso, using broad, fast strokes that left the surface a little coarse. With preparatory drawings as a guide, he sketched his compositions on the panels and then painted with casein tempera, an opaque, quick-drying commercial paint. He dragged his brush swiftly across the gesso, sometimes allowing areas of this pale ground to show through, as seen here in the white-streaked depiction of the soil.[1]

Lawrence saw visual similarities between the flat, nonreflective surfaces of his casein tempera panels and fresco painting, in which pigment is applied to wet plaster on a wall and allowed to dry. It was a connection he liked: for a time he had wanted to become a mural painter, perhaps attracted by hearing about the Mexican muralist Diego Rivera's ultimately destroyed fresco at Rockefeller Center, much in the news in 1933 and 1934. Like many socially minded African-American artists of the 1930s and early '40s, Lawrence admired the Mexican muralists' commitment to producing art that illuminated the history of subjugated races and classes. In 1940, while he was working on the Migration Series, MoMA film curator Jay Leyda invited him to meet the muralist José Clemente Orozco, who was painting a portable mural at the Museum. Lawrence succeeded in translating Mexican muralism's ambitions to create socially and politically transformative public art into works that match the murals' thematic breadth and visual potency despite their small scale.

1. For more on Lawrence's technique see Elizabeth Steele and Susana M. Halpine, "Precision and Spontaneity: Jacob Lawrence's Materials and Techniques," in Elizabeth Hutton Turner, ed., *Jacob Lawrence: The Migration Series* (Washington, D.C.: The Rappahannock Press in association with The Phillips Collection, 1993), pp. 155–59, and Steele, "The Materials and Techniques of Jacob Lawrence," in *Over the Line: The Art and Life of Jacob Lawrence*, ed. Peter T. Nesbett and Michelle DuBois (Seattle: University of Washington with the Jacob Lawrence Catalogue Raisonné Project, 2000).

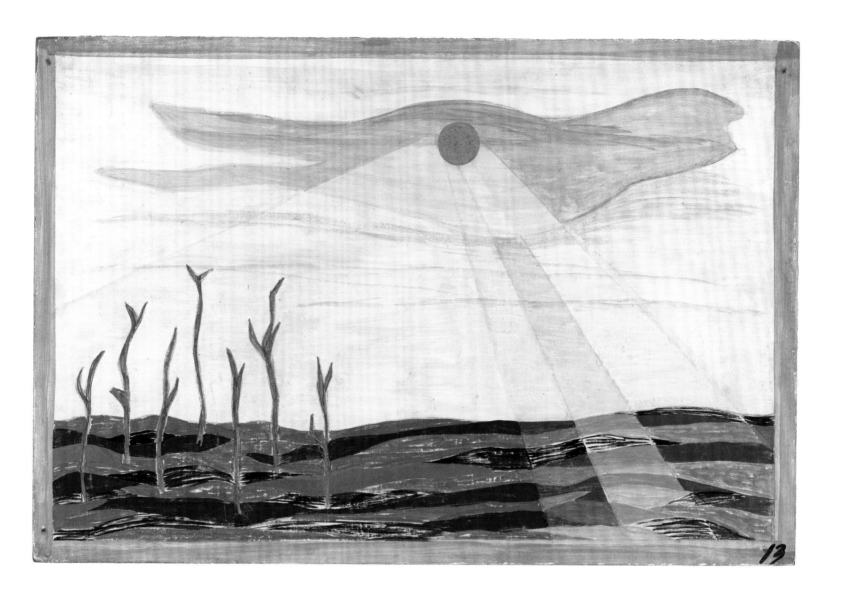

Panel 14

Among the social conditions that existed which was partly the cause of the migration was the injustice done to the Negroes in the courts. (1941)

For African Americans there was no justice in the southern courts. (1993)

Looming over two black men from a lofty courtroom bench, this white judge embodies the intimidating threat of legal authority so often wielded against black Southerners. Poring over something on the desk before him with bulging eyes, he shows no sign of sympathy for the two anonymous defendants who stand below. Stories of the South's prejudiced court system were no doubt familiar to Lawrence, being regularly addressed in news reports in the black press and highlighted in early sociological accounts of the Great Migration.

Specifically, Lawrence surely had in mind the Scottsboro Boys trials, which had galvanized activists and cultural leaders across the country and had generated national headlines and public outcry for more than a decade. In 1931, nine young African-Americans had been arrested after an altercation with a group of white youths on a train to Memphis. Brought before a court in the town of Scottsboro, Alabama, and charged with raping two white women on the train, they were convicted by an all-white jury and all but the youngest, a twelve-year-old boy, were sentenced to death by electrocution. A travesty of the legal system, the case sparked a series of appeals, retrials, and a clamorous international defense campaign that continued until 1950, when the last in the group was released from prison. Harlem-based writers were prominent among the protesters. In 1932, Langston Hughes published poems and a play inspired by the case in the book *Scottsboro Limited*. Two years later, Countee Cullen's poem "Scottsboro, Too, Is Worth Its Song" asked why white poets had held their tongues as the young men languished in jail, implicitly calling on all writers, regardless of race, to use their talents to fight for justice.

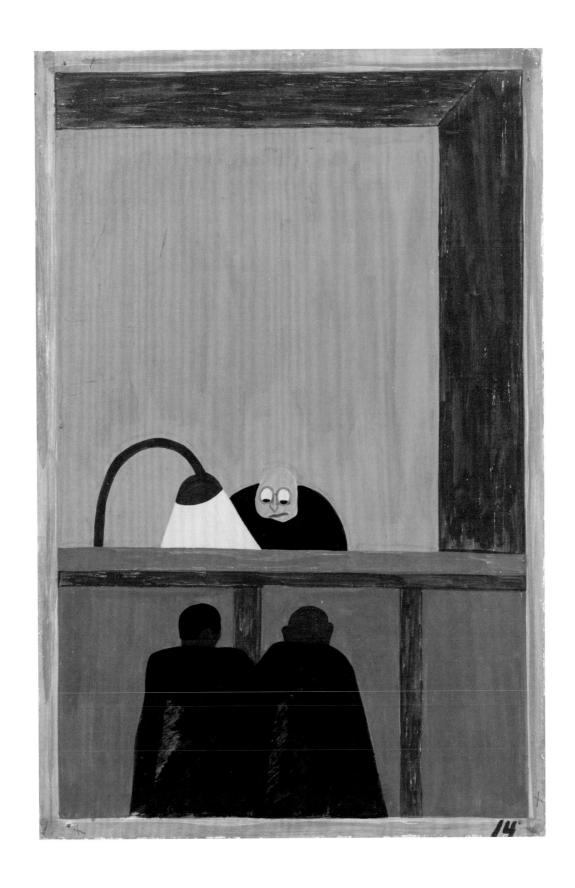

Panel 15

Another cause was lynching. It was found that where there had been a lynching, the people who were reluctant to leave at first left immediately after this. (1941)

There were lynchings. (1993)

The emotional power of this panel hinges on absence. Instead of depicting the body that once hung from the noose at the work's center, Lawrence focuses on the huddled figure at the left. Face turned from the viewer, head bowed, limbs tucked in, the mourner's body collapses in on itself, as if to shield itself from threats both physical and emotional. The grieving figure is a poignant visual manifestation of the lasting sorrow produced by racial violence. The panel evokes "Strange Fruit," the song made famous by the jazz singer Billie Holiday two years earlier. Although the lyrics never explicitly mention lynching, the metaphor they establish is clear: "Southern trees bear a strange fruit/Blood on the leaves and blood at the root/Black bodies swingin' in the southern breeze/Strange fruit hangin' from the poplar trees." When Holiday performed the song in nightclubs, she insisted on a completely quiet room, and sang in a single spotlight on an otherwise dark stage, the better to convey the gravity of the subject.

In the early twentieth century, lynching was a horribly common crime. Between 1880 and 1951, at least 3,400 African-Americans were lynched in the United States, most of them in the South.[1] Hundreds of gruesome images of lynchings circulated in newspapers, books, postcards, and pamphlets during this period. Photographs documenting the spectacle-like nature of many lynchings circulated among white participants as grizzly souvenirs. They were also published in books and pamphlets produced for antilynching campaigns as evidence of the crime's barbarity and corrosive effect on American culture. Yet in its lack of lurid detail, its quiet emptiness, Lawrence's painting stands apart from these images.

1. These statistics appear on the website
 www.amistadresource.org/plantation_to_ghetto/racial_violence_and_terror.html (consulted
 November 2014).

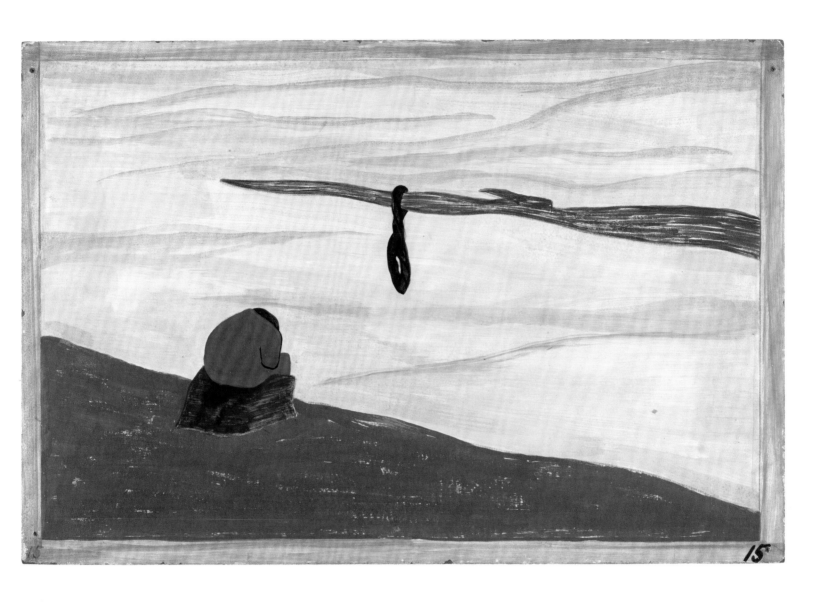

Panel 16

Although the Negro was used to lynching, he found this an opportune time for him to leave where one had occurred. (1941)

After a lynching the migration quickened. (1993)

The table and chair in the panel, constructed from zigzagging surfaces and volumes, seem on the brink of tumbling into the viewer's space. This construction of tilted planes, its faux bois effects made with strokes of a dry brush, makes clear the young artist's interest in the innovations of Cubist painters such as Pablo Picasso and Georges Braque. Yet Lawrence's concern here is more than formal: he deploys these modernist devices to heighten the sense of physical compression suffered by both figure and space. The image of a woman physically wilted under the burden of her grief presents the subject of lynching as one of overarching psychic oppression. Lawrence homes in on the physical and emotional signs of despair to evoke a situation so bleak as to leave few justifications for staying in the South. He knew from his research for the Migration Series that images of lynchings and their aftermath could inspire movement in communities far removed from the sites of those crimes.

In the mid-1930s, many left-leaning artists and cultural figures joined the fight to raise awareness of racial violence and campaigned to persuade Congress to pass antilynching legislation. In 1935, both the John Reed Club, a New York Communist organization, and the city's branch of the National Association for the Advancement of Colored People (NAACP) organized antilynching art shows. Some of Lawrence's most famous contemporaries, including Isamu Noguchi, Thomas Hart Benton, and José Clemente Orozco, contributed works to these shows. Their grim images made for a powerful political statement. "This is not an exhibition for softies. It may upset your stomach," warned the *New York World-Telegram* of the NAACP show. "If it upsets your complacency on the subject it will have been successful."[1]

1. *New York World-Telegram*, quoted in "An Art Exhibit Against Lynching," *Crisis* 42 (April 1935):106.

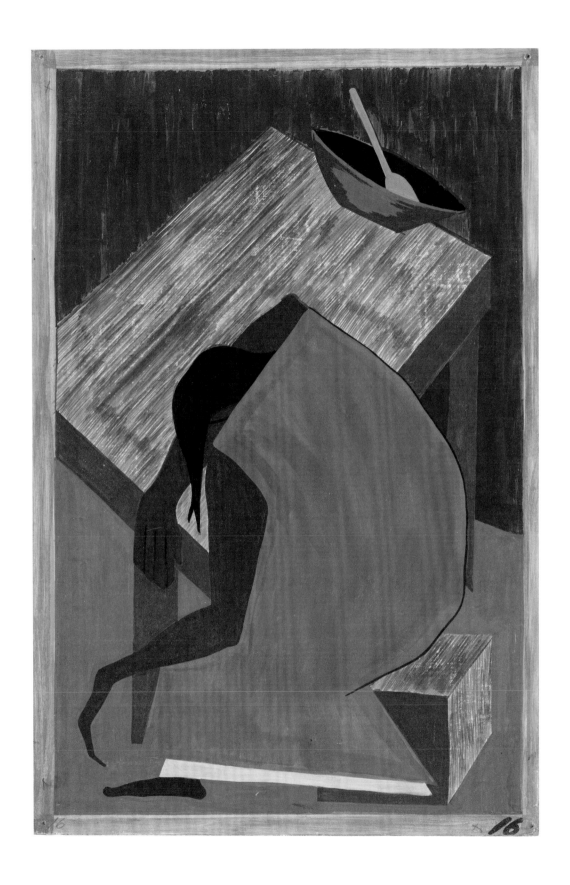

Panel 17

The migration was spurred on by the treatment of the tenant farmers by the planter. (1941)

Tenant farmers received harsh treatment at the hands of planters. (1993)

Without overt violence, this panel offers one of the most direct scenes of interracial confrontation in the entire Migration Series. Two black men struggle to carry heavy bags of harvested crops to a scale. A white landowner or foreman weighs the goods and intently tallies the count on a slip of blue paper. While most of the African-Americans in Lawrence's series appear in ways that don't show their eyes, here the foremost worker stares directly at the man taking notes.

The encounter that Lawrence represents was a crucial moment in the work year of thousands in the South. African-Americans rarely owned the land they cultivated; instead they worked the land of others, through the system known as sharecropping. The arrangement called for the landowner to provide seed, housing, and equipment such as farm animals to tenant farmers at the beginning of the year, in what was called a "furnish." At the end of the growing season came the tense moment of accounting depicted here: profits from the crops grown were summed up, and the cost of the furnish was subtracted from them. Not surprisingly, under a system in which blacks had no legal and little social recourse to question dubious accounting, the numbers usually tipped in favor of the landowner: black farmers were lucky if they received a subsistence wage, and were commonly declared to be in debt to the farmer whose land they had worked for the season. "Sometimes make twenty some bales of cotton and come out behind," recalled Mandie Moore Johnson, a sharecropper from Mississippi. "We didn't clear nothing. The only way we could make it was to go back and borrow some more money for the next year."[1] Those deemed to have failed to clear the furnish were required to repay what they owed through more work, a form of indentured servitude that was enforced by local sheriffs and, at times, the National Guard. Such forms of peonage perpetuated aspects of slavery in the South until well after World War II.

1. Mandie Moore Johnson, in an oral history interview with Doris Dixon, August 4, 1995, available online at http://library.duke.edu/digitalcollections/behindtheveil_btvct03030/ (consulted October 2014).

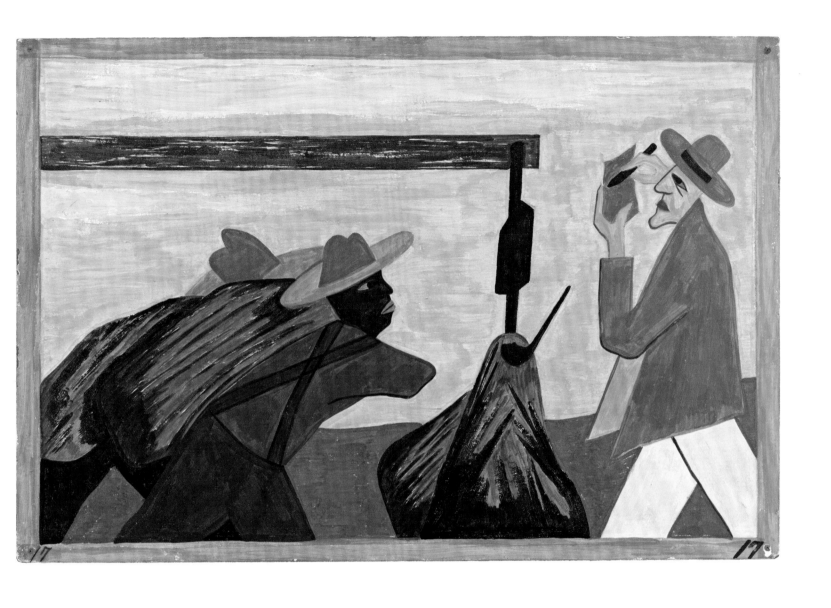

Panel 18

The migration gained in momentum. (1941)

The migration gained in momentum. (1993)

Painting techniques traditionally used to craft the appearance of three-dimensional space on a flat surface enthralled Lawrence. "One of the fascinating things about two-dimensional art is that it has a kind of magic," he said of an artist's ability to create spatial depth and the illusion of objects in the round.[1] Lawrence described long hours spent at New York's Metropolitan Museum of Art studying paintings by the fourteenth- and fifteenth-century Italian artists credited with inventing rational systems for mimicking the appearance of the real world on paper, canvas, and other flat planes. Beginning these visits when he was thirteen or fourteen years old, he learned firsthand about linear perspective, a mathematical means of using converging lines to create the illusion of three-dimensional space. Atmospheric perspective, in which objects at a distance are rendered with less clarity than those in the foreground, also piqued Lawrence's attention, though he employed it only rarely in the Migration Series, instead applying colors across all the panels with great consistency of tone. As a student, Lawrence received few lessons on Renaissance perspectival systems; teachers such as Charles Alston, who had trained at Columbia University Teachers College and first encountered the teenaged Lawrence at Utopia Children's House, a center for the children of working women, instead encouraged him to explore the visual possibilities of abstract shapes and patterns. Still, this panel's converging groups of figures—their bodies becoming smaller to suggest that they are farther from the viewer— reveal his sensitivity to art-historical systems of spatial arrangement.

1. Jacob Lawrence, quoted in Ellen Harkins Wheat, *Jacob Lawrence: American Painter* (Seattle: Seattle Art Museum, 1986), p. 32.

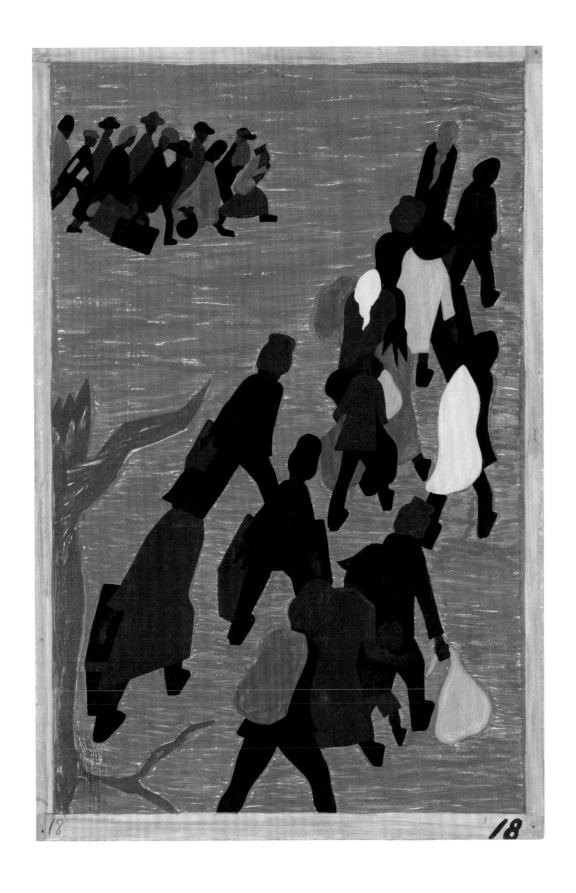

18

Panel 19

There had always been discrimination. (1941)

There had always been discrimination. (1993)

Two women, one white, one black, stand on either side of a river. Each drinks from a separate water fountain, the black woman sharing hers with a child. Lawrence often renders the insidious psychic barriers of segregation as physical ones: a judge's rostrum, a weigh station's hook, a ticket window's bars, a restaurant's rope barrier. The drinking fountain is a particularly charged symbol, a hallmark of the Jim Crow laws that segregated public facilities throughout the South.

Introduced in the late nineteenth century, Jim Crow laws disenfranchised black Southerners of basic civil liberties, such as the right to vote, and ratified their unequal treatment in public spaces. In 1896, the landmark Supreme Court case *Plessy* v. *Ferguson* upheld a Louisiana state law requiring separate railroad cars for black and white passengers, effectively offering federal protection for segregation. By 1920, Southern states had passed more than 350 laws demanding the separation of races in places ranging from schools to cemeteries, from cafés to movie theaters, from restrooms to water fountains, as Lawrence highlights here. In 1954, the Supreme Court overturned the nation's "separate but equal" policy with the case *Brown* v. *Board of Education of Topeka, Kansas*, paving the way for the integration of public spaces across the United States.

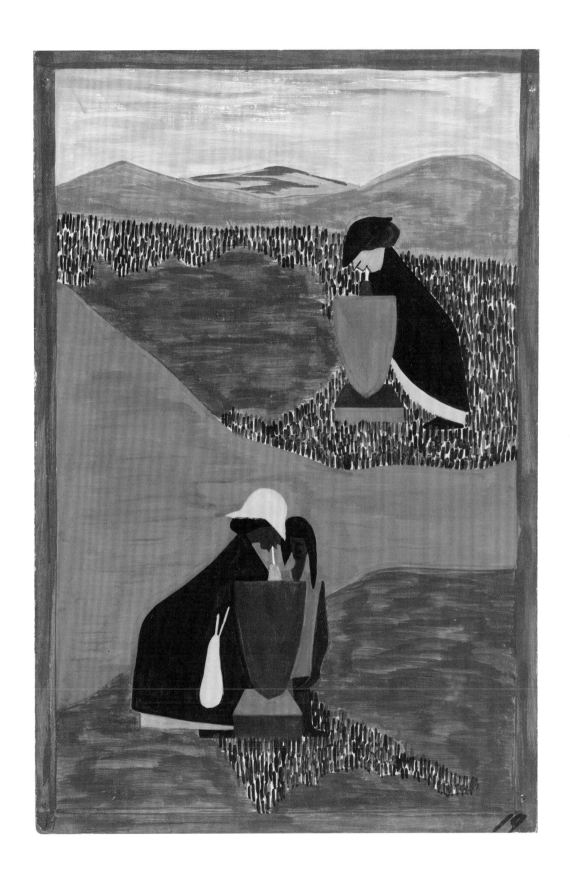

Panel 20

In many of the communities the Negro press was read continually because of its attitude and its encouragement of the movement. (1941)

In many of the communities the Black press was read with great interest. It encouraged the movement. (1993)

Huddled together behind a large open newspaper, the three figures in the foreground of this panel hungrily devour its writing with wide, eager eyes. Setting their three heads above the red broadsheet and crowding their bodies tight, Lawrence emphasizes reading as a collective act. In the distance, two more figures pressed together to read a single paper appear as a three-legged form in counterpoint to the three-headed creature below.

The most widely read publications of the black press, including weeklies such as Chicago's *Defender* and Harlem's *New Amsterdam News* and the New York–based journals *Crisis*, *Messenger*, and *Opportunity*, steadily encouraged Southerners to seek better fortunes in the North. They reported unsparingly on lynchings, labor exploitation, and other injustices of the South while producing ebullient descriptions of life in the Northern cities, idealized images of black schools, leisure activities, and cultural life, not to mention abundant job advertisements. Journals and magazines nourished black arts and letters, providing public platforms for the era's artists and writers, including close friends and colleagues of Lawrence's such as Charles Alston, Romare Bearden, Langston Hughes, and Claude McKay. Copies of these publications circulated widely in Southern states during the Migration years. Between 1916 and the early 1920s, the circulation of the *Defender* skyrocketed from about 33,000 to upward of 200,000.[1] The number of copies sold, however, amounts to only a fraction of the *Defender*'s and other black publications' total readership, as copies were generously shared and often read aloud at homes, churches, and social gatherings.

1. See James Grossman, "Blowing the Trumpet: The 'Chicago Defender' and Black Migration during World War I," *Illinois Historical Journal* 78, no. 2 (Summer 1985):82–96.

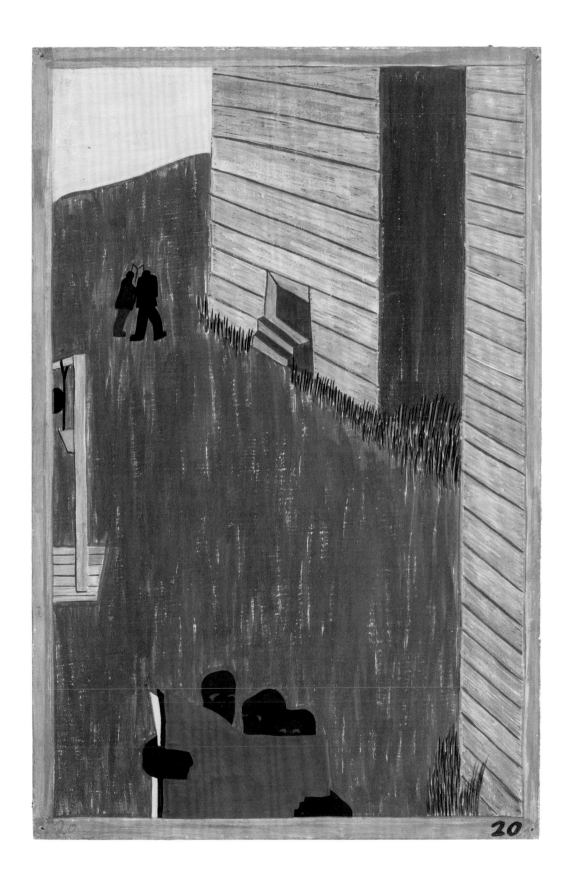

Panel 21

Families arrived at the station very early in order not to miss their train North. (1941)

Families arrived at the station very early. They did not wish to miss their trains north. (1993)

This is one of many panels in the Migration Series in which Lawrence asks his viewers to pay attention to time. Here, time is drawn out, it passes slowly: "Families arrived at the station very early," his caption reads, and they patiently wait. The figures in the foreground gaze out, their backs turned to us, as they pass the hours in a vast, unpopulated landscape, taking in a last view of home. Lawrence uses three bands of brown, painted in successively lighter shades from foreground to background, to suggest an expanse that stretches far into the distance, covered only by a patch of vegetation at the horizon. This emphasis on the rural South's protracted sense of time and physical openness—its seemingly boundless fields, arid expanses, unspoiled rivers, and sparse architecture—also appears elsewhere in the series.

In the North, on the other hand, time flew. Vivid descriptions of rural Southerners' first encounters with the North's bustling urban centers feature centrally in the period's fiction about the experience of the Migration. More often than not, arrival in the city is presented as a shock to the system: towering buildings, narrow streets filled with crowds and cars, and a cacophony of sounds and smells assaulted the Southerner's senses. King Solomon Gillis, the migrant protagonist of Rudolph Fisher's 1925 short story "The City of Refuge," for example, is left "dazed and blinking" by his first moments in New York: "The railroad station, the long, white-walled corridor, the impassible slot-machine, the terrifying subway train—he felt as if he had been caught up in the jaws of a steam shovel, jammed together with other helpless lumps of dirt, swept blindly along for a time, and at last abruptly dumped." In highlighting the disparity between the South's slow pace and natural landscape and the North's quick rhythms and technological marvels, works like Fisher's story and Lawrence's series describe the migrants' journey as a process of psychological as well as geographic dislocation.

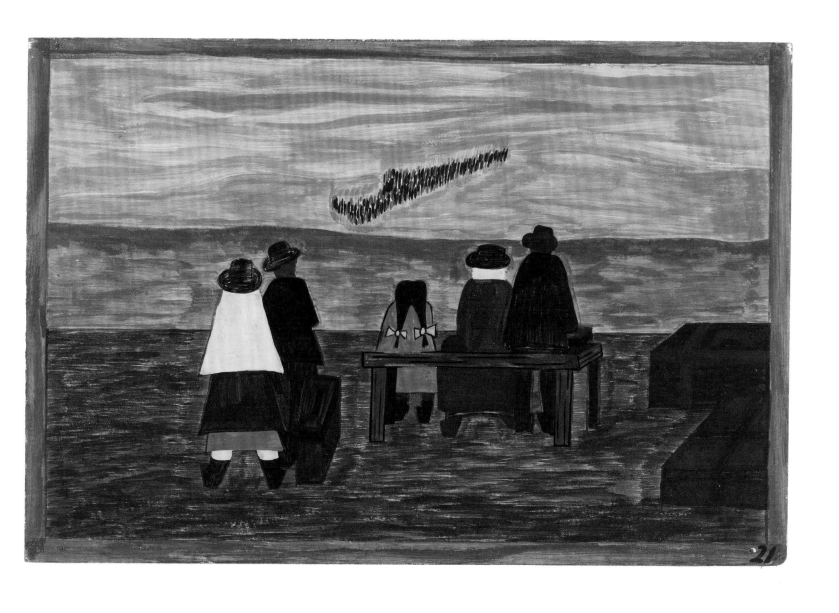

Panel 22

Another of the social causes of the migrants' leaving was that at times they did not feel safe, or it was not the best thing to be found on the streets late at night. They were arrested on the slightest provocation. (1941)

Migrants left. They did not feel safe. It was not wise to be found on the streets late at night. They were arrested on the slightest provocation. (1993)

Manacled together behind imposing metal bars, the three men in this panel form a human chain that fills the painting's frame. Their vertical forms create a visual rhyme with the stripes of the window bars. Lawrence only shows us their backs, but their clothes—street attire rather than prison uniforms—indicate that they have just been pulled in. Facing the harsh penal system of the South, the men are emblems of the thousands of African-Americans who were arrested capriciously there.

Black Southerners living under Jim Crow spoke again and again of detainment based on little more than whim. Walking along a railroad track, spitting, drinking, loitering, vagrancy, and speaking loudly in public were all charges applied almost exclusively to African-Americans, producing scores of black prisoners. States and counties could profitably lease out these men's labor, compelling convicts to work unpaid for employers ranging from private plantation owners to corporations such as U.S. Steel and the Tennessee Coal and Iron Company. Leased convicts often did the most arduous and dangerous jobs, and were treated brutally; convict workers caught in the prison labor system survived there an average of only seven years.[1] Throughout the first decades of the twentieth century, newspapers denounced the convict leasing system as "disgraceful" and "worse than slavery," but it thrived in some parts of the South until World War II.[2]

1. See Helen Taylor Greene and Shaun L. Gabbidon, eds., *Encyclopedia of Race and Crime* (Thousand Oaks, Calif.: Sage Publications, 2009), p. 99.
2. *Slavery by Another Name*, PBS television documentary, 2012, produced and directed by Sam Pollard, available online at www.pbs.org/tpt/slavery-by-another-name/watch/ (consulted November 2014).

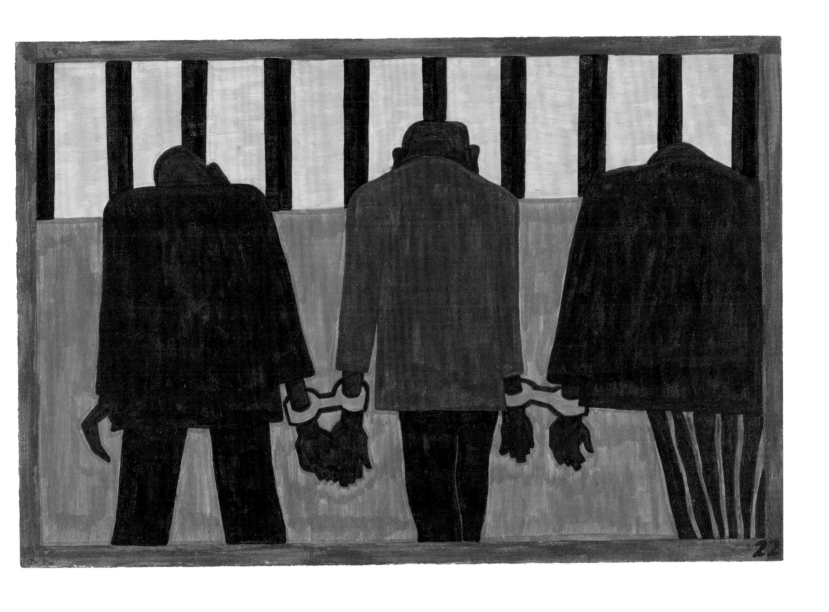

Panel 23

And the migration spread. (1941)

The migration spread. (1993)

The travelers in this panel push from the train platform into the narrow gap between railroad cars. To evoke the intense pressure of their massing before they move inside, Lawrence shapes the brightly colored figures, loaded down with coats and bags, as roughly triangular wedges. "And the migration spread," reads the caption, making the dispersal of passengers through the train stand in for the movement of migrants across the country.

When deciding where to move, many African-Americans settled on Northern cities where they would be reunited with family and friends who had already left the South. Extended families and church congregations were often reconstituted in Northern towns. Since few of the early black migrants could afford automobiles, and depended instead on trains, the geography of the country's railroad lines played a key role in establishing the makeup of migrant communities in the North. The travelers' destinations often coincided with stops along a major rail line. Railroads on the Atlantic Coast carried migrants from Florida, eastern Georgia, and the Carolinas to states like Pennsylvania, New Jersey, and New York. The Illinois Central Railroad and other lines that connected to it took those living in Mississippi, Louisiana, Alabama, and western Georgia to industrial powerhouse states like Indiana and Illinois.

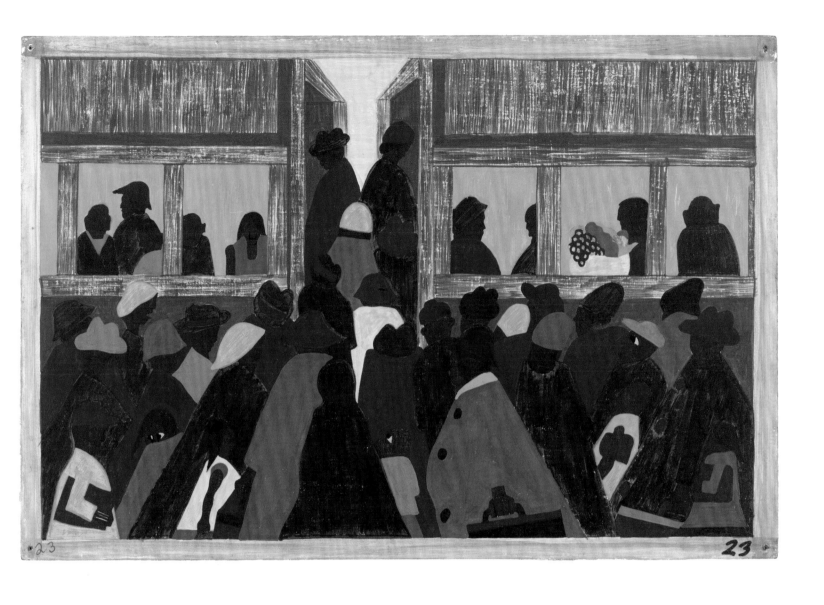

Panel 24

Child labor and a lack of education was one of the other reasons for people wishing to leave their homes. (1941)

Their children were forced to work in the fields. They could not go to school. (1993)

Arranged in frontal and profile positions and mostly in the same horizontal plane, as in a frieze, the sinuous bodies of the children in this panel recall the images of agricultural laborers found on the walls and in the papyrus scrolls of ancient Egypt. Lawrence emphasizes the allusion by setting his figures in a brown, desertlike landscape, dressing them only to the waist, and burdening them with woven baskets, presumably of cotton, a crop associated with both the Southern United States and the Nile Valley. The suggestion of Egypt carries potent allegorical meaning: as slaves were freed from bondage in Egypt thousands of years ago, according to the Bible, so would be the sharecroppers in the South. Here Lawrence may be drawing on the many references to the Jews' exodus from Egypt in African-American spirituals such as "Go Down Moses," made popular in Lawrence's day by the deep-voiced singer and actor Paul Robeson: "Go down, Moses/Way down in Egypt's Land/Tell old Pharaoh/Let my people go."

The widespread use of child labor on Southern farms was a persistent concern for black leaders and educators. The children of the region's black agricultural workers were rarely able to attend classes for a full school year: their studies were cut short by weeks or, more often, months so that they could work alongside adults in the fields. Parents who wanted their children in school often saw their efforts thwarted by white planters. "We would go about four months and then school would close out," recalled David Matthews, a Mississippi native who grew up in the 1920s and '30s. "Through the courtesy of some of the parents, the teachers were retained for maybe another month or so, but even at that sometimes the parent would have a problem with the bosses on a place. They wanted a lot of children to work in spite of the fact the parents were responsible for the teachers being retained."[1]

1. "David Matthews," in William H. Chafe, Raymond Gavins, and Robert Korstad, eds., *Remembering Jim Crow: African-Americans Tell About Life in the Segregated South* (New York: New Press, 2001), p. 108.

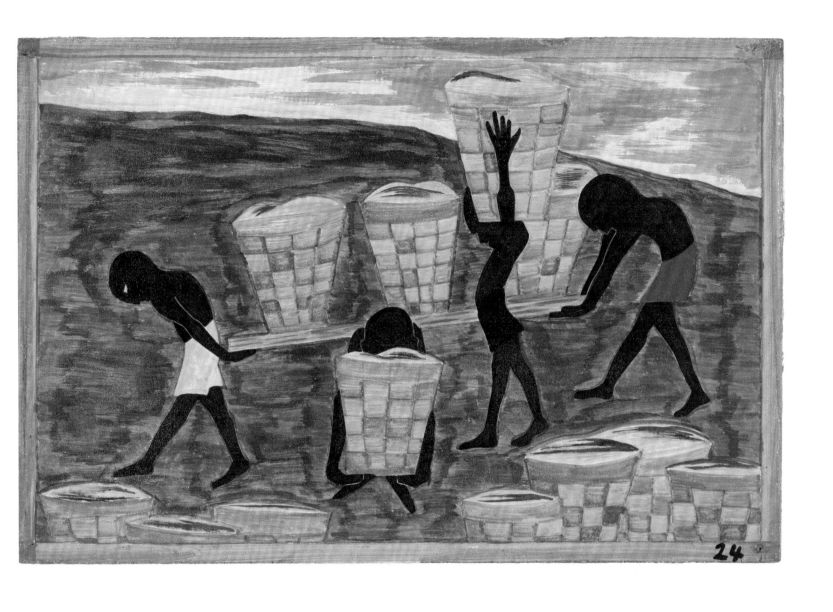

Panel 25

After a while some communities were left almost bare. (1941)

They left their homes. Soon some communities were left almost empty. (1993)

To craft this empty room, Lawrence relies on a limited range of visual elements: three geometric planes, in varying shades of brown, press together to create the illusion of a cube-shaped space. Stripes of mostly parallel lines, set at differing angles, mimic the wooden planks of the floor and walls of a sharecropper's cabin. Their flat expanses, punctuated only by a small window covered by a black blind, offer ample space for Lawrence's faux-bois painting technique, which elsewhere in the Migration Series he uses to describe tabletops, building exteriors, and wood-paneled train cars. With its steeply tilted planes and single aperture, its lack of both human presences and the furnishings that would accompany them, the room seems more memorial than home.

Lawrence's bare cabin chimes with early sociological reports on the quick depletion of African-American towns and neighborhoods throughout the South during the Great Migration. The "black belt"— parts of agricultural South Carolina, Mississippi, Georgia, Alabama, and Louisiana where over 40 percent of the population had been black in 1910—was hit particularly hard.[1] The region's quickly diminishing African-American presence gave rise to stories of veritable ghost towns. A 1917 report on Mississippi by the Chicago-based sociologist Charles S. Johnson told of hundreds of abandoned homes in Greenville, deserted streets in Jackson, and shuttered churches and schools elsewhere in the state.[2] As black Southerners watched their networks of family and neighbors fall apart, motives for staying put dissipated. "If I stay here any longer I'll go wild," complained a woman from a small Mississippi town in 1917. "Every time I go home I have to pass house after house of all my friends who are in the North and prospering."[3]

1. James N. Gregory, *The Southern Diaspora: How the Great Migrations of Black and White Southerners Transformed America* (Chapel Hill: The University of North Carolina Press, 2005), p. 18.
2. See James Grossman, *Land of Hope: Chicago, Black Southerners, and the Great Migration* (Chicago: at the University Press, 1989), p. 107.
3. Quoted in ibid., p. 108.

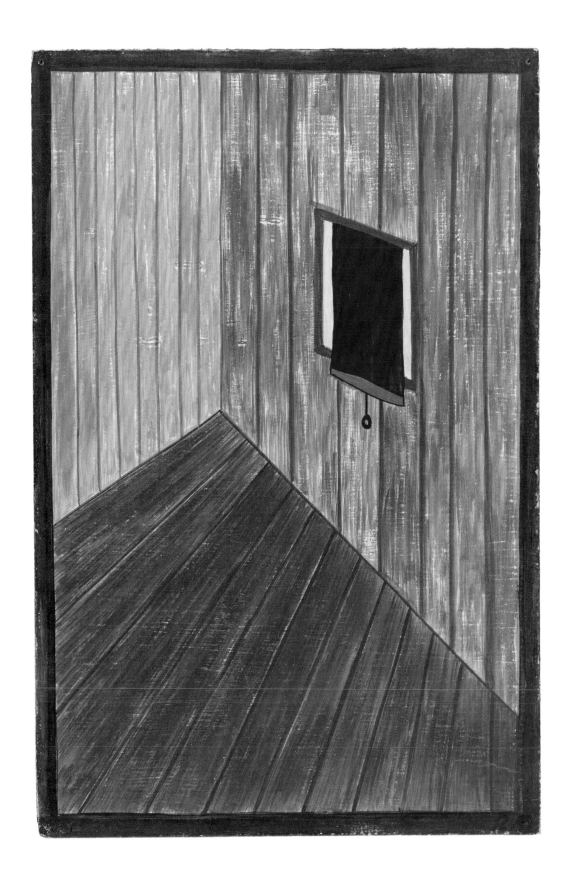

Panel 26

And people all over the South began to discuss this great movement. (1941)

And people all over the South continued to discuss this great movement. (1993)

Here Lawrence uses exaggerated facial expressions to describe
a conversation, but renders them highly economically: quick strokes
of light brown represent closed mouths, a dark horizontal slash signals
downcast eyes and a furrowed brow, and an open triangle describes
lips parted in speech. Composed out of unmodeled areas of color
articulated with bold black lines, these simplified but highly expressive
faces bring to mind the style of the popular comic strips of the period.
So too do the dark silhouettes of the figures' bodies, which read in strong
graphic contrast to the light-blue sky beyond. In the 1920s and '30s
Lawrence was something of a comic book connoisseur: "I read *Dick
Tracy, Katzenjammer Kids, Maggie and Jiggs, Little Orphan Annie*, things
like that," he would recall, listing hit titles from his younger years.
"I remember *Mutt and Jeff* [flip books] in school, and they were pretty
pornographic. During recess, the kids would turn the pages; it was like
a movie, and you'd see things happen."[1] The impact of Lawrence's
interest in cultural forms such as comics is felt throughout the Migration
Series in the pared-down descriptions of human bodies and faces in
paintings like this one, as well as in the series' limited but bright color
palette and multipanel structure. Moving from panel to panel, the
narrative of the Migration Series unfolds sequentially over time, shifting
in perspective from frame to frame, much like the comic strips and flip
books that Lawrence enjoyed in his youth.

1. Jacob Lawrence, quoted in Ellen Harkins Wheat, *Jacob Lawrence: American Painter* (Seattle: Seattle Art
 Museum, 1986), p. 33.

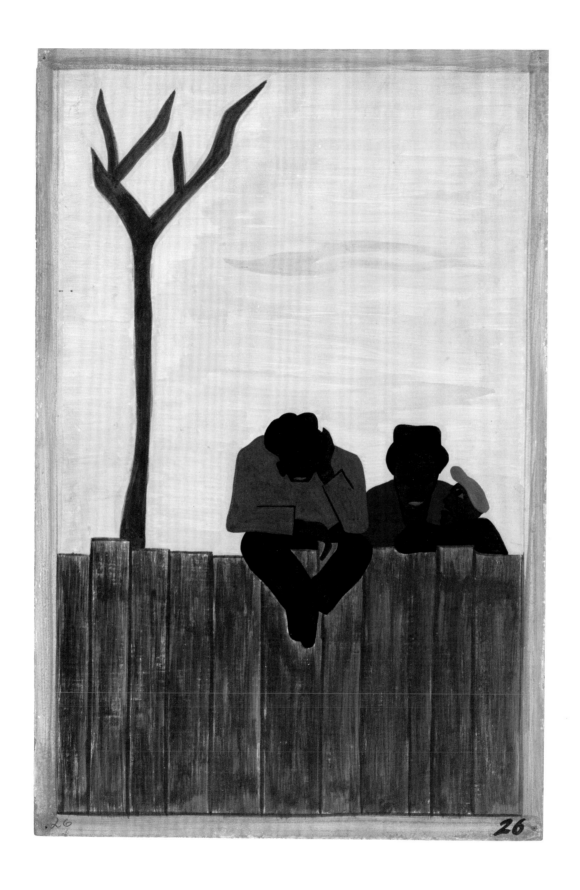

Panel 27

Many men stayed behind until they could bring their families North. (1941)

Many men stayed behind until they could take their families north with them. (1993)

The mother and children in this panel—sitting on an enormous trunk that surely holds the entirety of the belongings they will carry north— wait for the man at the ticket window to buy their train tickets. In contrast to the many images in the Migration Series of train stations packed with migrants young and old, this family is alone: having waited while they saved enough money to travel together, they have missed the momentum of the Migration's first rush and their move is a quiet affair. The wide gap that separates the woman and children from the man hints at the threat of separation that many migrant families faced.

As the Migration picked up pace during the years of World War I, the cost of train tickets, often calculated by the mile, increased dramatically: by 1918, for example, the fare from New Orleans to Chicago was roughly $20—more than $300 in today's dollars, and a forbidding sum for most potential migrants.[1] Many sold what property they had to cover the price, and when that money was not enough, they devised other ways to pay for the train. Migrants banded together in clubs to secure discounted group-rate fares. They petitioned potential employers in the North, as well as charitable organizations and pro-Migration press outlets, for help with tickets:[2] "i am redy to come at once and i have not got money to pay our train fair and if you will send after us i will sure pay you your money back," a man from Laurel, Mississippi, wrote hopefully to the Chicago Urban League in 1917.[3] The financial toll of moving was particularly hard on families. Unlike the parents and children in this panel, many decided that their only option was to move in stages, sending a single family member, often the oldest or most able-bodied male, along first in the hope that he would find work, settle in, and make enough money to send train fare for the rest.

1. See James Grossman, *Land of Hope: Chicago, Black Southerners, and the Great Migration* (Chicago: at the University Press, 1989), p. 103.
2. See ibid., pp. 103–7.
3. Quoted in ibid., p. 104.

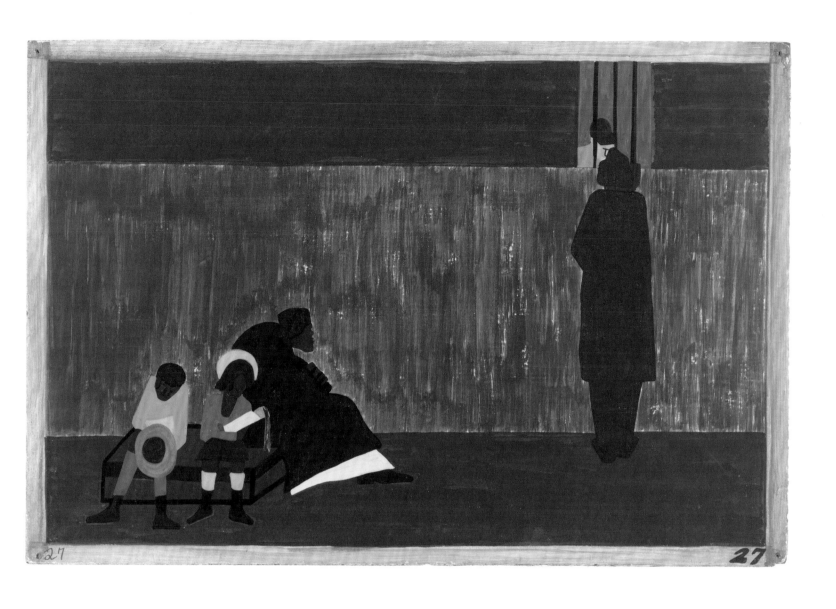

Panel 28

The labor agent who had been sent South by Northern industry was a very familiar person in the Negro counties. (1941)

The labor agent sent south by northern industry was a familiar presence in the Black communities. (1993)

A white labor agent writes busily on a sheet of yellow paper, inscribing names in a roster of new recruits. A double line of strong men looking for work extends before him. Lawrence's painting and caption suggest frequent and unfettered interactions between agents representing Northern companies and black workers in the South. In reality, the scene pictured here was a rarity during much of the Migration: only early on were recruiters sent south with any regularity, as industrial employers struggled to find extra hands to keep up with increased wartime demand. By the end of World War I, Northern companies had all but stopped sending out agents.

Yet the figure of the labor agent would captivate commentators on the Great Migration for years. Both newspaper accounts and early studies of the Migration listed these men as a crucial motivating force. "In the first communities visited by the representatives of northern capital, their offers created unprecedented commotion," wrote Emmett Scott in his pioneering book *Negro Migration during the War* (1920). "Drivers and teamsters left their wagons standing in the street. Workers, returning home, scrambled aboard the trains for the North without notifying their employers or their families."[1] With dramatic flourish, Scott presents the labor agent as the herald of new opportunity. Yet for many landowning white Southerners, the labor agent was a figure of blame: but for the intervention of wily outsiders, they suggested, black Southerners would have stayed home, happy with their lot.

1. Emmett J. Scott, *Negro Migration during the War*, 1920, quoted in Joe William Trotter, Jr., "Introduction: Black Migration in Historical Perspective. A Review of the Literature," in Trotter, ed., *The Great Migration in Historical Perspective: New Dimensions of Race, Class, and Gender* (Bloomington and Indianapolis: Indiana University Press, 1991), p. 7.

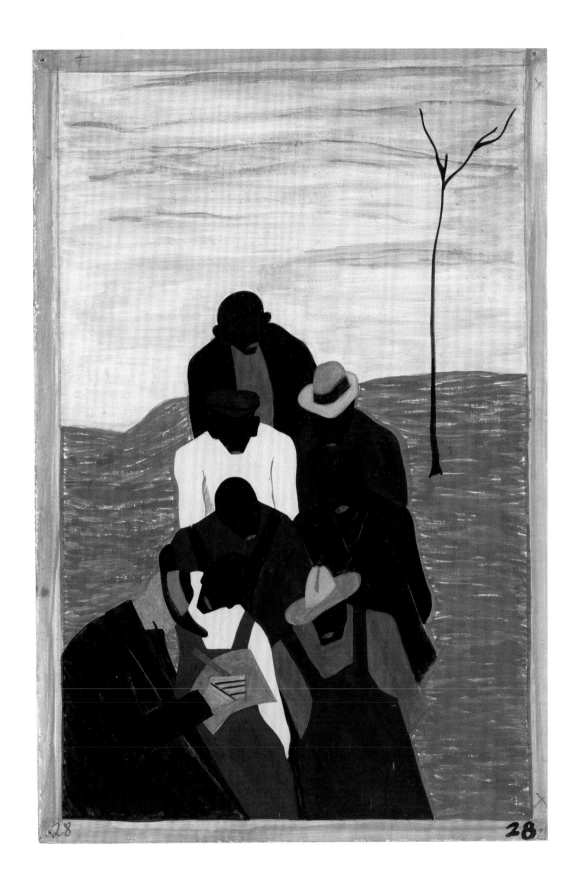

Panel 29

The labor agent also recruited laborers to break strikes which were occurring in the North. (1941)

The labor agent recruited unsuspecting laborers as strike breakers for northern industries. (1993)

Faceless, dressed in black, and sitting with his back to the viewer, the white labor agent in this panel offers a contract to three African-American men who stand in line to sign it. Such arrangements could be mixed blessings: as Lawrence's caption shows, black migrants often unwittingly found that they had become players in a struggle between employers and unions.

The first years of the Great Migration coincided with a heated moment in the history of U.S. labor relations. The end of World War I brought with it a rise in union militancy as workers demanded better conditions and improved wages to offset high inflation. More than 4 million people—about 22 percent of the nation's workforce—went on strike in different actions over the course of 1919.[1] In this context the arrival of black workers in Northern factories could be explosive. Black laborers recognized that white union leaders did not necessarily have their interests at heart. They did not cross picket lines more frequently than workers of other races, but those that did, at the risk of violence, often justified strikebreaking as a form of labor activism that gave them entry into industries previously closed to them.[2] During the nationwide steel strike of 1919, the black weekly the *St. Louis Argus* noted that "we do not relish the expression 'strike breaker,'" but "when the wheels of these plants have been stopped or threatened with stoppage by reason of strikes," the paper explained, "necessity forces us to accept work when and where we can get it."[3]

1. See Eric Arnesen, *Black Protest and the Great Migration: A Brief History with Documents* (Boston: Bedford, and New York: St. Martin's, 2003), p. 30.
2. See Arnesen, "Specter of the Black Strikebreaker: Race, Employment, and Labor Activism in the Industrial Era," *Labor History* 44, no. 3 (2003):322.
3. "The Steel Strike," *St. Louis Argus*, October 24, 1919, quoted in ibid., p. 324.

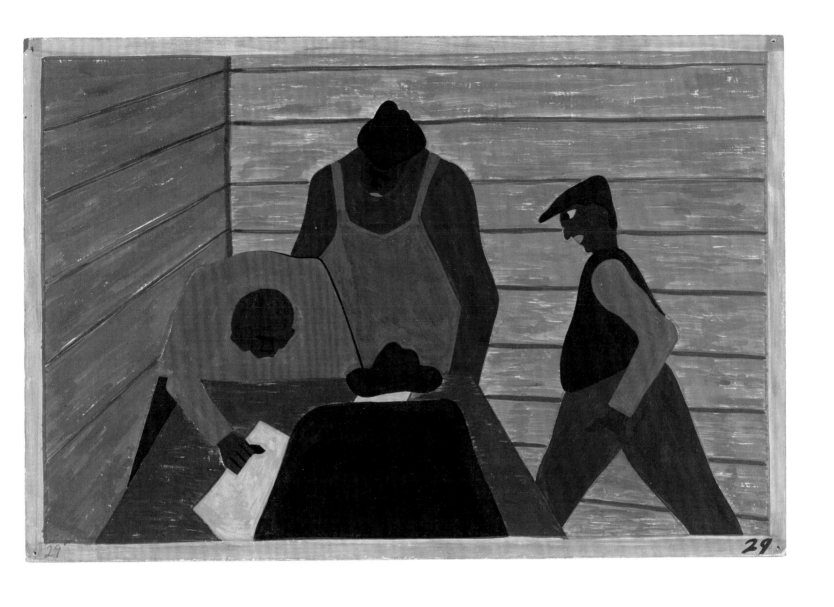

Panel 30

In every home people who had not gone North met and tried to decide if they should go North or not. (1941)

In every southern home people met to decide whether or not to go north. (1993)

Here Lawrence crafts the illusion of a three-dimensional room with a rectangle representing the back wall and diagonal lines extending from its corners to create a sense of spatial recession. With the fourth wall of this boxlike space removed to offer a view inside, Lawrence's room resembles a proscenium stage. The group of figures arranged around the dinner table at the back, and the potted plant on a round stand in the foreground, are placed like actors and props. Lawrence knew theater space well: during his art-student years he regularly attended plays, concerts, and comedy shows at theaters large and small in Harlem. In the later 1930s, the Federal Theatre Project—a division of the Works Progress Administration, a government program to provide employment through public works—ran a New York Negro Unit that supported stage productions in Harlem from a home base in the Lafayette Theater on 132nd Street. Federal Theatre Project productions often took on topics of political significance. *Turpentine* (1936), for example, a social drama written by J. Augustus Smith and Peter Morell, focused on the injustice of Southern labor camps; and *Haiti* (1938), by William DuBois, a white Southern reporter, celebrated the overthrow of the colonial Haitian government by Toussaint L'Ouverture. (Lawrence expressed enthusiasm about this production when he was working on his own series on the black revolutionary.) Lawrence also made regular trips to Harlem's legendary Apollo Theater. The actors and comedians he saw there stimulated his awareness of his Harlem community—the inspiration, he always insisted, behind works like the Migration Series. "I didn't separate what was going on on the stage from what was going on in the street," he would recall. "I would leave the Apollo, go out on the street and it was like a continuation of what was going on on the stage."[1]

1. Jacob Lawrence, in an interview with Elizabeth Hutton Turner, Seattle, Washington, October 3, 1992. Transcript in The Phillips Collection Archives, Washington, D.C.

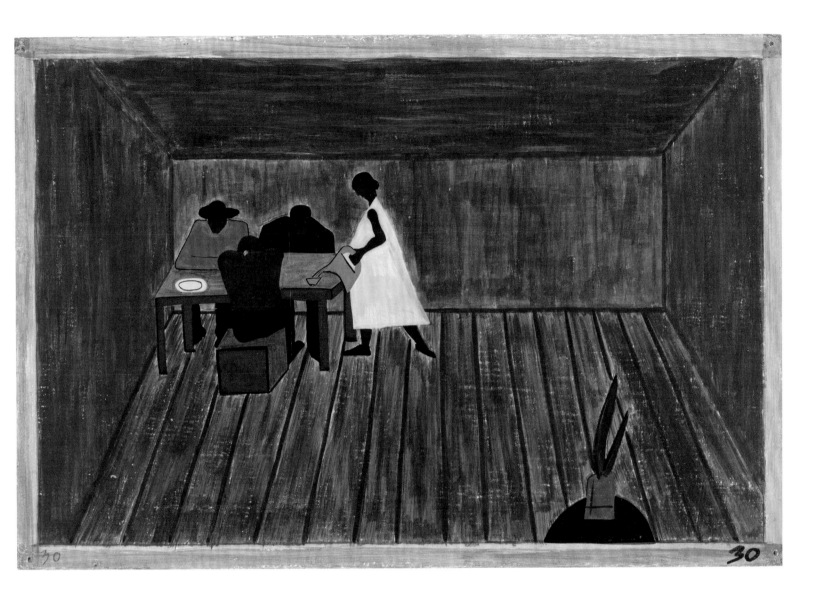

Panel 31

After arriving North the Negroes had better housing conditions. (1941)

The migrants found improved housing when they arrived north. (1993)

The geometric shapes and vertical proportions of Harlem buildings—neatly squared off and set flush with one another across entire blocks—caught Lawrence's attention as soon as he moved to New York from Philadelphia in 1930. "We came to New York and of course this was a completely new visual experience seeing the big apartments," he recalled, "When I say 'big' I mean something six stories high because I wasn't used to apartment houses."[1] In this panel Lawrence translates Harlem's architectural forms into a composition on the brink of abstraction: three separate building facades read as flat planes of color, white, brown, and brick red, while their doorframes and windows mutate into an irregular grid of multihued rectangles. Paring these structures down to basic geometric components, Lawrence creates a composition that resonates with works by modernist pioneers of abstraction such as Piet Mondrian and Kazimir Malevich. His trips to The Museum of Modern Art in the 1930s may have exposed him to works by these and other abstract artists. Such firsthand observation would have complemented his lessons with Charles Alston, who had studied at Columbia University's Teachers College with Arthur Wesley Dow, a champion of art education based not on realistic representation but on sensitivity to line, color, and patterns of light and dark.

Harlem's distinctive architecture also inspired artists working in other media to create works that give allusive interpretations to the experience of urban space. In 1940, the jazz composer Duke Ellington wrote "Harlem Airshaft," an instrumental that he conceived as a musical evocation of the sounds and smells that pressed in on the tenants of Harlem apartments. "So much goes on in a Harlem airshaft," Ellington noted in 1944, "you hear fights, you smell dinner, you hear people making love, you hear intimate gossip floating down, you hear the radio. An airshaft is one big loudspeaker. . . . I tried to put all that in 'Harlem Airshaft.'"[2]

1. Jacob Lawrence, in an oral-history interview with Carroll Greene, October 26, 1968, Archives of American Art, Smithsonian Institution, Washington, D.C. Available online at www.aaa.si.edu/collections/oralhistories/transcripts/lawren68.htm (consulted November 3, 2014).
2. Duke Ellington, quoted in Richard O. Boyer, "The Hot Bach," *The New Yorker*, 1944, repr. in Mark Tucker, ed., *The Duke Ellington Reader* (Oxford: at the University Press, 1993), p. 235.

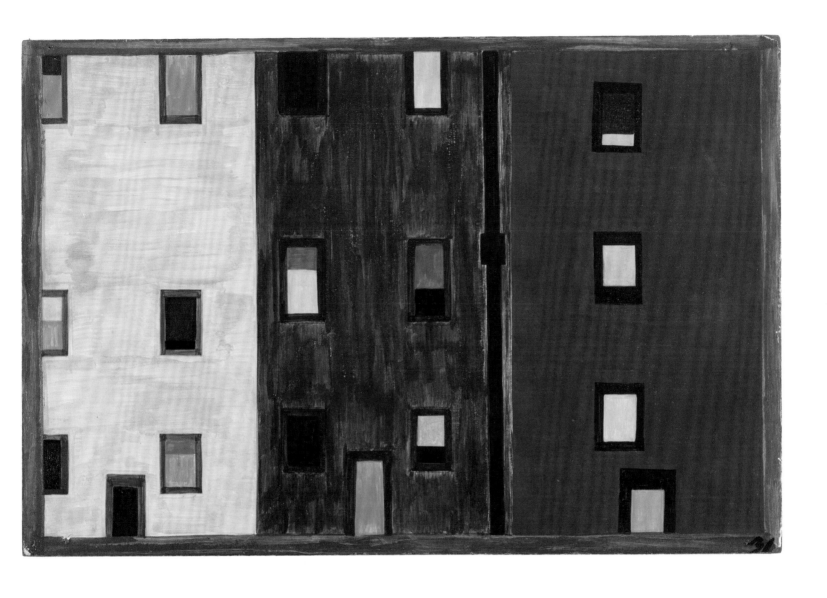

Panel 32

The railroad stations in the South were crowded with people leaving for the North. (1941)

The railroad stations in the South were crowded with northbound travelers. (1993)

The distinctive color palette that Lawrence uses for all of the Migration Series' images of railroad stations and train cars reappears here in a patchwork of black, green, blue, red, and yellow set against a brown background. Using discrete sections of flat color to represent bodies, clothing, luggage, rows of seats, and other details, the artist creates a rhythmic pattern of bright hues and irregular shapes. Vivid yellow and red stand out from brown and black to emphasize key details— here, the hats and coats.

Lawrence was methodical in constructing dynamic color relationships not only within individual pictures but across the Migration Series as a whole. After sketching the outlines of each picture on all sixty panels, he spread them out on the floor of his studio. Then he painted the colors one by one across every panel of the series, starting with dark colors, then moving on to brighter ones. Asked about his unusual method of working on all the panels simultaneously, Lawrence replied that he wanted to maintain stylistic continuity from work to work.[1] His strategy grew from a precocious grasp of pattern and design. The young artist's teachers encouraged his experiments with compositional techniques that accentuated the lively distribution of colors and shapes across the expanse of a painting. The artist Charles Alston, with whom Lawrence began studying at the Utopia Children's House in Harlem in 1930, said he understood right away that "this was a kid to leave alone" and deliberately refrained from "cramming him with classical ideas about art."[2]

1. Lawrence worried that if he "executed each panel separately . . . I would maybe feel different from the sixtieth panel than I would from the first." Quoted in Elizabeth Steele and Susana M. Halpine, "Precision and Spontaneity: Jacob Lawrence's Materials and Techniques," in Elizabeth Hutton Turner, ed., *Jacob Lawrence: The Migration Series* (Washington, D.C.: The Rappahannock Press in association with The Phillips Collection, 1993), p. 156.
2. Charles Alston, quoted in Patricia Hills, *Painting Harlem Modern* (Berkeley: University of California Press, 2009), p. 11.

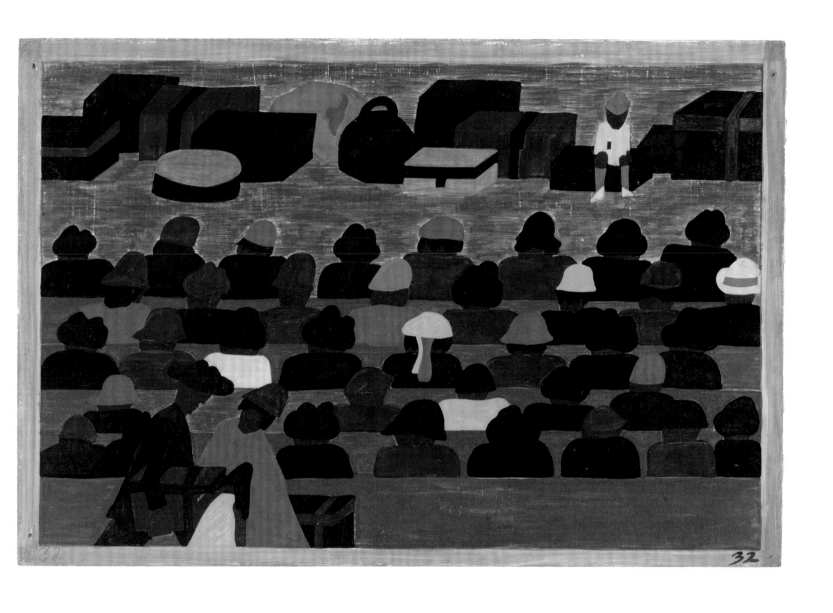

32

Panel 33

People who had not yet come North received letters from their relatives telling them of the better conditions that existed in the North. (1941)

Letters from relatives in the North told of the better life there. (1993)

Seen from above her head, lying in a large bed, the woman at the center of this painting holds up a letter on a sheet of light blue paper. The child kneeling beside her sits quietly with head propped up on hands, presumably listening as she reads aloud. In describing this quiet interaction in the most private of settings, Lawrence highlights the personal ties that letter-writing helped to maintain across distance. Eager to reunite with loved ones they had left in the South, migrants in the North offered inviting descriptions of the better lives they had secured far from home. Meanwhile letters from South to North relayed news and preserved bonds. As a child of migrants, Lawrence knew the importance of these epistolary relationships firsthand: describing the central figure in this panel in later years, he said, "Maybe it represents my mother reading a letter, or my sister."[1]

Letters from friends and family in the North were passed from person to person and read aloud at social events and at church meetings, creating an unofficial but highly effective communications network spreading word of the North's benefits. Letters offered advice on securing jobs and told of the wages a worker could expect at a factory, packinghouse, or construction site. They told of integrated schools, voting rights, and other civil liberties unthinkable in the South. Stories of wealth and material goods, while often exaggerated to impress folks back home, nonetheless stoked hopes of escaping the drudgery and poverty that many black Southerners endured. So tempting were these letters that in 1917 the Chicago sociologist Charles S. Johnson estimated that "fully one-half, or perhaps even more" of that city's migrants had left the South "at the solicitation of friends through correspondence."[2]

1. Jacob Lawrence, quoted in Elsa Smithgall, Henry Louis Gates, Jr., and Elizabeth Hutton Turner, *Jacob Lawrence and the Migration Series from The Phillips Collection* (Washington, D.C.: The Phillips Collection, 2007), p. 19.
2. Charles S. Johnson, quoted in James Grossman, *Land of Hope: Chicago, Black Southerners, and the Great Migration* (Chicago: at the University Press, 1989), p. 91.

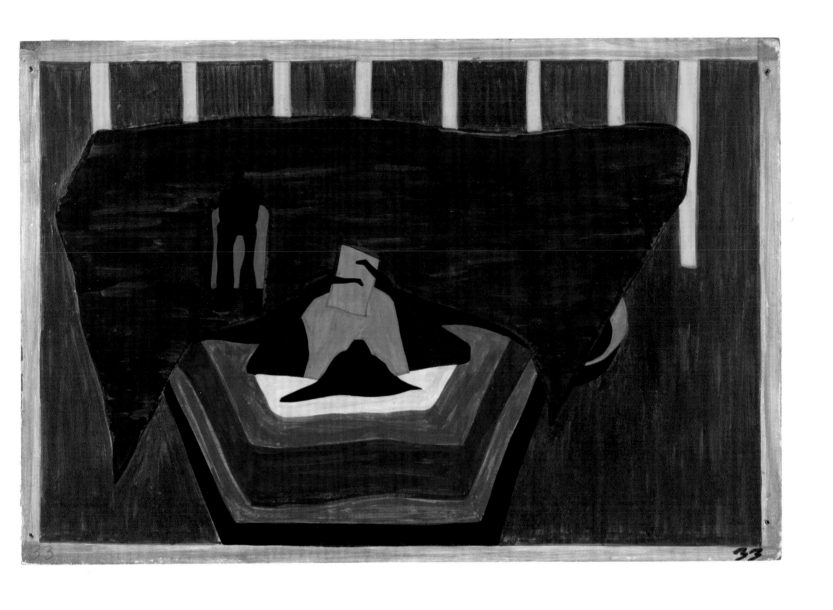

Panel 34

The Negro press was also influential in urging the people to leave the South. (1941)

The Black press urged the people to leave the South. (1993)

A man devours the pages of an open newspaper. With his back to the viewer, shoulders hunched, neck bent, and head pushed close to the paper, his body blocks a clear view of its contents. The woman in the background looks on, maybe listening to him read aloud, or waiting for her own turn. Here as in **panels 20** and **33**, Lawrence stresses the importance of reading as a spur to moving north.

By the late 1910s, many outlets of the black press had been forced underground in the South as officials, worried about the growing momentum of the Migration, worked to suppress reports of better conditions elsewhere. White authorities routinely harassed both vendors of pro-Migration periodicals and the black ministers, teachers, and community leaders known to read these news sources aloud. The punishments for buying or distributing the titles could be harsh: arrests were common, and a writer in Georgia claimed that a "Negro risks his life every time he buys a *Defender*."[1] Undeterred, black communities found ways to circulate their news sources. Railroad porters took stacks of newspapers and magazines with them on their routes south, and migrants bundled copies in the packages they sent to family and friends.[2] Through maneuvers such as these, black Southerners undermined limitations on their access to the black press.

1. See Eric Arnesen, *Black Protest and the Great Migration: A Brief History with Documents* (Boston: Bedford, and New York: St. Martin's, 2003), p. 10.
2. James Grossman, "Blowing the Trumpet: The 'Chicago Defender' and Black Migration during World War I," *Illinois Historical Journal* 78, no. 2 (Summer 1985):90.

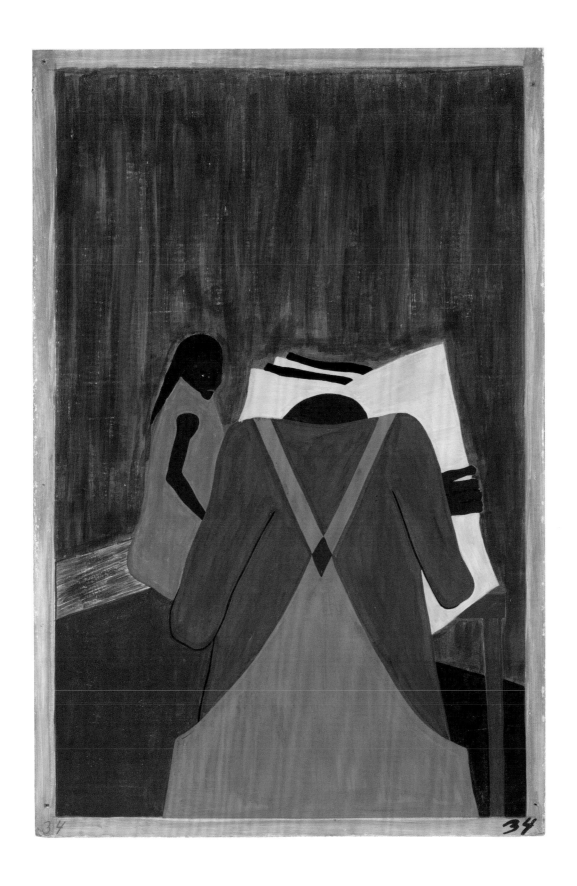

34

Panel 35

They left the South in large numbers and they arrived in the North in large numbers. (1941)

They left the South in great numbers. They arrived in the North in great numbers. (1993)

Lawrence fills this panel with migrant figures viewed only from the waist up, their bodies cut off by the sides and bottom of the painting. Like a photographer or filmmaker framing a close-up, he homes in on a partial view of a group that implicitly extends far to the left and right of the picture's edges. Giving no hint of his characters' location, he focuses instead on the act of moving itself. Resolutely facing forward— only a figure at the right turns her head to talk to another behind her— the group marches en masse toward a better life.

Panels like this one, which pair an image of migrant crowds with captions emphasizing their continual movement north over time, serve as a visual and textual refrain throughout the Migration Series. Periodic reminders of the sheer number of black Southerners who left their homes over the course of several decades, they underscore the Migration's dramatic demographic impact. Between the 1910s and 1920, over 400,000 black Southerners left for the North. By the end of the 1920s, that number had exceeded 1.2 million. Two decades later, approximately 3 million African-Americans from the South had headed for Northern states.[1] Lawrence's many pictures of migrants traveling side-by-side, whether on foot or by train, offer a politically potent image of this collective self-transformation. "It is interesting to note that this migration is apparently a mass movement and not a movement of the leaders," noted W. E. B. Du Bois in 1917; "the colored laborers and artisans have determined to find a way for themselves."[2]

1. James N. Gregory, *The Southern Diaspora: How the Great Migrations of Black and White Southerners Transformed America* (Chapel Hill: The University of North Carolina Press, 2005), p. 15.
2. W. E. B. Du Bois, "The Migration of Negroes," *Crisis* 14, no. 2 (June 1917):66.

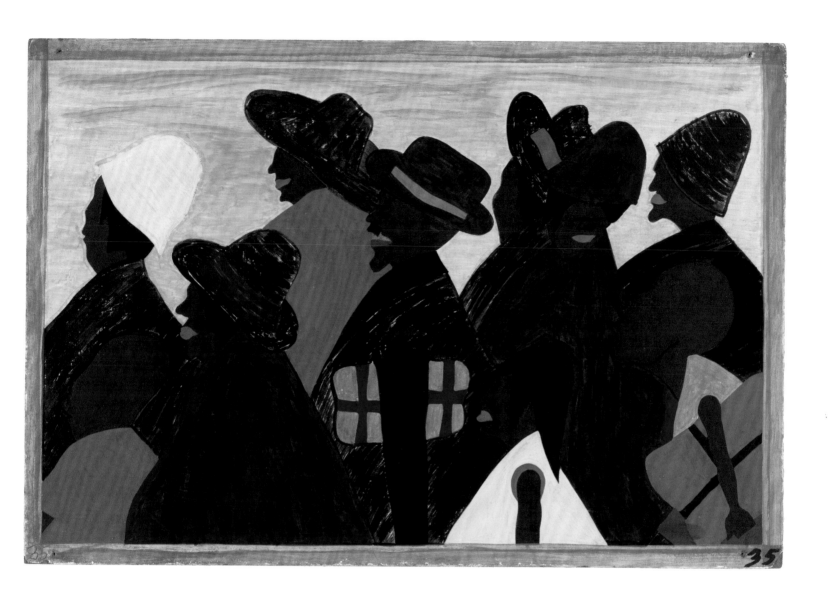

Panel 36

They arrived in great numbers into Chicago, the gateway of the West. (1941)

Migrants arrived in Chicago, the gateway to the West. (1993)

Penned behind a wooden fence, a line of livestock animals extends across the foreground of this panel, one creature's outline bleeding into the next. Behind them two factory-scale packinghouses pump smoke into the air, emblems of an industrialized agriculture quite different from the Southern farms that many migrants had once worked by hand. Chicago was the hub where the livestock and agricultural goods of the Midwest were processed to be distributed to the rest of the United States; its stockyards and meatpacking plants absorbed thousands of black workers during and after World War I. In a self-reinforcing process, the fact that so many migrants found a first foothold here helped to solidify the city's reputation as a beacon of economic opportunity, which in turn attracted more migrants.

The black Southerners who moved to Chicago also transformed the city into a capital of African-American cultural and intellectual life. As Chicago's South Side filled up with Southern migrants, it provided fertile ground for writers such as William Attaway and Richard Wright, who would become key figures in Lawrence's circle after moving to New York in the mid-1930s. Both men made the Migration and its impact a central theme in their work. The South Side Community Art Center, which was founded in 1940 with support from New Deal cultural programs, offered critical support to a variety of young black artists, including the poet Gwendolyn Brooks, the photographer Gordon Parks, the mural painter Charles White, and the sculptor and printmaker Elizabeth Catlett. Lawrence too had a presence at the Art Center: in 1941, he exhibited his series on the life of Harriet Tubman there. The exhibition augmented his reputation outside New York and strengthened the ties between Chicago's and New York's black intellectual communities.

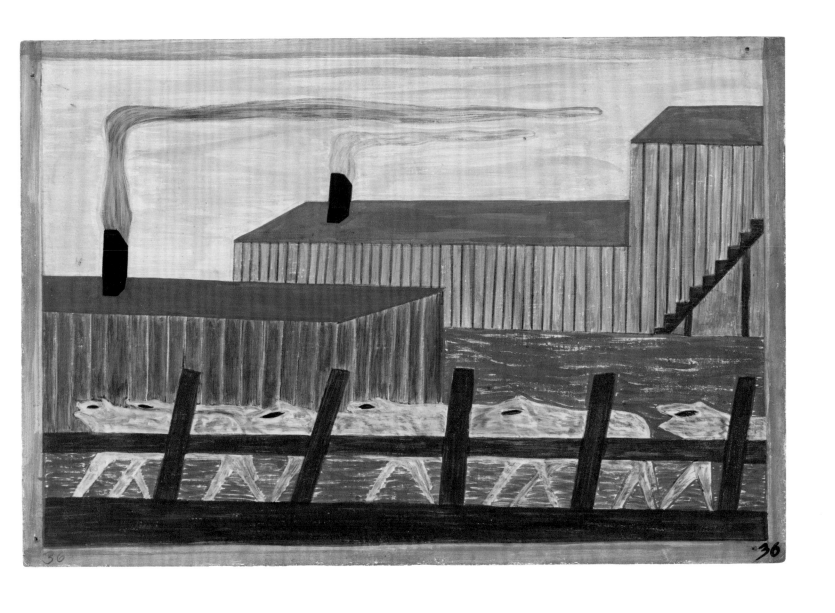

Panel 37

The Negroes that had been brought North worked in large numbers in one of the principal industries, which was steel. (1941)

Many migrants found work in the steel industry. (1993)

A bright stream of molten metal pours through the air and splashes into a crucible, illuminating the dark factory around it. This panel adds Lawrence to the considerable list of artists who in the 1930s and early '40s used images of factories and machinery to forge a visual vocabulary for the period's industrial drive. Modern media like photography and film were often enlisted to celebrate this world. Although Lawrence's picture is painted, its framing—a close-up view of a liquid metal pour, cropped to exclude workers or the larger environment—resembles avant-garde camera images.

Lawrence's panel conjures the power of industrial processes, but its burst of fiery metal also evokes their danger. As he knew, on-the-job injury at steel mills was a particular peril for African-Americans: the black migrants who flocked to Illinois, Indiana, and Pennsylvania were often assigned to the plants' most hazardous jobs. Lawrence's understanding of conditions in the steel industry came from news accounts, sociological texts, and, just as important, contemporary literature. He regularly saw the writer William Attaway, who was both a neighbor (in 1940–41, both men were living at 33 West 125th Street in Harlem) and a fellow attendee at "306," or 306 West 141st Street— the studio of the artists Henry Bannarn and Lawrence's mentor Charles Alston, where a group of painters, writers, photographers, and musicians often convened. At the time, Attaway was working on what became his best-known novel, *Blood on the Forge*; when published in 1941, it bore a cover designed by Alston. A masterful migration narrative, Attaway's novel follows three brothers on their journey from Kentucky to Pennsylvania, drawing a harrowing portrait of life for African-Americans in the steel industry. Lawrence's and Attaway's narrative strategies diverge, the painter accentuating the epic scale of the Migration as a mass movement and the writer centering on a single family to convey its personal toll. Nonetheless, their common thematic ground reveals a pervasive concern with the Great Migration in the community of African-American thinkers in Lawrence's orbit.

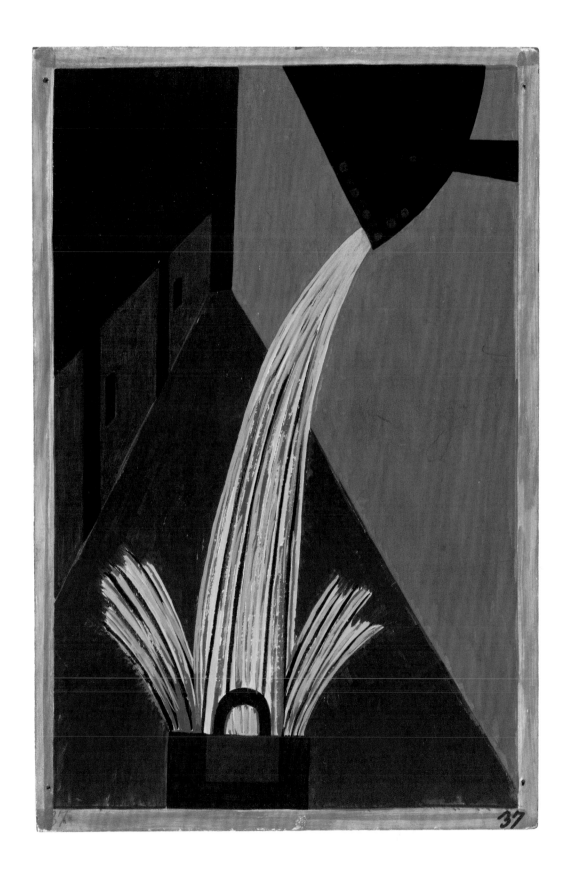

They also worked in large numbers on the railroad. (1941)

They also worked on the railroads. (1993)

Curving in a dramatic sweep from the lower left to the upper right corner of the panel, Lawrence's train track implicitly continues beyond the bounds of the painting. In this way, although focused on only a few wooden ties and a couple of short lengths of metal rail, the image calls to mind the thousands of miles of U.S. terrain traversed by railroad tracks in the early twentieth century and the immense resources—both material and human—required to build and maintain this system. African-American labor had played an important role in constructing the railroads' physical infrastructure in the mid- and late nineteenth century, and as Lawrence suggests, railroads remained a key source of jobs for black workers decades later.

Yet by the time Lawrence began to paint the Migration Series, work on the railroads signified more than manual labor. The Brotherhood of Sleeping Car Porters, established in 1925 and led by the Harlem-based activist A. Philip Randolph, was the first African-American union officially recognized by the American Federation of Labor. It represented the black employees of the Pullman Company, a manufacturer and operator of plush railway sleeping cars. Among the largest employers of African-Americans in the country in the 1920s and '30s, the Pullman Company restricted black workers to low-ranking positions: they were the porters (and less often the maids) who attended to white passengers, working long hours at low wages and depending on tips to supplement their income. The company fought fiercely against their attempt to unionize, often resorting to spying on them and firing potential organizers, but ultimately the Brotherhood prevailed. In 1937, it won its first collective bargaining agreement— a milestone in the history of black labor and a harbinger of future victories for racial equality in the workplace.

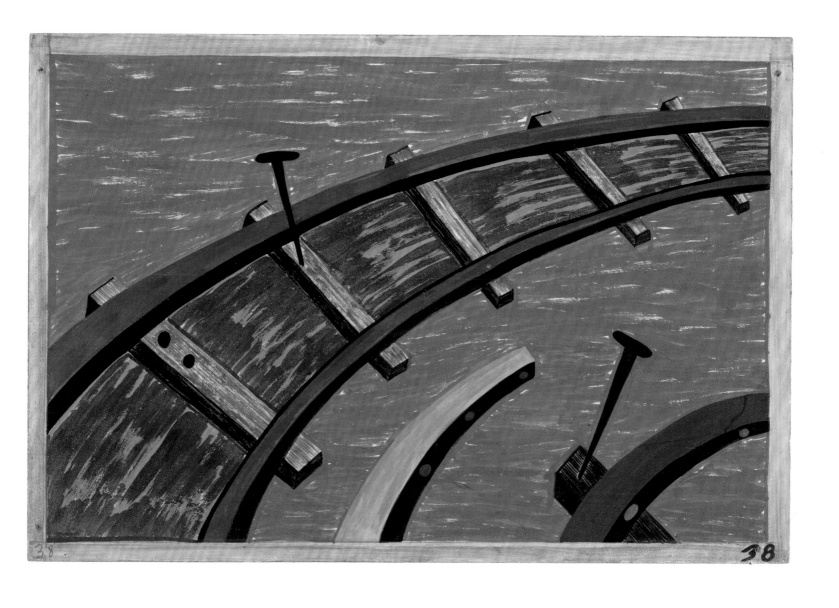

Panel 39

Luggage crowded the railroad platforms. <small>(1941)</small>

Railroad platforms were piled high with luggage. <small>(1993)</small>

A woman and the baby peeking over her shoulder watch over an enormous quantity of luggage. Multicolored trunks and voluminous bags, some visually larger than the woman herself, pile high, filling more than half the composition. This monumental mound of personal possessions signals both black migrants' determination to remain in the North in the long term and the difficulty of their passage. For those with no plan to come back, packing was an ordeal: migrants carried anything they thought would give them a head start as they settled into a new life in the North.

Southern railroad companies often combined spaces for luggage storage and seating for black passengers, making for an uncomfortable ride. The experience of fighting for space with bags, trunks, and suitcases in these "Jim Crow combine" cars recurs in memoirs and fictional accounts of the journey north. Ralph Ellison's short story "Boy on a Train" (written in 1937–38 but published posthumously) describes the unpleasantness: "It was hot in the train, and the car was too close to the engine, making it impossible to open the window....The car was filthy, and part of it was used for baggage.... Bags and trunks covered the floor up front, and now and then the butcher came in to pick up candy, or fruit or magazines, to sell back in the white cars."[1] Many migrants rode great distances standing in train-car aisles, able to relax only after they had crossed the Mason-Dixon line: once a train had entered one of the Northern states, rules about segregated cars were usually dropped, allowing black travelers to seek seats in other compartments.

1. Ralph Ellison, "Boy on a Train," *The New Yorker*, April 26, 1996, p. 110.

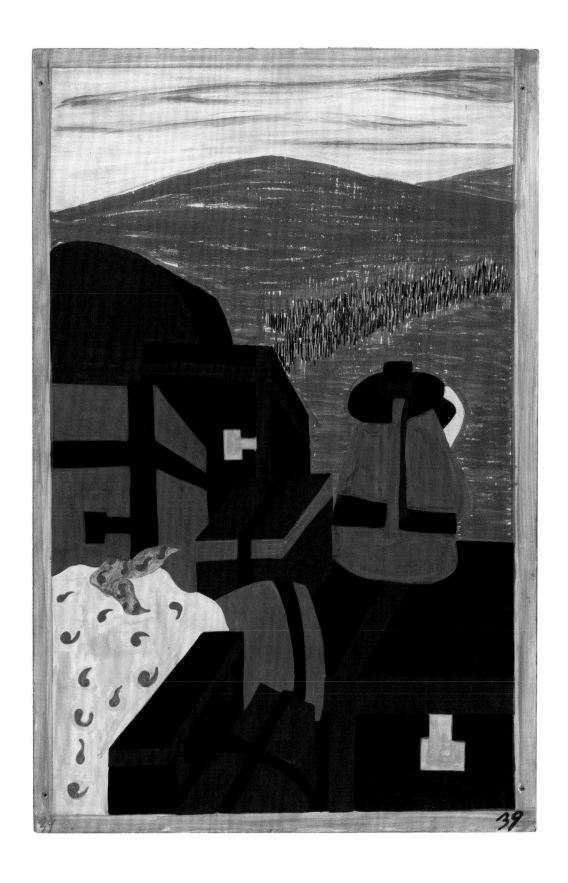

Panel 40

The migrants arrived in great numbers. (1941)

The migrants arrived in great numbers. (1993)

The migrants in this panel, arranged in what appear to be family clusters, stride across an empty expanse of land. Lawrence breaks the landscape's light-brown uniformity only beneath the migrants' feet, where spiky blades of green and yellow grass provide a soft landing for their forward steps. Near the center of the panel, a young boy playfully swings his suitcase behind him in an exuberant burst of energy. Through details like this one, Lawrence suggests the migrants' keen anticipation of a better life to come. A counterweight to his emphasis on the hardships of black Southerners in many other panels, this image stands as a reminder of the crucial role of optimism in propelling migrants north.

News reports, poems, and other writings on the Migration carried similarly hopeful messages. "I've watched the trains as they disappeared/Behind the clouds of smoke/Carrying the crowds of working men/To the land of hope," wrote William Crosse, in a poem published periodically in the Chicago *Defender* throughout the 1920s. Musicians, amateur and professional alike, were also key to building expectations of better days in the North. Traditional African-American spirituals were repurposed as anthems of the Migration: drawing biblical analogies, songs like "I'm on My Way to Canaan's Land" and "Bound for the Promised Land" spoke of redemption from the travails of the South and helped to forge a new vocabulary of slogans that quickly gained traction. In a final sendoff to the Southern towns and cities they were leaving behind, migrants often chalked phrases like "Bound for the Land of Hope" on the sides of train cars headed north.[1]

1. James Grossman, *Land of Hope: Chicago, Black Southerners, and the Great Migration* (Chicago: at the University Press, 1989), p. 113.

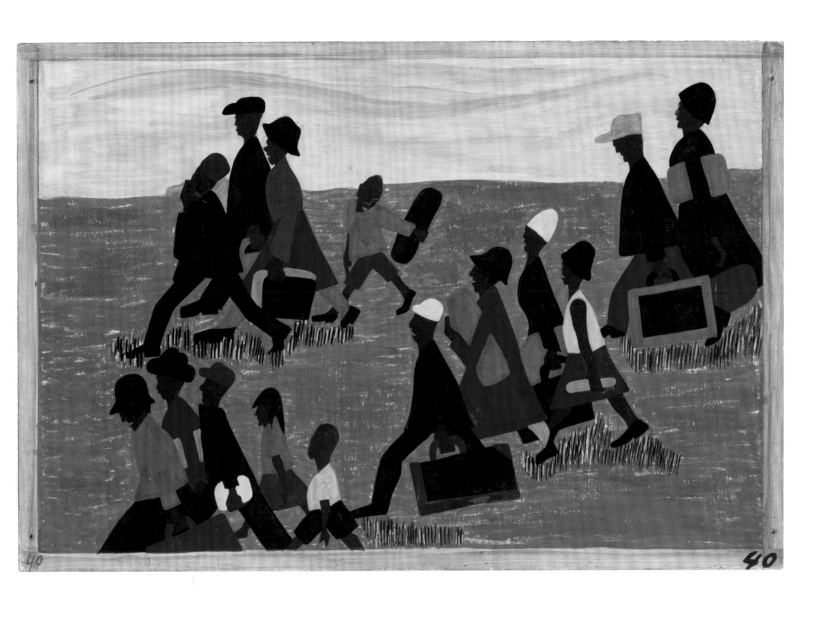

Panel 41

The South that was interested in keeping cheap labor was making it very difficult for labor agents recruiting Southern labor for Northern firms. In many instances, they were put in jail and were forced to operate incognito. (1941)

The South was desperate to keep its cheap labor. Northern labor agents were jailed or forced to operate in secrecy. (1993)

The white labor agent in this panel is visible only by his fingers, which clutch the metal bars across a prison window. Rather than the agent himself, Lawrence shows his jail, a formidable stone building that reaches high into the darkened sky and offers no visible means of escape. Bars are a motif at several key places in Lawrence's series: ticket-window grilles must be negotiated before migrants can travel **(panels 12 and 27)**; posts pen livestock in Chicago **(panel 36)**; cell bars face black men capriciously arrested **(panel 22)**. In each case, the bars stand as emblems of obstructions to freedom and movement.

Acting in the belief that outside influences, including labor agents, were to blame for the exodus of African-Americans from the South, the region's cities, counties, and states often passed laws to ban recruitment activities or to require agents to pay hefty licensing fees.[1] Newspaper articles and editorials helped drum up support for these laws by playing to white landowners' fears of losing labor in the fields, and by appealing to paternalistic assumptions about African-Americans' need for supervision and care. In August 1916, for example, the *New Orleans Times-Picayune* declared that the flight of black workers warranted "safeguards and protection around both employer and laborer" so as to "make sure that no harm or demoralization results from the excessive and unusually unscrupulous activities of labor agents from the North."[2] Attempts to prohibit the operations of labor agents, however, had little if any effect on the pace of black migration. Once word spread of the opportunities in the North, the Migration continued unabated for decades.

1. James Grossman, *Land of Hope: Chicago, Black Southerners, and the Great Migration* (Chicago: at the University Press, 1989), p. 46.
2. "Luring Labor North," *New Orleans Times-Picayune*, August 22, 1916, repr. in Eric Arnesen, *Black Protest and the Great Migration: A Brief History with Documents* (Boston: Bedford, and New York: St. Martin's, 2003), p. 60.

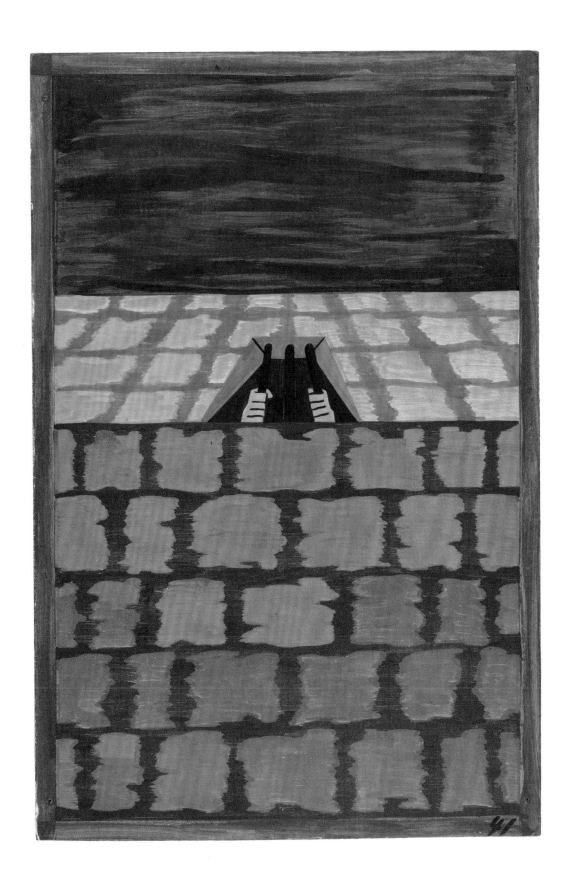

Panel 42

They also made it very difficult for migrants leaving the South. They often went to railroad stations and arrested the Negroes wholesale, which in turn made them miss their trains. (1941)

To make it difficult for the migrants to leave, they were arrested en masse. They often missed their trains. (1993)

Where the barriers preventing free movement in **panel 41** are metal bars, here they take human form: a gun-toting official blocks the open end of a space where two black figures sit. Perhaps the officer has caught them on a train car and makes a dramatic display of his physical stature before throwing them off; or perhaps he uses his body to detain them inside a holding cell. The graphic power of the composition builds on the interplay of horizontal, vertical, and diagonal lines: Lawrence balances the crossing diagonals of the guard's body with an arrangement of rectangles—the painting's outer framing edge, the metal railings attached to the cell, and the interior of the space—to create a three-part series of boxes, one nestled inside the next.

The frame-within-a-frame device that Lawrence uses here was common in modernist photographs and film. Close study of these media was crucial to both Lawrence's thinking about individual panels like this one and his overarching strategy of storytelling through multipanel series, a form he employed four times in the years between 1938 and early 1941. In preparation for the Migration Series, he pored over documentary photographs and vividly illustrated photo magazines and books at the 135th Street branch of the New York Public Library (now the Schomburg Center for Research in Black Culture). His study of these sources is reflected in the series' image-plus-caption format, which it shares with countless printed photographs. Similarities between Lawrence's narrative structure and film are also clear: elaborated picture by picture, the series' sequential unfolding is cinematic in its progression over time. It was the points of contact between Lawrence's work and cinema that drew Jay Leyda, a film curator at The Museum of Modern Art, to the young artist's work; Leyda would prove an important early supporter.

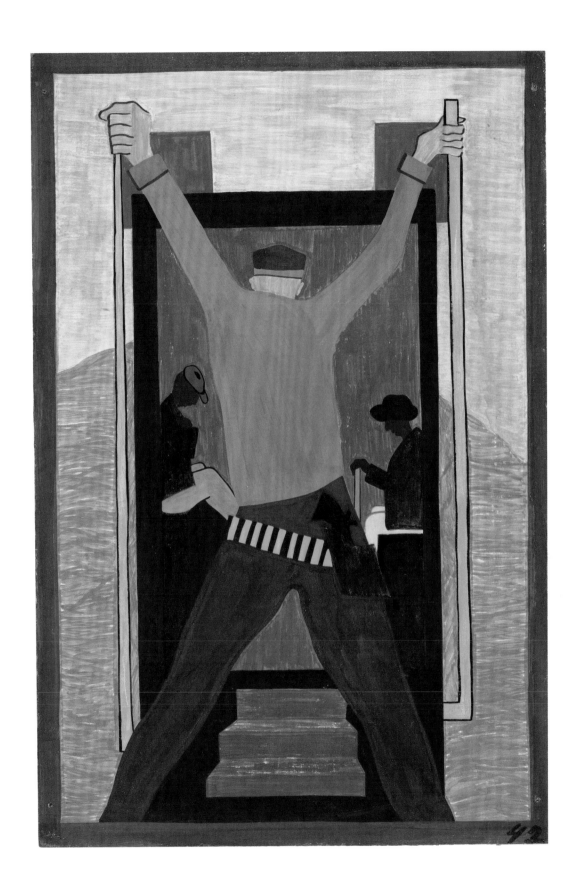

Panel 43

In a few sections of the South the leaders of both groups met and attempted to make conditions better for the Negro so that he would remain in the South. (1941)

In a few sections of the South leaders of both Black and White communities met to discuss ways of making the South a good place to live. (1993)

A white man holds forth, leaning forward and resting his weight on the table in front of him, which he uses as a rostrum. Behind him, African-American and white figures sit side-by-side, all dressed in suits and ties. The setting is a proscenium stage, on which a mixed-race committee faces a public audience for the negotiations at hand.

The degree of interracial cooperation shown here was a stark departure from the norm of Jim Crow. Debates about improving life for African-Americans in the South played out less often in community meetings than in newsprint; white reformers put pressure on their neighbors through articles listing the abuses that were prompting black Southerners to leave, including violence both threatened and real, low wages, poor housing, and inadequate education. Substantive changes, however, rarely took hold.[1] Facing a dwindling labor supply, Southern farmers and businesses themselves turned to the news media to lure blacks who had already moved north. Articles in both Northern and Southern press outlets painted a rosy picture of the South as a land of opportunity for those willing to return. In 1919, for example, the *Tampa Morning Tribune* extended offers to cover travel expenses from Chicago and other Northern cities: "Plenty of farm and mill work, better wages than ever before paid and improved living conditions await Southern negroes who have gone to the North," the paper promised.[2] Black migrants were largely unmoved. In an essay titled "Why Southern Negroes Don't Go South," published in the widely read social-issues journal *The Survey*, the secretary of Chicago's Urban League, T. Arnold Hill, voiced distrust of reports of a reformed South: "persuasion, suggestion, and subtle diplomacy" were being used "to stimulate a tide of return," Hill wrote, but "the promises of fairer treatment and unrestricted economic development are powerless because . . . Negroes know they are barren."[3]

1. See James Grossman, *Land of Hope: Chicago, Black Southerners, and the Great Migration* (Chicago: at the University Press, 1989), pp. 50–54.
2. "Negroes Who Come to South Are Better Off," *Tampa Morning Tribune*, August 24, 1919, repr. in Eric Arnesen, *Black Protest and the Great Migration: A Brief History with Documents* (Boston: Bedford, and New York: St. Martin's, 2003), p. 182.
3. T. Arnold Hill, "Why Southern Negroes Don't Go South," *The Survey* 43, no. 6 (November 29, 1919):183, 185.

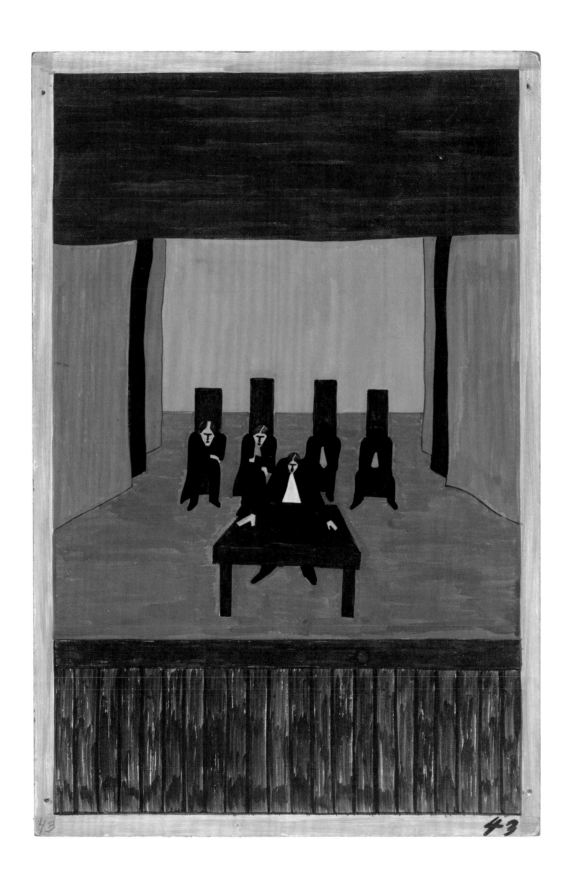

Panel 44

Living conditions were better in the North. (1941)

But living conditions were better in the North. (1993)

Painted in vibrant, fleshy red and creamy pink, a shoulder of marbled meat hangs heavy on a nail. Beside it is a hefty loaf of bread, sliced and ready to eat. The meat is a fine cut, far more expensive than the fatback at the center of panel 11, and it makes for a hearty meal, in stark contrast to the meager sustenance seen on the tables of black Southerners in panels 10, 16 and 30. This image of plenty portends a rich life in the North. It also evokes the Dutch old master tradition of still life painting, which produced sensuous images of food-laden tables for wealthy patrons. Lawrence could have seen Dutch still lifes on his visits to The Metropolitan Museum of Art.

Black Southerners in the North, many of them living for the first time without access to vegetable gardens, updated their cooking with store-bought ingredients. In cosmopolitan cities like Lawrence's New York, they found they could afford goods they had once considered sumptuous, such as choice cuts of meat and sugary baked goods. They also encountered exotic fruits, vegetables, and cooking methods imported from the other regions—including the Caribbean—represented in Harlem's rich population mix. Introduced to new recipes by new neighbors, they pulled from distinct cuisines to create new, hybrid strains of Southern food. Modern stoves and kitchens also changed the way Southern recipes were cooked. Food played a key role in preserving family and community connections: those still in the South often sent local delicacies to migrant friends and relatives in the North, new Northerners came back for holiday feasts, and the Southern flavors of meals prepared by migrant cooks in the North carried memories of home.

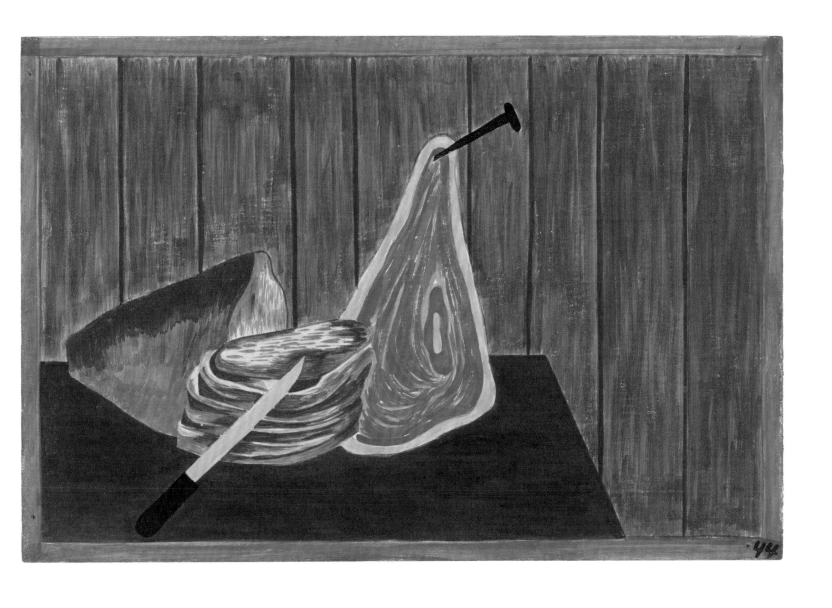

Panel 45

They arrived in Pittsburgh, one of the great industrial centers of the North, in large numbers. (1941)

The migrants arrived in Pittsburgh, one of the great industrial centers of the North. (1993)

The passengers in a train car chat animatedly, one man smiling broadly at his companion while a woman points excitedly out the window to pink and gray smokestacks—emblems of Pittsburgh's booming steel industry. The man behind her, entranced by his view of the city, fully turns his back on his companions. Two babies on their mothers' laps embody hopes for generations to come. At the center of the composition, a full picnic basket signifies meals shared en route, and hints at the origin of this family's journey in the South: prohibited from using the dining cars of segregated trains, black Southerners often packed food for their trips north. Lawrence's image suggests both the hope that fueled the migrants' journeys and the challenges they met on the way.

During World War I, major steel companies in western Pennsylvania for the first time opened their doors to African-American workers in any number. The lure of jobs drew thousands of black Southerners to the Pittsburgh area; the approximately 27,000 African-Americans who called the city home at the start of World War I saw their numbers triple to close to 82,000 by the mid-1940s.[1] This influx set the stage for a cultural florescence. Pittsburgh's Hill District, the city's most densely populated black neighborhood, suffered from overcrowding and a lack of public resources, but it also nourished a vibrant network of churches, nightclubs, ballparks, and other cultural venues. The *Pittsburgh Courier*, a weekly newspaper based in the Hill District, became a staple of the national black press, its readership and influence extending far beyond Pennsylvania.[2]

1. See Joe W. Trotter and Jared N. Day, "War, Politics, and the Creation of the Black Community," in *Race and Renaissance: African Americans in Pittsburgh since World War II* (Pittsburgh: at the University Press, 2010), p. 9.
2. Ibid., p. 20.

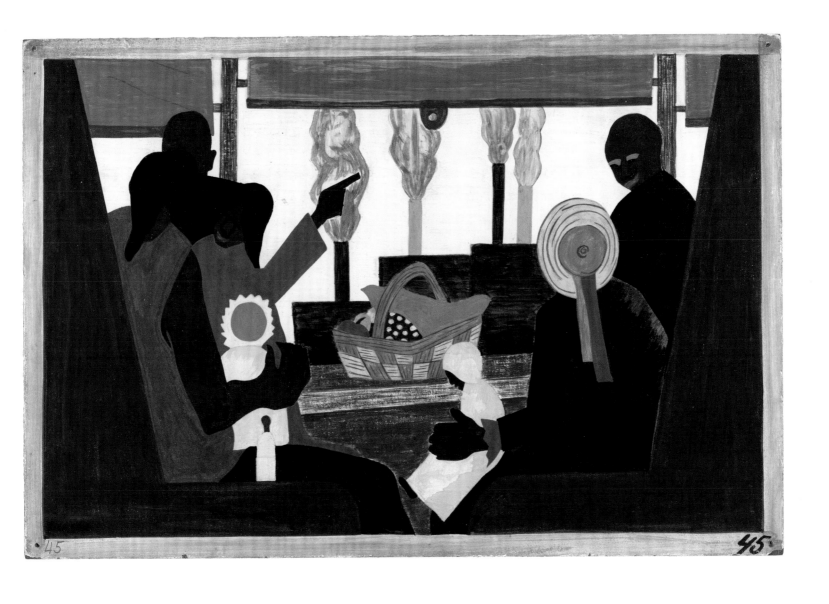

Panel 46

Industries attempted to board their labor in quarters that were oftentimes very unhealthy. Labor camps were numerous. (1941)

Industries boarded their workers in unhealthy quarters. Labor camps were numerous. (1993)

This image of workers' quarters is striking for its economy of means. Lawrence limits his palette to three colors—brown, dark green, and yellow—and uses only geometric shapes to delineate a dark, airless space. The arrangement of white-streaked rectangles along two converging diagonals transforms these abstract shapes into a staircase, the only escape from the depressing accommodations. At its top, a yellow circle that reads simultaneously as a doorknob and a beckoning moon is a poetic emblem of freedom and of a life beyond the limitations of the present.

In this and several other works in the Migration Series, Lawrence investigates the territory between abstraction and figuration. This combination of formal experiment and audacious subject matter surely captivated the directors of the two most prestigious collections of contemporary art in the United States in the early 1940s: The Museum of Modern Art, in New York, and the Phillips Memorial Gallery (now The Phillips Collection), in Washington, D.C. Alfred H. Barr, Jr., founding director of MoMA, and Duncan Phillips, founder of the Washington collection, recognized the importance of the Migration Series right away. Early in 1942, the gallerist Edith Halpert made Barr's praise of the work part of an ultimately successful argument to convince the philanthropist Adele Rosenwald Levy to purchase half of the panels for MoMA. Perhaps drawn to **panel 46**'s ingenious play between clear description and the formal study of geometric shapes, Levy was particularly fond of it—so much so that Barr wanted it included in the MoMA acquisition, a desire that informed the plan to divide the series by even- and odd-numbered panels. After MoMA acquired the even-numbered panels, Barr wrote to Levy to let her know that "the staircase picture you liked so much" had entered the Museum's collection.[1] Phillips happily added the odd-numbered panels to his own pioneering collection of contemporary art.

1. Alfred H. Barr, Jr., quoted in Diane Depfer, "Edith Gregor Halpert: Impresario of Jacob Lawrence's *Migration* Series," in Elizabeth Hutton Turner, ed., *Jacob Lawrence: The Migration Series* (Washington, D.C.: The Rappahannock Press in association with The Phillips Collection, 1993), p. 137.

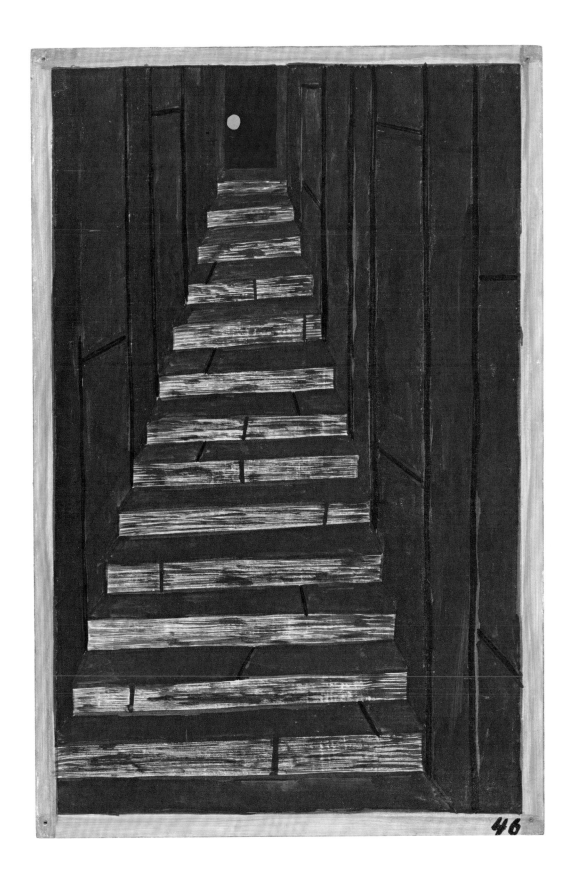

46

Panel 47

As well as finding better housing conditions in the North, the migrants found very poor housing conditions in the North. They were forced into overcrowded and dilapidated tenement houses. (1941)

As the migrant population grew, good housing became scarce. Workers were forced to live in overcrowded and dilapidated tenement houses. (1993)

The quilts and pillows that cover and comfort the sleepers in this panel bring swatches of vibrant color and busy pattern to a cramped room. Lawrence knew such housing conditions firsthand: he had spent most of his youth living in settlement houses in Philadelphia and a tenement apartment in Harlem. The artist's recollections of his childhood homes, and of those of his Harlem neighbors, however, highlight the lasting impact on him of residents' efforts to enliven their surroundings with colorful objects. "We lived in a deep depression. Not only my mother, but the poor people in general," Lawrence explained. "In order to add something to our lives, they decorated their tenements and their homes in all of these colors. . . . my artistic sensibility came from this ambiance It's only in retrospect that I realized that I was surrounded by art."[1]

Finding and maintaining decent living quarters in the North's wildly overcrowded black neighborhoods could be an ordeal. The politicians and landlords of big cities often conspired to confine black residents to particular areas—the Hill District of Pittsburgh, the South Side of Chicago, or New York's Harlem, which during the Migration years became one of the most densely populated black neighborhoods in the country.[2] As the populations of black communities grew, their apartments and homes were subdivided into claustrophobic, unsanitary, and overpriced living spaces. In Harlem, black renters often paid a third more than their white neighbors, although they earned significantly less.[3]

1. Jacob Lawrence, quoted in Henry Louis Gates, Jr., "New Negroes, Migration, and Culture Exchange," in Elizabeth Hutton Turner, ed., *Jacob Lawrence: The Migration Series* (Washington, D.C.: The Rappahannock Press in association with The Phillips Collection, 1993), pp. 20–21.
2. See Lonnie G. Bunch III and Spencer R. Crew, "A Historian's Eye: Jacob Lawrence, Historical Reality, and the Migration Series," in ibid., p. 28.
3. See Kimberly L. Phillips, *Daily Life during African American Migrations* (Santa Barbara: Greenwood, 2012), p. 63.

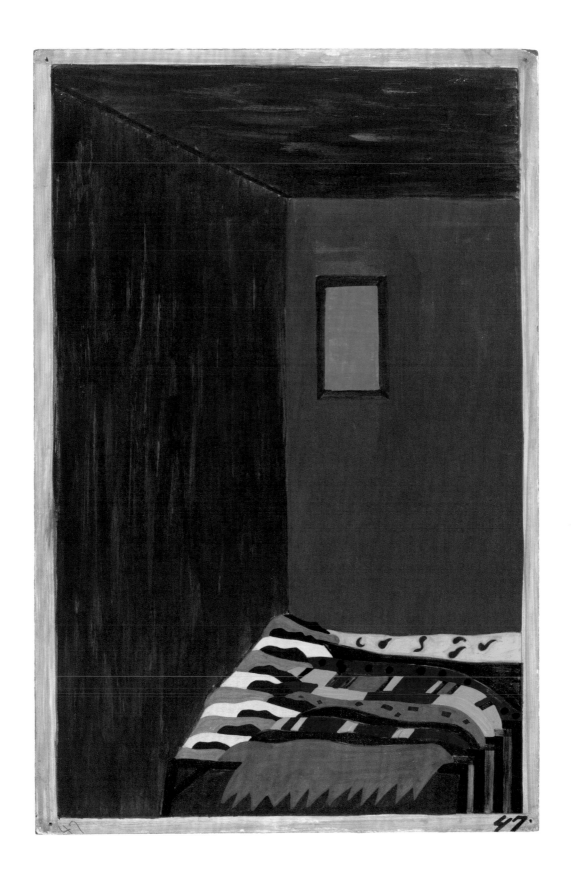

Panel 48

Housing for the Negroes was a very difficult problem. (1941)

Housing was a serious problem. (1993)

Like the previous image, this panel places the viewer inside one of the rooms of a shared residence. As though seated on a bed, the viewer peers through its frame—a rectangle of thick black bars that runs almost from top to bottom and side to side of the picture—into the room beyond, where other beds with barred headboards appear. Creating a dynamic interplay of horizontal and vertical lines, the repetition of the bedframes restates the use of bars as a visual motif earlier in the series (**panels 12, 22, 27, and 36**), insinuating a sense of containment and constraint. The luggage lying on the floor emphasizes the lack of personal space.

The overcrowded housing units depicted here and in **panel 47** echo hard-hitting depictions of the problem in contemporary artworks, novels, poetry, songs, and the press. Bigger Thomas, for example, the protagonist of Richard Wright's hugely popular 1940 novel *Native Son*, lives with his mother, brother, and sister in a rat-infested single-room apartment on Chicago's South Side, where Wright had lived for years. Langston Hughes's autobiography *The Big Sea*, published that same year, described the extortionate practices of landlords in black neighborhoods in Cleveland, where Hughes spent his teenage years: "An eight-room house with one bath would be cut up into apartments and five or six families crowded into it, each two-room kitchenette apartment renting for what the whole house had rented before."[1] In 1941, the blues singer Josh White recorded "Bad Housing Blues," which describes housing so terrible that it inspires political protest: "I'm goin' to the Capitol, goin' to the White House lawn," White sings, "Better wipe out these slums. Been this way since I was born." Shaped by each man's personal experience, the works of Lawrence, Wright, Hughes, and White draw attention to the living conditions of African-Americans across the country.

1. Langston Hughes, *The Big Sea*, 1940 (reprint ed., with an introduction by Arnold Rampersad, New York: Hill and Wang, 1993), p. 27.

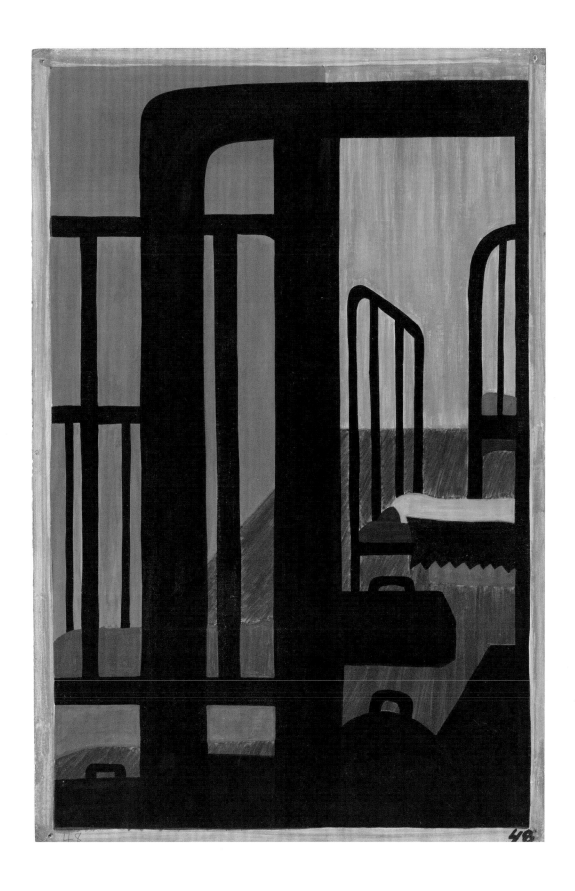

Panel 49

They also found discrimination in the North although it was much different from that which they had known in the South. (1941)

They found discrimination in the North. It was a different kind. (1993)

Divided in two by a bold yellow rope—white diners on the left, black ones on the right—this restaurant offers a stark image of segregation. Lawrence's caption insists that while racial discrimination in the North took different forms from Jim Crow, it was nonetheless keenly present. The prohibition of interaction between blacks and whites described in this painting would have struck Southern migrants as disturbingly familiar.

The black press, and the letters Southerners received from family and friends in Northern cities, often described the North as a haven of racial equality. It may indeed have seemed so by comparison with the South, but race relations above the Mason-Dixon line were far from idyllic. Segregated schools, public facilities, beaches, and even university dormitories were not uncommon in Northern cities. In Washington, D.C., in the 1910s, President Woodrow Wilson allowed cabinet members to segregate federal employees in their respective departments, setting a highly visible standard that provoked protest from prominent black leaders.

Even when local legal codes did not dictate segregation, social norms and expectations often did. Growing up in New York, Lawrence was familiar with this more subtle strain of racial discrimination. As a young artist, he was curious about New York's world-famous art collections but hesitated to wander alone outside Harlem: "One did not just go into galleries ... you could go into galleries, you could [go] into the museums, but you didn't feel that you were welcome. Physically you could go in, but you weren't going to be a patron, you weren't going to buy works of art."[1]

1. Jacob Lawrence, in an interview with Charlayne Hunter-Gault, *PBS Newshour*, 1995, rebroadcast June 13, 2000.

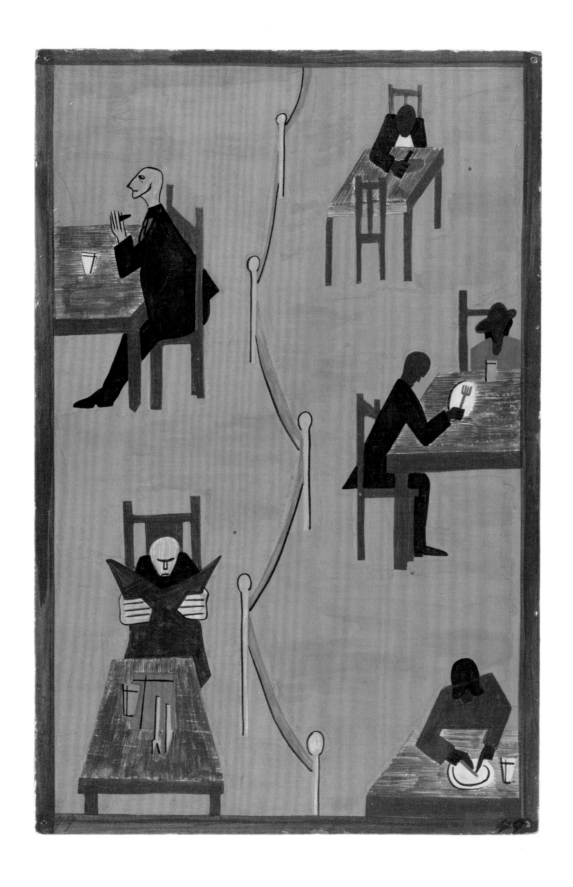

Panel 50

Race riots were very numerous all over the North because of the antagonism that was caused between the Negro and white workers. Many of these riots occurred because the Negro was used as a strike breaker in many of the Northern industries. (1941)

Race riots were numerous. White workers were hostile toward the migrant who had been hired to break strikes. (1993)

An angry red-headed white man raises a baton above his head to strike a blow. Behind him another man, this time black skinned, wields a wooden club, and a third yet farther in the distance holds a knife in his outstretched hand. Although each of these men raises a weapon with violent intent, their gestures echoing one another, they do not confront each other face to face and their victims remain unseen. The setting, which Lawrence bisects into a triangle of brown and a field of steely blue, offers no hint of any particular time or place. The panel evokes a sense of antipathy so blindly ferocious that it exceeds the specificities of a single conflict.

In this panel and the two that follow, Lawrence addresses the waves of racial violence that swept American cities after World War I. As demobilized white soldiers came home and found themselves looking for work in a changed racial landscape, anxieties about the Migration's impact on the economic and social structure of cities across the nation ran high. In the summer and fall of 1919, race riots exploded nationwide: within a few months, more than two dozen conflicts broke out in as many cities. Some clashes lasted just a few hours, but the most destructive— in Washington, D.C.; Knoxville, Tennessee; Elaine, Arkansas; and Chicago, Illinois—went on for days. The causes of the fights were said to range from labor conflicts to rumors of sexual assault, but their prevalence and intensity suggest that in many cases white attackers sought simply to remind blacks of their place on the bottom of America's economic and social ladder. By the end of the year, hundreds of people— the great majority of them black—had been killed and thousands had lost homes, property, and businesses. "Eight months after the armistice," noted the African-American writer and activist James Weldon Johnson, "there broke the Red Summer of 1919, and the mingled emotions of the race were bitterness, despair, and anger."[1]

1. James Weldon Johnson, *Black Manhattan*, 1930, quoted in Jan Voogd, *Race Riots and Resistance: The Red Summer* (New York: Peter Lang, 2008), p. 1.

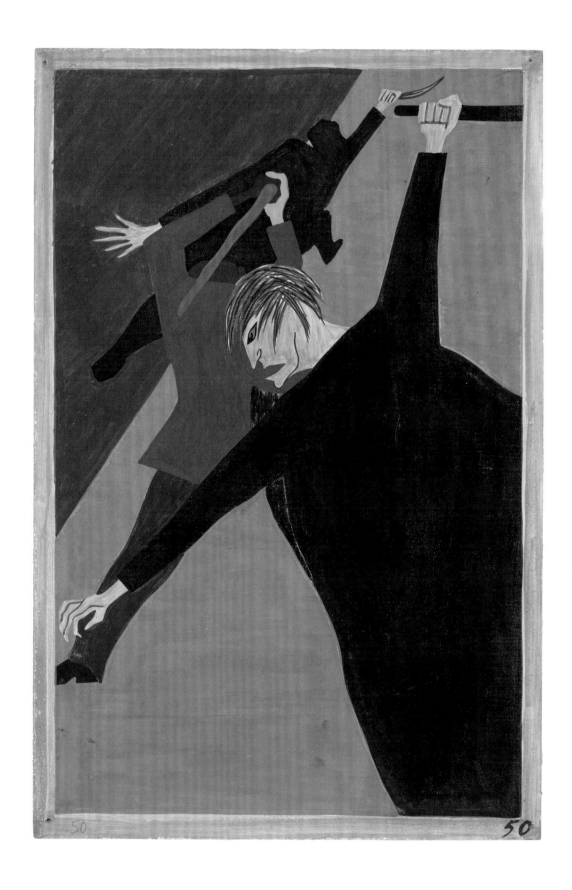

50

Panel 51

In many cities in the North where the Negroes had been overcrowded in their own living quarters they attempted to spread out. This resulted in many of the race riots and the bombings of Negro homes. (1941)

African Americans seeking to find better housing attempted to move into new areas. This resulted in the bombing of their new homes. (1993)

Explosive bursts of wild color and bright orange, yellow, and blue flames rise from buildings whose tight juxtaposition accentuates the architectural density of the urban North. Toward the bottom of the panel, a single room lit from within by a bright yellow light suggests the presence of an occupant. Other windows are darkened, at times shattered. Lawrence offers no hint of who is responsible for the bombing.

The specter of anonymous attacks on black homes in the North loomed large in the early years of the Great Migration. Unease over growing black populations, as the caption to this work highlights, was a key cause of aggression. As African-Americans moved into the Hyde Park–Kenwood communities of Chicago, for example, white residents protested loudly in community meetings, speeches, and newspaper editorials. Then violence erupted: between 1917 and 1921, fifty-eight bombings hit the homes of blacks who had dared to live in the area, as well as the homes and offices of realtors who had assisted them.[1] The most notorious manifestation of white anxiety, however, was more diffuse: in the late 1910s and the '20s, rates of participation in the Ku Klux Klan skyrocketed not only in the group's earlier base in the South but across the United States. In the Midwest, where intense industrial growth had attracted tens of thousands of black migrants, membership soared. Detroit alone housed more than 40,000 Klansmen, while the Indiana branch of the Klan was the most politically powerful in the nation. Hooded gangs regularly terrorized black neighborhoods from Rhode Island to Illinois, largely with legal impunity. In August 1925, the Klan organized a parade of about 50,000 people down Pennsylvania Avenue in Washington, D.C., putting the organization's strength, size, and national influence on full public view.

1. Chicago Commission on Race Relations, *The Negro in Chicago: A Study of Race Relations and a Race Riot* (Chicago: at the University Press, 1922), pp. 115–22.

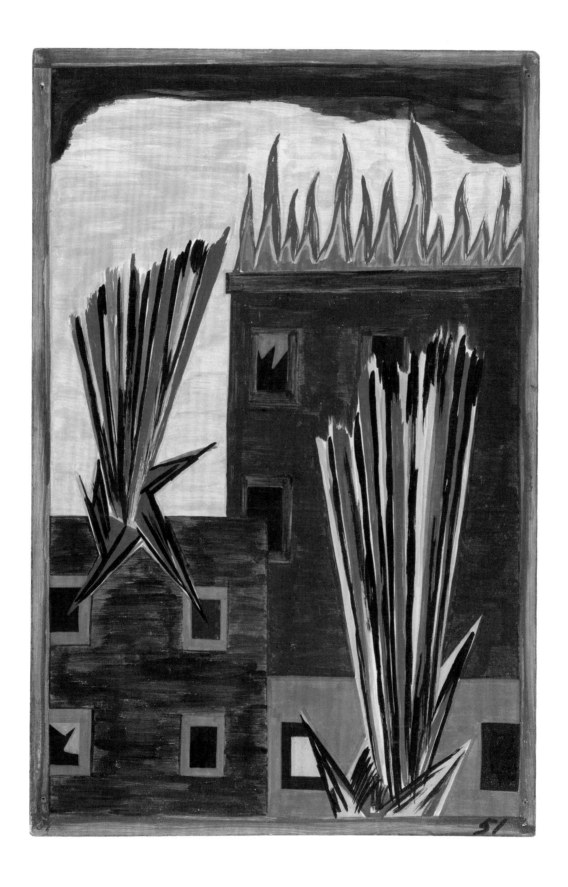

Panel 52

One of the largest race riots occurred in East St. Louis. (1941)

One of the most violent race riots occurred in East St. Louis. (1993)

An outsized body lies on the ground, stunned or dead. A black man holds the head of a white one in a viselike grip; his opponent reaches up with a knife. At center, a man in a yellow jacket raises a rod to strike an African-American on the ground. Bodies spread across the composition in a tumult of crisscrossing shapes: limbs bend at abrupt angles, are distorted in scale, and at times seem to go missing. This chaotic tangle of arms and legs, feet and hands, clenched fists and bulging eyes, defines a battle of blind rage and disorder.

The riots of 1917 in East St. Louis, Illinois, mentioned in Lawrence's caption were among the most destructive in the wave of racial violence that swept the country during and after World War I. The city's demographics had changed rapidly with the Migration: between 1916 and 1917, more than 10,000 black Southerners had moved to East St. Louis in search of wartime jobs.[1] Taking advantage of this newly available workforce, the Aluminum Ore Works Company began to hire African-Americans to break a protracted strike. On July 1, with tensions high over the labor dispute, the city erupted. The violence, aimed principally at African-American communities, left dozens dead and hundreds injured, and created a fortune in property damage; whole swaths of the city were burned out. Fearful for their lives, more than 6,000 black residents of East St. Louis fled. The uprising spurred protests across the country. In a speech in Harlem, the black activist Marcus Garvey called the riot a "massacre that will go down in history as one of the bloodiest outrages against mankind for which any class of people could be held guilty."[2] On July 28, 10,000 people joined a silent march down Manhattan's Fifth Avenue, holding signs demanding justice and equal rights for blacks across the nation.

1. "People & Events: The East St. Louis Riot," *American Experience. Marcus Garvey: Look for Me in the Whirlwind*, companion website to the PBS documentary of the same name, 2002, online at www.pbs.org/wgbh/amex/garvey/peopleevents/e_estlouis.html (consulted November 18, 2014).
2. Ibid.

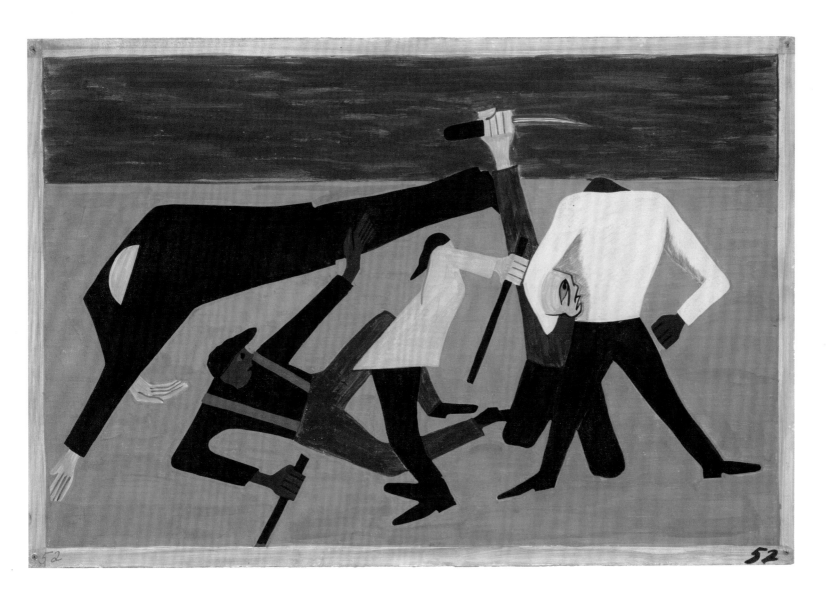

Panel 53

The Negroes who had been North for quite some time met their fellowmen with disgust and aloofness. (1941)

African Americans, long-time residents of northern cities, met the migrants with aloofness and disdain. (1993)

An urban couple poses in impeccable attire, she in an elegant patterned coat, matching hat, and fur stole, he in a long black coat and top hat. They are cloaked in affluence and sophistication. Couples like this did exist: their image resonates with photographs, paintings, and literary descriptions of well-heeled black New Yorkers during the Harlem Renaissance, a period of cultural florescence that coincided with the strong economy of the 1920s. The picture of luxury, they embody an economic and social status that inspired widespread faith in opportunities in the North.

Yet only a small minority of African-Americans commanded this level of prosperity. And among those in the North who did, the worry circulated that an influx of rural Southerners would undermine their relatively comfortable life-styles. "There was a great deal of elitism and snobbery," Lawrence would remember; "You'd had blacks living in the North for years since the turn of the century, . . . and many of the blacks coming from the . . . rural areas of the South were almost illiterate."[1] Both the child of migrants and the beneficiary of mentorship from prestigious longstanding New Yorkers, Lawrence was sensitive to these tensions. Yet he also saw cooperation take place between Northern blacks and migrants: in cities like New York and Chicago, for example, black professionals helped to create job-placement services for new arrivals from the South, and charity and relief organizations worked to ease the burden and stress of the move north. As migrants came to Harlem, Lawrence often noted acts of kindness among his neighbors.

1. Jacob Lawrence, quoted in Henry Louis Gates, Jr., "New Negroes, Migration, and Cultural Exchange," in Elizabeth Hutton Turner, ed., *Jacob Lawrence: The Migration Series* (Washington, D.C.: The Rappahannock Press in association with The Phillips Collection, 1993), p. 20.

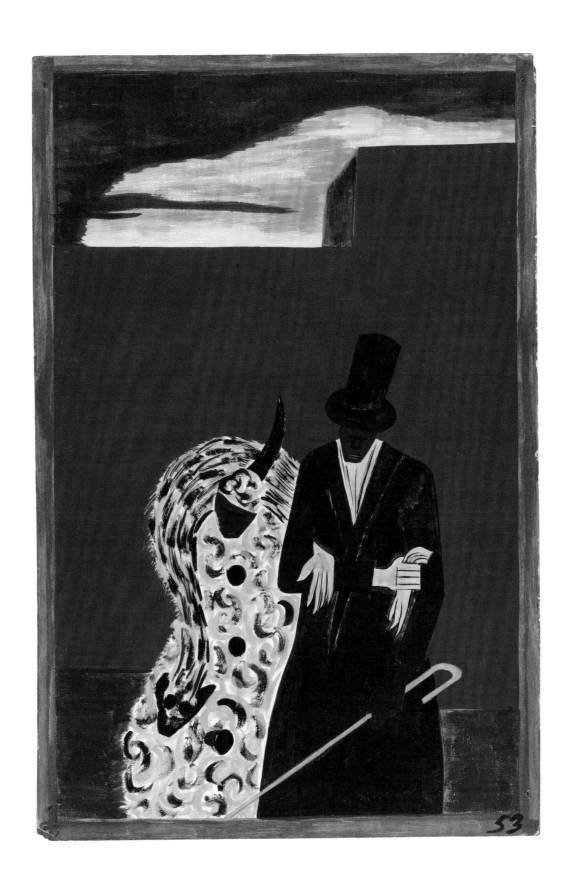

One of the main forms of social and recreational activities in which the migrants indulged occurred in the church. (1941)

For the migrants, the church was the center of life. (1993)

As we look across the pews of a church, the man and a woman closest to the aisle bow their heads reverently; a figure in the front row stares ahead attentively, perhaps listening to the sermon; the two men beyond him, visible only by the tops of their heads, turn to one another in friendly interaction. On the wall behind these rows of seated congregants is a large three-part mural depicting the cross, Christ's emergence from the tomb, and the Virgin Mary grieving. Such themes of persecution, transformation, and loss resonated with the experience of the migrants.

Black churches in the North swelled with new members during the Great Migration. Searching for community and comfort, Southerners both set up storefront churches in black urban neighborhoods across the country and joined the fold of established religious institutions. Between 1915 and 1920, for example, the congregation of Chicago's Olivet Baptist Church doubled. By the late 1930s, the membership of the Abyssinian Baptist Church in Harlem, which Lawrence attended from the time he arrived in New York in 1930, exceeded 10,000, making it one of the largest Protestant congregations in the United States.[1] Black urban churches catered to more than the spiritual needs of their migrant parishioners: as attendance grew, they became charitable relief stations, community meeting houses, daycare centers, and even employment offices. Adam Clayton Powell, Jr., who headed the Abyssinian Baptist Church's relief efforts before replacing his father as pastor in 1937, founded a credit union, ran a soup kitchen, opened the church community center to the homeless, and hired hundreds of needy workers to clean and maintain church premises.[2]

1. Abyssinian Baptist Church, entry for "1937" in "History of the Abyssinian Baptist Church," available online at http://abyssinian.org/about-us/history/ (consulted November 19, 2014).
2. See Timothy E. Fulop, "Abyssinian Baptist Church," in *Encyclopedia of African-American Culture and History*, 2nd ed. (Detroit: Macmillan Reference USA, 2006), p. 1:14, and Lenworth Alburn Gunther, III, "Flamin' Tongue: The Rise of Adam Clayton Powell, Jr., 1908–1941," PhD diss., Columbia University, 1985, p. 131.

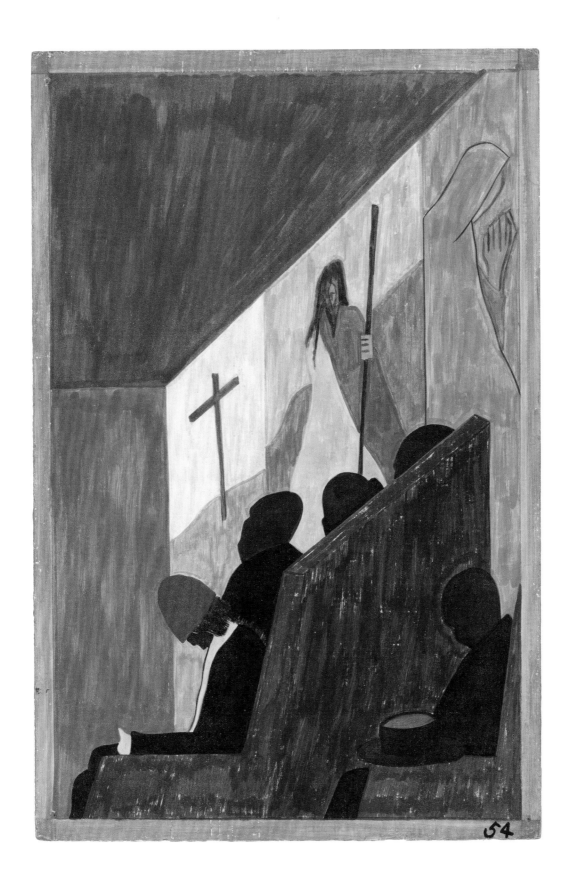

Panel 55

The Negro being suddenly moved out of doors and cramped into urban life, contracted a great deal of tuberculosis. Because of this the death rate was very high. (1941)

The migrants, having moved suddenly into a crowded and unhealthy environment, soon contracted tuberculosis. The death rate rose. (1993)

With faces downturned, heads covered in black hats, bodies cloaked in black capes, and hands in white gloves, three pallbearers move in solemn procession. Simplified to the point of anonymity, they serve as modern avatars of death. As Lawrence's caption points out, such grim callers were far too frequent visitors to black urban neighborhoods, where congested living quarters, and chronic lack of access to good health care, led to disproportionately high mortality rates. Tuberculosis in particular was a recurrent threat. Dissatisfied with the city government's response, black Harlemites found their own ways to fight this crisis. In 1920, the New York Urban League launched an Annual Health Campaign and Clean-up Week, during which preachers at black churches offered "health sermons" and volunteers distributed sanitation- and disease-related educational materials door-to-door. The Lower East Side's Henry Street Settlement Visiting Nurse Service affiliated with the Urban League offices and paid visits to thousands of Harlem homes, and the Harlem Tuberculosis and Health Committee delivered a wide range of services, including dental clinics for children. Community-run initiatives like these blurred the lines between health-care advocacy and political activism. Even so, in 1935, in the depths of the Great Depression, Harlem's tuberculosis rate was triple that of the rest of New York City.[1] Attuned to the inevitability of death, migrants to the urban North often set up burial societies that maintained the specific regional funeral customs of their Southern birthplaces.

1. Larry Alfonso Greene, "Harlem in the Great Depression, 1928–1936," PhD diss., Columbia University, 1979, p. 214.

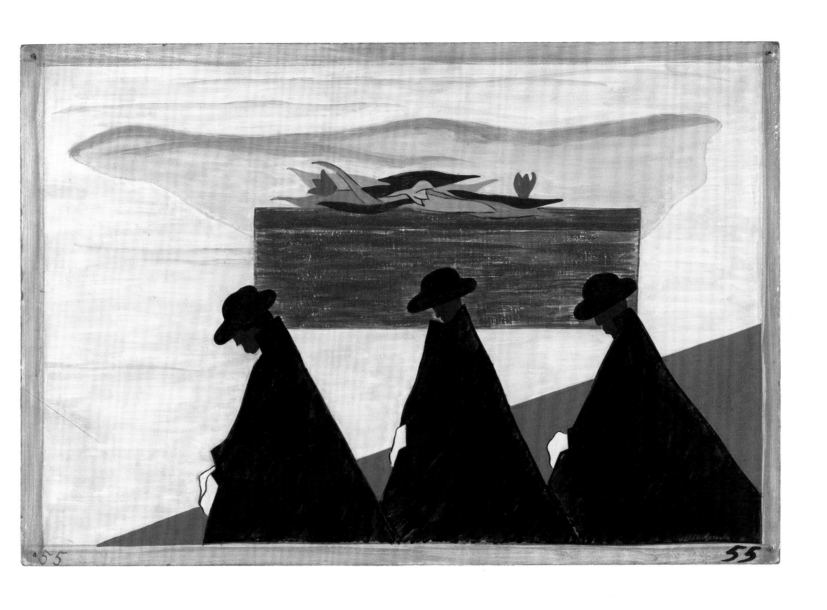

Panel 56

Among one of the last groups to leave the South was the Negro professional who was forced to follow his clientele to make a living. (1941)

The African American professionals were forced to follow their clients in order to make a living. (1993)

Lawrence sets this image of a black doctor practicing his profession in counterpoint to the previous panel, which depicts the funeral of a victim of tuberculosis. Equipped with his instruments—stethoscope, medical bag, and robe—the doctor leans over to examine a bare-chested patient. His imposing physique contributes to his air of authority, a stark contrast to the thin prone man he treats. He is enveloped in a triangular beam of bright light from an unknown source, like a divine spotlight reflecting the esteem in which he is held as a source of aid and care.

In the South, African-American professionals such as doctors, nurses, and lawyers were usually restricted to working with clients of the same race, and therefore tended to live in large cities with substantial black populations, such as Atlanta, New Orleans, Richmond, and Durham. Even in these metropolitan areas their success was hard-won: they often coped with insufficient supplies, a lack of staff, and a clientele base that could not pay for treatment. Yet they forged social and professional networks, developed loyalties to their patients, and earned a measure of financial success. As Lawrence's caption suggests, some of these men and women were accordingly ambivalent about the prospect of migration. Others, though, saw moving north as a way to expand their businesses by leaving the restrictions of the South behind. Black Southerners with specialized training—doctors and lawyers, but also writers, teachers, social workers, and ministers—quickly filled leadership positions in the North. The entry for Philadelphia in the 1927 issue of *Who's Who in Colored America* lists more Southern-born professionals than native Northerners, a statistic that held true for many Northern urban centers.[1]

1. See James N. Gregory, *The Southern Diaspora: How the Great Migrations of Black and White Southerners Transformed America* (Chapel Hill: The University of North Carolina Press, 2005), pp. 28, 121–22.

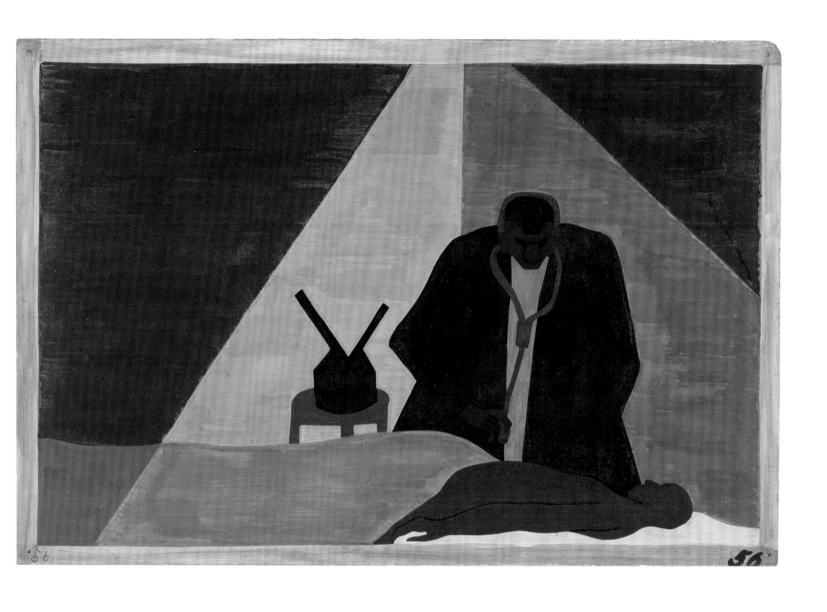

Panel 57

The female worker was also one of the last groups to leave the South. (1941)

The female workers were the last to arrive north. (1993)

Immersed in a jigsaw puzzle of colorful rectangles—simplified representations of textiles hung to dry—a laundress stirs a sea of fabric in a massive vat. Besides working as a study of shape and hue, her shadowy environs suggest that the scale of the job at hand far surpasses typical domestic work: perhaps this woman works in a laundry, or perhaps she has taken in clothes and linens from multiple clients, increasing her workload to near-unmanageable proportions for extra funds. Paid paltry wages, many female domestic workers in the South had to cobble together odd jobs to make ends meet.

Labor shortages during World War I allowed migrant women to find better jobs in the North. They worked at garment-industry sewing machines, packaged goods for shipping, and even took care of lumber and rail yards.[1] This shift in the demographics of labor was significant enough to prompt the black journal *The Crisis* to report proudly in November 1918 that "an army of women is entering mills, factories and all other branches of industry."[2] But as men returned from overseas at the end of the war and the rate of American industrial production slowed, black women were the first to lose their jobs. A decade later came the Great Depression, when unemployment rates among African-American women were particularly high, soaring to around 40 percent.[3] Finding their struggle for financial security no easier in the North than in the South, many went into private domestic work. Those unable to find regular employment often congregated on urban street corners at what were known as "slave markets"—sites where white women could hire a black worker for a temporary stint as a maid, cook, or caretaker, bargaining her pay down to the lowest rate possible.[4] One of the largest of these "slave markets" was in the Bronx in New York City, not far from Lawrence's home in Harlem.

1. See Eric Arnesen, *Black Protest and the Great Migration: A Brief History with Documents* (Boston: Bedford, and New York: St. Martin's, 2003), pp. 7–9.
2. Mary E. Jackson, "The Colored Woman in Industry," *The Crisis* 17, no. 1 (November 1918):12.
3. See Robert L. Boyd, "Race, Labor Market Disadvantage, and Survivalist Entrepreneurship: Black Women in the Urban North during the Great Depression," *Sociological Forum* 15, no. 4 (December 2000):648 n. 3.
4. Ibid., pp. 648–50.

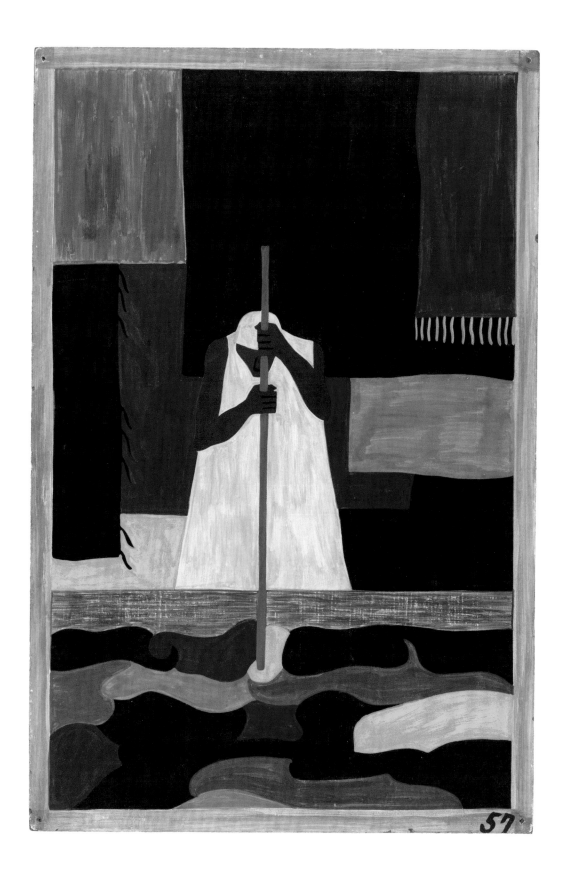

Panel 58

In the North the Negro had better educational facilities. (1941)

In the North the African American had more educational opportunities. (1993)

Reaching with arms stretched high to write numbers on a large clean chalkboard, these three girls embody the aspirations of thousands of Southern migrants. Their bright dresses and adequately supplied classroom suggest that these students enjoy a standard of living comfortable enough to let them focus on school work. Lawrence's picture of an education-focused childhood in the North contrasts sharply with his depiction of underage labor in the South in **panel 24**, in which bare-chested children work in cotton fields under the sun.

Doubly disadvantaged by crippling poverty and ill-equipped schools, few black children in the South had access to good-quality, long-term education. Local and state governments granted only paltry resources to black public schools, making children face overcrowded classrooms lacking basic books and supplies. Teachers were underpaid, undertrained, and overworked. In 1917 there were only sixty-four black public high schools in the entire South, most of them in major cities.[1] Until World War II, rural black children often went to school for no more than three to six months a year, spending the rest of the time working at home or on farms to help support their families.[2] In letters to the Urban League, black newspapers, and potential employers in the North, hopeful migrants in the South often cited better schools for their children as key to their desire to move. "Your name have bin given me as a Relibal furm putting people in toutch with good locations for education there children," wrote a Mississippi man to the Chicago *Defender* in 1917. "I have a wife and seven children 5 girls and 2 boys allso I am a preacher.... I want to raise by family nice and I would like for my children to have the advantage of good schools and churches."[3]

1. See Robert A. Margo, *Race and Schooling in the South, 1880–1950: An Economic History* (Chicago: at the University Press, 1991), p. 20.
2. See Michael Fultz, "Teacher Training and African American Education in the South, 1900–1940," *The Journal of Negro Education* 64, no. 2 (Spring 1995):196.
3. In Emmett J. Scott, ed., "More Letters from Negro Migrants, 1916–1918," *Journal of Negro History* 4, no. 4 (October 1919):436.

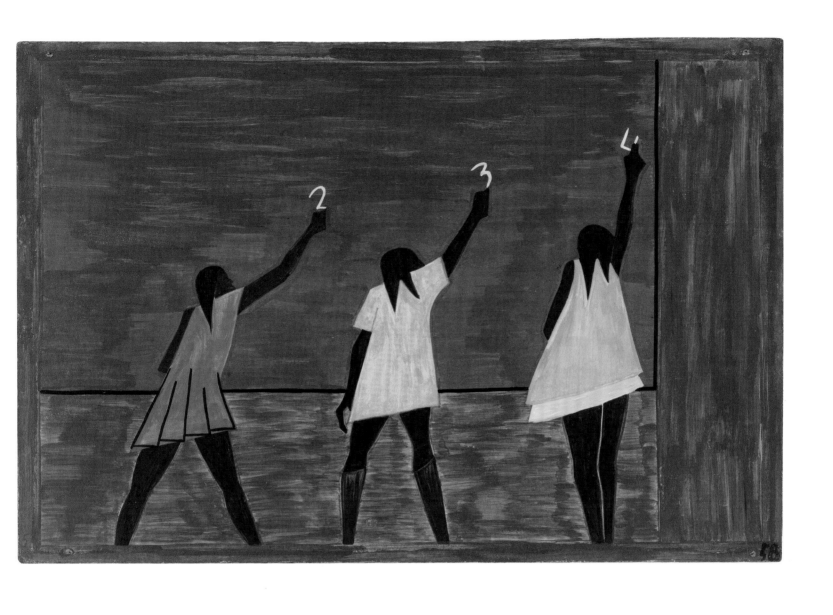

Panel 59

In the North the Negro had freedom to vote. (1941)

In the North they had the freedom to vote. (1993)

A long line of men and women stands patiently, waiting to vote. Beside them two figures sit at a table to deal with the paperwork of the process. The only white figure, a nightstick-wielding guard stationed at the entrance to the voting booth, is an intimidating presence, but he does not interfere with the African-Americans' procession to the polls.

This depiction of orderly voting procedures in the North contrasts starkly with the systematic disenfranchisement of black voters in the South during the Migration years. Between the 1880s and the 1910s, Southern states enacted a range of laws that essentially annulled the right to vote that had been constitutionally guaranteed to African-Americans by the Fifteenth Amendment of 1870. The adoption of a "grandfather clause," for example, allowed state officials to deny suffrage to anyone whose grandparents had not registered to vote before the end of the Civil War. In practice the rule barred most black citizens from the polls. Literacy tests required voters to read and interpret passages from official documents, such as a state constitution, to the satisfaction of white officials; no matter their level of education, black Southerners almost always failed these tricky tests. Poll taxes and property requirements also kept poor blacks out of voting booths. So effective were these restrictions that in 1940, only about 3 percent of black Southerners were registered to vote.[1] For many migrants, settling in the North brought with it a first taste of political empowerment. Areas with dense African-American populations, like Harlem in New York and the South Side of Chicago, formed congressional districts with black majorities, launching national careers for black politicians like Adam Clayton Powell, Jr., and Oscar De Priest.

1. See Howard Dodson and Sylviane A. Diouf, *In Motion: The African American Migration Experience* (Washington, D.C.: National Geographic Society, 2004), p. 151.

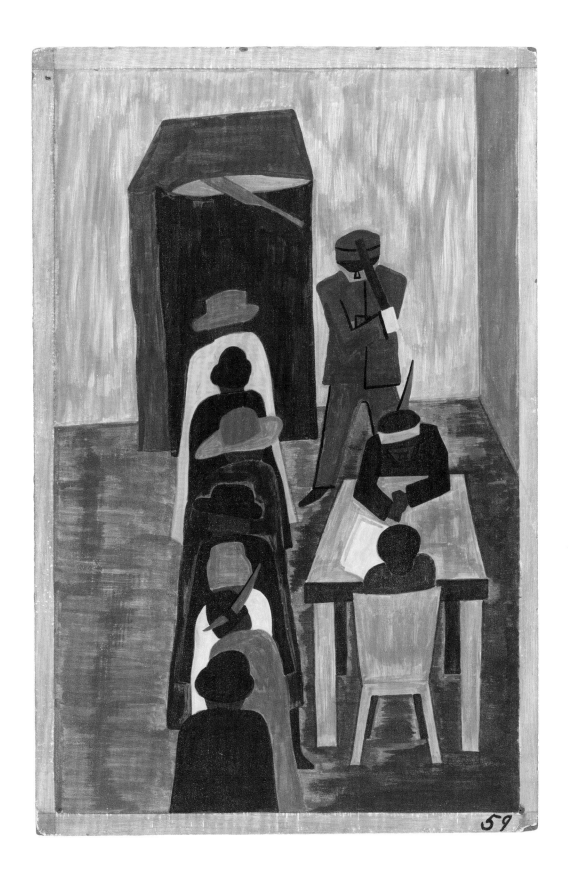

Panel 60

And the migrants kept coming. (1941)

And the migrants kept coming. (1993)

In the last panel of the Migration Series, Lawrence returns to the visual refrain that punctuates the work as a whole: once again we see a crowd of anonymous black figures filling a railroad station. Packed shoulder to shoulder across the full width of the panel, the migrants stand on a platform with their bags and suitcases, waiting to pile into the next train. The caption, "And the migrants kept coming," ends the series on an elliptical note: the rush of black Southerners into the North, Lawrence suggests, will continue well into the future. Poetic in its brevity and evocative tone, the artist's short phrase brings to mind Sterling Brown's 1931 poem "Strong Men," an homage to African-American resiliency after centuries of oppression: "They cooped you in their kitchens/They penned you in their factories/They gave you the jobs that they were too good for," writes Brown. "One thing they cannot prohibit/The strong men . . . a-comin on/The strong men gittin' stronger."

As Lawrence had predicted, the Great Migration continued long after he finished his series. Southerners found new reasons to leave their homes after World War II, as renewed economic growth added thousands of jobs to the payrolls of major industrial companies in the North and the West. Over the next two decades, the continued movement of African-Americans northward transformed the nation's geographies of race. In 1900, only 8 percent of the country's African-American population lived above the Mason Dixon line; by 1970, 47 percent of black Americans lived outside the South.[1] The Migration's momentum abated only once the watershed cultural and legal reforms of the Civil Rights era began take effect in the South, putting an end to the segregation of public accommodations and schools, prohibiting restrictions on voting rights and other civil liberties, and opening new paths to economic opportunity. But the accomplishments of community leaders, student organizations, politicians, and other advocates of racial equality in the 1950s and '60s would in many ways have been unthinkable without the example set by the millions of black migrants in previous decades. In leaving their homes, black Southerners collectively took a stand against the enforcement of racial discrimination that had plagued their social, political, and economic well-being for centuries.

1. James N. Gregory, *The Southern Diaspora: How the Great Migrations of Black and White Southerners Transformed America* (Chapel Hill: The University of North Carolina Press, 2005), p. 18.

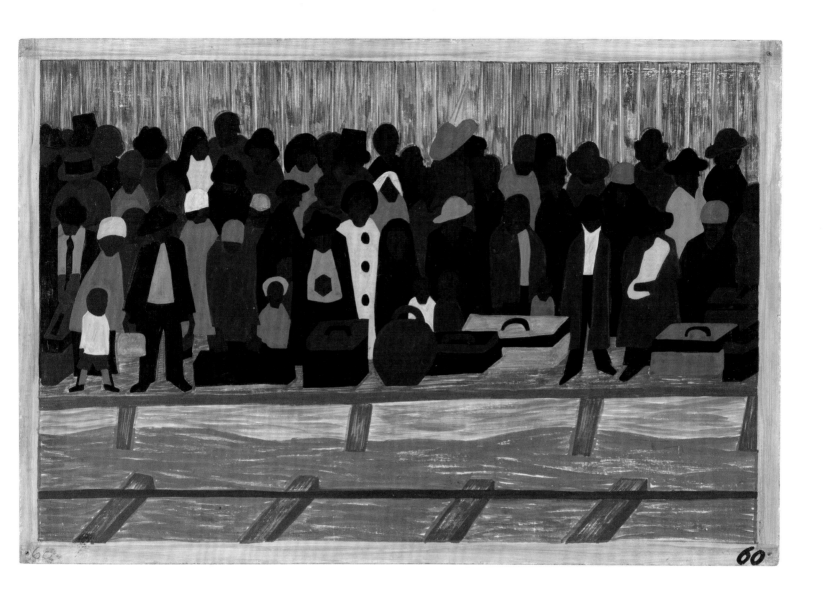

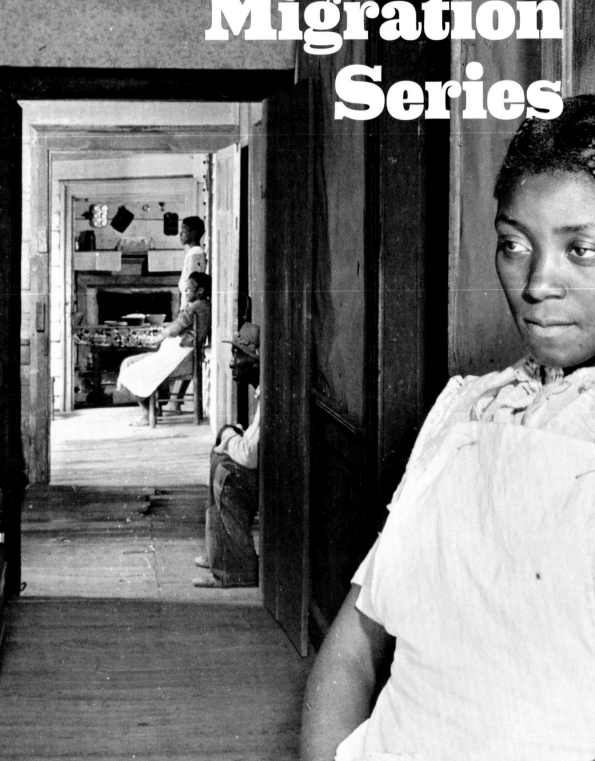

The Migration Series

Poetry Suite

The poets' people come from Alabama, Mississippi, Arkansas, Louisiana, South Carolina. In some generations they moved to Akron, Detroit, Topeka, Decatur. The poets today are found everywhere, in Georgia, South Carolina, Virginia, New York, New Jersey, Maine, Pennsylvania. The poets are the descendants of the 6 million or more black people whose migration, according to Nicholas Lemann, constituted "one of the largest and most rapid mass internal movements in history" and shaped America evermore.[1]

By commissioning these ten great poets to write new poems in response to Jacob Lawrence's Migration Series, I imagined that as Lawrence looked to the Souths within him to paint his mighty panels from Harlem, so, too, these American poets might discover something poetically new in themselves that Lawrence's work would call out. There is the Great Migration itself, and the complex and indelible social shifts it engendered. But then there is the art, and that is of course what we see here in Lawrence: not documentary or history, per se, but rather art born of an extraordinary shift in history, carried in the bodies of our people. Art, as well

Jack Delano. *Interior of Negro Rural House, Greene County, Georgia.* 1941. Gelatin silver print, 10 11/16 × 13 11/16" (27.2 × 34.8 cm). The Museum of Modern Art, New York. Purchase

as history, inspires and gives birth to new art. What poems might be born from deep engagement with Lawrence's art?

The rich African-American ekphrastic tradition begins with Phillis Wheatley's "To S.M., A Young Painter, on Seeing his Works" (1773) and moves through Robert Hayden ("Monet's Waterlilies," 1966); Gwendolyn Brooks ("The Chicago Picasso" and "The Wall," both 1967); June Jordan, and her book-length children's poem *Who Look at Me* (1969); and Ntozake Shange, whose *Ridin' the Moon in Texas: Word Paintings* (1988) is a series of conversations with art made by friends of hers, such as the late Ana Mendieta. The tradition includes poems by many of our contributors herein: Rita Dove's poem in response to Christian Schad's 1929 painting *Agosta, the Pigeon-Chested Man, and Rasha, the Black Dove*; Kevin Young's book-length meditation on Jean-Michel Basquiat, *To Repel Ghosts*; Natasha Trethewey's *Bellocq's Ophelia: Poems*; and Patricia Spears Jones's earlier poem on Lawrence, "To the Builders," to name a few.

Hayden wrote a poem on John Brown to accompany an exhibition of Lawrence's John Brown series when it was shown at the Detroit Institute of Arts in 1978.[2] But there is no body of poems inspired by this iconic and familiar painter's work that speaks to the experience of migration,

Introduction by Elizabeth Alexander

which in some way most African-Americans share. I think this gap is in part explained by the narrative burden on African-American visual, literary, and performing artists. When black art engages narrative it is sometimes undervalued as a version of the greatest story ever told, doing the work of history instead of art, with cruder tools. I also think there is a formal, compositional issue that has left an opening for new Lawrence poems: when a poet engages with art in which the narrative work has in fact already been done—when seriality is already in place, as it is so powerfully in the Migration Series—there can seem to be, for the poet, a closed door of entry, as though the whole story had already been told.

We can be fooled by the historical and serial aspects of Lawrence's work, neglecting to see how it is also open-ended, inventive, allusive, fascinatingly strange. What happens when we look at the paintings one by one and unlace them from their context? What happens when a poet writes between the frames? For this project we commissioned a group of highly esteemed African-American poets to make new poems responding to the Migration Series. In the difficult task of choosing—there could easily be 100 poets apt for this job—I considered generational, geographic, and aesthetic diversity and different relationships to various regions of the South and their attendant migrations. I wanted there to be an occasion for the poets to mine their own relationships to migration, for so many of those stories are endangered and narrators are dying out. I knew, also, that some would not turn to the personal explicitly and would rather see the paintings for us as poets uniquely "see."

Personal history and collective history feed into poetry. The initiating premise of this extraordinary suite, by some of America's most extraordinary poets, is that art begets art and influence crosses art forms. We have here new American poems, another indelible piece of this American epic that continues to live and reveal itself.

Along with my fellow poets, this project furthered my own thinking, in particular of my maternal grandparents, who began life in Selma and Tuskegee, Alabama, and came to Harlem, U.S.A., around the time Lawrence did, with hopes and sorrows, suitcases and stories, some of which I know, some of which my own art may imagine, and some of which are lost forever.

Notes

1. Nicholas Lemann, *The Promised Land: The Great Black Migration and How It Changed America* (New York: Knopf, 1991), p. 6.
2. Jacob Lawrence and Robert Hayden, *The Legend of John Brown* (Detroit: Detroit Institute of Arts, 1978). I am grateful to George Hutchinson for calling this poem to my attention.

Poems

Yusef Komunyakaa

The Great Migration

Where's the forty acres & a mule
 in the long, great getting-up
 morning? sharecroppers

asked the sun hidden by cotton
 & pulpwood. Hawkish agents
 from the northern factories

trekked into Jim Crow twilight
 between promise & no way
 as farmers questioned soil

under fingernails, the knowhow
 of dreaming in the hot shine
 of blast furnaces up there.

They crossed lines drawn in dust,
 huddled in trains racing trees.
 Blues hitched a ride, washed out

of overalls & jumpers, threadbare suits
 & floral dresses, & flour-sack gowns
 bleached translucent by runagate

skies at noontime. As the trains
 jostled along winding tracks, tales
 of the North Star & rivers to cross

unstitched beneath heavy eyelids
 till the electric hum of big cities
 shone under the night's hardscrabble.

A tug of the line, a fish story on the hook
 snagged. The steel mills, foundry smoke
 & hiss, stockyards, packing houses,

Rock Island Line an unending song
 unwound like a spool of red thick
 thread in the sluggish dawn.

Someone carried the pattern
 of squares & triangles hand sewn
 into a circle & passed down.

The unborn rode the rail for free.
 Some could still see the sanctified
 taken down to the muddy river.

Cuttings, sprigs, & potato vines,
 took root in half-gallon tin cans
 facing the sooty south windows.

Ragged tunes in their heads flowered
 in all-night cabarets & speakeasies
 up & down the eastern seaboard.

Shellshock & mustard gas in trenches
 followed home some soldiers
 who danced the lindy hop

with the newcomers, while others
 called them breakers, as work
 took another life in the word

& deed of porters & superheroes
 in the movies or on the radio,
 forgetting the eleven-foot long

cotton sacks, as they strolled down
 tree-lined boulevards & avenues,
 & ghosts from the old country

hung out on street corners
 drawn to a drifting harangue
 of field hollers in the snow.

Crystal Williams

Year after Year We Visited Alabama

~After Jacob Lawrence's "There Were Lynchings"

The past has long legs & is heavy, which was a kind of warning —
stay clear of the enormous twisted tree on Tidwell Hill.
To we cousins the tree seemed fabulous, a grand old heron,
wings stroking eternity, the southern vista beneath it so soft
& innocent, so dramatically green. We were dazzled. From there
our lives unfurled hypnotically before us: we could be
doctors & principals, actresses & mayors. We wanted to escape
their watchfulness & murmurings, their relentless apprehensions
that seemed to want to reign everything about us in, our unruly hair,
our clothes, & our brash voices & sauce, even our childlike curiosities.
So we'd climb up, lay on Daisey's ancient red quilt, play word games,
dream up novellas about a mutant boll weevil named Boll Winkle,
lament missing summer in Detroit with our friends. Truthfully,
we thought they were too southern, too old school,
overly full of moon-gloss & doom. In our imagination,
the past had no place among us, certainly didn't have
heavy legs, wasn't resting on our shoulders, & wasn't hanging
from a twisted tree. We also mistook their burgeoning pity
for disapproval, the weight, the growing tightness in our shoulders
as ephemeral & of only that place.

Nikky Finney

Migration Portraiture

North
"When the subject

First time Colored could sit on something moving fast for free, ride
the shoe leather of the train all the way up to men standing on Harlem
corners with faces like ours, they, moving along in a white man's coat
never nodding back our way. Cotton still stuck in their shoes, *Zoots!*
waiting to be shipped back to green pastures. (60)

South
is strong

The snapped bloody rope the undertaker pulled off my Jack's neck is
wrapped around my little girl's depot suitcase like a wedding garter,
tight, *Recognize*, I tell her. *De camp from the field, learn to read blood on
a rope like an encyclopedia, then Get!* Persimmon hat pushed back
sideways on her little head, pencil eyes pointing *that a way.* (60)

South
simplicity

From Mexico to Carolina they tore through cotton like beetles from the
Bible. We human boll weevils sally forth now, ready to land in a new
northern field, push our long snouts down into the bud of something fat
and sweet and suck. A three-lettered poison will help the cotton ride the
rails back. What about dusty black us? (60)

North
is the only way to treat it." Jacob Lawrence

Mama hammers hot steel pretending she is a man in a heavy heat suit.
Her baldhead and sexless hands pay for coal and bread and new books.
On the new fire escape she whispers and smokes, *I didn't come all this way
to clean and polish another white house*, then asks me to memorize her new
northern words, *Flying & Dutchman.* (60)

Terrance Hayes

"Another Great Ravager of the Crops Was the Boll Weevil"

By mid-1921, the boll weevil had entered South Carolina. In a
1939 interview for the Federal Writers' Project, South Carolina
native Mose Austin recalled that his employer was adamant
"he don't want nothin' but cotton planted on de place; dat he in
debt and hafter raise cotton to git de money to pay wid."
Austin let out a long guffaw before recounting, "De boll weevil
come … and, bless yo' life, dat bug sho' romped on things dat fall."

Right now, when I should be considering the tracks
Of black folk slanting in fast drying tempera,

I am picturing a brood of boll weevils migrating to the U.S
In bales of Mexican cotton or maybe in the bowels

Of the great Galveston hurricane or the ears
Of four apocalypse horses or maybe hidden somewhere

On an industrious industrial train traveling from one corner
Of the south to another around the time sharecroppers

And other restless black folk figured it was time to head north.
You can probably hear me humming Lead Belly's

"Boll Weevil Blues." Sometimes an image leads to a tune.
The boll weevils Jacob Lawrence painted are little more

Than silhouettes, but a southern landowner would have
Recognized them as symbols of bad luck, bold evil,

The money eaters. The boll weevil's scientific name,
Anthonomus grandis, sounds like "Grand Anonymous"

Which is as good a name as any for a force that sows
Trouble wherever it roams. "Just a-lookin' for a home,

Just a-lookin' for a home," is a common refrain
In a dozen or so different Boll Weevil songs.

They crossed the Cotton Belt ravaging about sixty miles a year
And reached the Carolinas long before I was born,

But I wouldn't know them from the raspberry weevils
Or apple blossom weevils or the weevils that share

My appetite for corn. I have never talked with a boll weevil,
But when I hear crickets cricketing, I know insects

And creatures like us basically ponder the same things:
Solace, survival, multiple genres of longing.

I remember how seeing a white woman walking alone
A few steps ahead of me late one night spooked me

So much I slowed and cast a harmless warble
Into evening. Sometimes even at a distance,

I know what unsettles this country can also unsettle me.
Sometimes fear tells us exactly where we are heading.

Lyrae Van Clief-Stefanon **Migration**

> . . . *if I see something happening*
> *which I like, I let it happen. . .*
> *-Jacob Lawrence*

Black is an ardor.
 Color moving as
 wholeness—yellow migrates blouse to light handle to bell green
 migrates button to satchel to wall blue migrates coat to sea to night
sky—finds an order. Black is

an ardor
 of smokestack cirrus birdflight
 blanket
 boll stem. Against spikehead
 slipper judgerobe nooserope—: Hair.

 Fatback sliced on a table is a block

of pink stripes falling
 open as a story's pages
 bout to be sliced and served.
 Please, pass me the last bit

of summer. August's green
 glide into overlays of gold
 shivers of goldenrod borders against a shirring sun-gilt pond.
 Here I sit. See

if you can't find Jacob's process
 in the snake-anxious way I crossed the grass
 to get at shade—
 I'm still southern—
 in the silvergrey whisper of underleaf
 the breeze brings up.
±

 Green is a table
 upon which that narrative of pig
 and hunger sits until green

 is the sky at the top of
 a labor camp stairwell
 holding the moon. Or

is green the door the yellow
moon a large bright knob
to turn to exit these quarters?

±

 I'm dying to say each soul

almost isosceles

 in her flair, in his onward press
 slants in slant rhyme to Mississippi's mouth—

 if I'm lying, I'm dying

to count every dropped leaf

 every spent petal towards black potential—
 say pre-

 historic swamp heat—
 peat—process: fossil fuel—

 to make a seam—

 the total black pealing
 outside St. Louis all week

 blue
 hard repetition.

±

Write about movement where it is most still.

 Black
 is arduous: in riot a raised baton in burning
 building what's behind the cracked window.

±

 Yellow a question
 of travel of red or orange alerts—:

key suddenly
 something from the bottom of the pond

 something as simple as caution or koi—:
 at first one giant until the vibrancy beneath the surface splits.

 It's forty fish making that orange glide/divide.

 You realize—
 and one flips its silver-bellied self out of the water— praise your

recognition
 belied.

±

The SWAT van that appeared suddenly and sat for twenty minutes outside your house drove
you from porch to pond. You wondered where a sister might find some peace though you know
you never use the word sister like that. You wrote *where I sister might find some peace* then revised
it. You're telling the truth—a correction. The I in you corrects. It rises like something from the
deep. You're not even at the pond anymore but still you want to feel outside like you want to
write rise over run. You're in a rush to work some delta in

<div align="center">if you're me</div>

±

dirt moves you. In music the dirty
writhes you further into the writing—
prof you are the proof is in the Plies
though it's hard to admit. How his
What that mean tickles your that
means you—recognize.

<div align="center">*What you do to me baby*
it never gets out of me</div>

You want him in the picture so write him too
through Jacob's rows. Like flames of green
crop streak squashblossomed color stripes soil
go with your ratchet— *Negro*

<div align="center">*who had been part of the soil...*</div>

now going into and living a new life in the urban
centers—

<div align="center">go with what moves you.
What you do
to me baby it never gets out of me</div>

Three pigtailed black girls at a chalkboard reaching

<div align="center">...2...3...4... for I</div>

Oh but the getting out—

Tyehimba Jess

Another man done...

Another of the social causes of the migrant's leaving was that at times they did not feel safe, or it was not the best thing to be found on the street late at night.
They were arrested at the slightest provocation. (1940-41)
Another of the social causes of the migrant's leaving was that at times they did not feel safe, or it was not the best thing to be found on the street late at night.
They were arrested at the slightest provocation. (1941-42) *that at times they did not feel safe, or it was not the best thing to be found on the street late at night.*
They were arrested at the slightest provocation. (1942-43) *that at times they did not feel safe, or it was not the best thing to be found on the street late at night.*
They were arrested at the slightest provocation. (1953-54)
Another of the social causes of the migrant's leaving was that at times they did not feel safe, or it was not the best thing to be found on the street late at night.
They were arrested at the slightest provocation. (1954-55)
Another of the social causes of the migrant's leaving was that at times they did not feel safe, or it was not the best thing to be found on the street late at night.
They were arrested at the slightest provocation. (1956-57)
Another of the social causes of the migrant's leaving was that at times they did not feel safe, or it was not the best thing to be found on the street late at night.
They were arrested at the slightest provocation. (1967-68)
Another of the social causes of the migrant's leaving was that at times they did not feel safe, or it was not the best thing to be found on the street late at night.
They were arrested at the slightest provocation. (1968-69)
Another of the social causes of the migrant's leaving was that at times they did not feel safe, or it was not the best thing to be found on the street late at night.
They were arrested at the slightest provocation. (1979-80)
Another of the social causes of the migrant's leaving was that at times they did not feel safe, or it was not the best thing to be found on the street late at night.
They were arrested at the slightest provocation. (1989-90)
Another of the social causes of the migrant's leaving was that at times they did not feel safe, or it was not the best thing to be found on the street late at night.
They were arrested at the slightest provocation. (1990-91)
Another of the social causes of the migrant's leaving was that at times they did not feel safe, or it was not the best thing to be found on the street late at night.
They were arrested at the slightest provocation. (2002-03)
Another of the social causes of the migrant's leaving was that at times they did not feel safe, or it was not the best thing to be found on the street late at night.
They were arrested at the slightest provocation. (2013-14)
Another of the social causes of the migrant's leaving was that at times they did not.
They were arrested at the slightest provocation.

They were arrested at the slightest provocation.
They were ~~arrested~~ at the slightest provocation.

They were ~~arrested at~~ the slightest provocation.

They were ~~arrested at the slightest~~ provocation.

They were ~~arrested at the slightest provocation.~~

They were
They were.

Jacob Lawrence Migration Series Panel 22

Rita Dove

Say Grace

Jacob Lawrence: The Great Migration Series, panel 10

Got a spoon
Got a pan
Got a bucket for the scraps

Got a nail to hang our things on
A wish
An empty sack

Dear Lord bless our little bit
This table
Our beds

Dear Lord who made us
And the world
Now can we raise our heads

Protocol

Jacob Lawrence: The Great Migration Series, panels 22, 14

If they ask your name, give it.
If they shout, think: Sorry souls.

If they shove, remember water.
If they kick, remember grain.

Stand up inside yourself.
Your mama taught you who you are.

Natasha Trethewey ## As the Crow Flies

—from Mississippi

In every town Negroes were leaving by the
hundreds to go north and enter into Northern
industry. (1940–1941)

Of the four went three:
Hubert, Roscoe, Sugar—not
my grandmother, Lee.

Patricia Spears Jones # Lave

The female worker was also one of the last groups to leave the South (1940–41)
The female workers were the last to arrive north (1993) captions by Jacob Lawrence

Where is the lavender, the purple scent
that says the world is fresh and ready to receive
The woman who walks into whatever room
She walks into. What room will she enter

How will the female worker smell? Lemon, mint,
Roses crushed for homemade soap. No place
Here for the boiling recipe. There is no room.

And her extra money, how will she make it?
Who will she *do* for? How will she get there?
Will she find her old friends, her lovers?
She is lonely.

The artist says in Panel 57 that the female worker
(not Negro, not migrant) *is the last group* to leave the South

One woman is her own group?
Was she ready to leave or was she
Left behind? Caring for: baby, grandfather
Brother, sister, cousin, an elderly aunt?
Was her garden where the family sought
Nurture?
Were her skills at picking cotton so great
The bosses did all they could to keep her
Was there a fourth child, not wished for?
Does her skills at baking, barter, cooking,
Cleaning, farming, soap making
Create a one woman group?

The series narrate whole communities departing
Excited, wary, desperate, adventurous.

Much about the South is unseen or not shown—
The painter understands the usefulness of obscenity
Lynching
Hunger
The crops failing (boll weevil, boll weevil)

And so we see the cotton ball
But not the bleeding hands that pick
We see the rope dangling
We see the meagre rations of meat
And bread. And the table set—no plenty.

Is this the start of a woman's true blues
The men go ahead/The women stay behind and everyone is lonely?

In many of the paintings' planes, she is not seen
preparing the meals, cleaning, sewing , packing
Clothes to last for as long as they can last in the
Distant cities of Chicago, Pittsburgh, Detroit.
She is not seen crying at the preacher's table
Or burying her head into the broad chest of the man
Who gets up before sunrise to make it to the station/
Ticket in hand.

The men knew the hardships ahead, others were ignorant
Enough to believe the stories of plenty of work; plenty of
Food; plenty of shelter. All wanted a way out of
Dixie on a very bad day. Wanted out of stuck.

Women might want to believe in these stories—tall tales
But too many unwelcome hands, tongues, penises had found
Their bodies much too easily. A white man's promise
Of a better life up past the Mason-Dixon Line is some *thing*
to believe when fish fly on Friday and hogs dance a reel.

She will leave for the north and go to the cities
She will find the church where her bible meets the preacher's
Holy hollering and the music sounds as sweet
as in the Back woods.
She will see the kind of dresses she wanted to make
From the Butterick patterns at the notions counter.
The same counter where she finds the yellow ribbons
that tie the braids of the young girl in Painting 21
who arrived early to get on the train
going North.

Is this the start of another woman's blues
To journey north and find the men mired
To journey north and find her skills unknown
To journey north and discover an even greater loneliness

The female worker gets that ticket and joins that
Motion forward—the many shoulders, legs,
hands stretched across the paintings' frames counting
the rails away away away from Dixie Land.

Head bowed, holding an orange dolly
The laundress is charged with purgation.
Removing the dust and dirt and stains of city living
The marks of many sins: sex, drink, the opium den.

These swirling oblong colors rest
Beneath her gaze as if she has the power
To make this job seem better than
Picking cotton or hog butchering or taking
In washing for the old Gentleman
who pinches her breasts for that extra
Nickel.

Last to arrive north.
But first to see the way home/to make a home.
Put her skillets on the hot plate; shelves her mason jars
Full of peach preserves, pickles, tastes of home.
Chenille spreads on the lumpy mattresses
The Chicago Defender on a kitchen table.
Biscuits rising before sunrise.
Greens found in a market run by Italians.

She stands in this painting
A cruciform of desire
In a center of beauty
Dressed in white, the orange stick
Her cudgel, her sword. The laundry
Her step on that ladder to the future.

A migrant from the back of the bottom
Or a town just big enough for the railroad to notice
Gone to the city and its bitter possibilities so that
Church is a hearthstone and eau de cologne—
Lavender, roses, vanilla, hints of—a necessity.

Kevin Young **Thataway**

And the migrants kept coming
—Jacob Lawrence

Was walking. Was
walking & then waiting
for a train, the 12:40
to take us thataway.
(I got there early.)
Wasn't a train
exactly but a chariot
or the Crescent Limited come
to carry me some
home I didn't yet
know. There were those
of us not ready till good
Jim swung from a tree
& the white folks crowded
the souvenir photo's frame—
let his body black-
en, the extremities
shorn—not shed,
but skimmed off
so close it can be shaving
almost. An ear
in a pocket, on a shelf,
a warning where a book
could go. So
I got there early.
See now, it was morning
a cold snap, first frost
which comes even
here & kill the worms
out the deer. You can
hunt him then
but we never did want,
after, no trophy
crowned down
from a wall, watching—
just a meal, what
we might make last
till spring. There are ways
of keeping a thing.

Then there are ways
of leaving, & also
the one way. That
we didn't want.
I got there early.
Luggage less sturdy
(cardboard, striped, black)
than my hat. Shoebox
of what I shan't say
lunch on my lap.
The noise the rails made
even before the train.
A giant stomach growling.
A bowed belly. I did
not pray. I got there
early. It was not
no wish, but a way.

Index

Credits

All works by Jacob Lawrence © 2015 The Jacob and Gwendolyn Knight Lawrence Foundation, Seattle/Artists Rights Society (ARS), New York.

In reproducing the images contained in this publication, the Museum obtained the permission of the rights holders whenever possible. In those instances where the Museum could not locate the rights holders, notwithstanding good-faith efforts, it requests that any information concerning such rights-holders be forwarded so that they may be contacted for future editions.

Photograph by Jack Allison, courtesy Prints and Photographs Division, Library of Congress, Washington D.C.: 35 bottom left.

Photograph by James L. Allen, courtesy Harmon Foundation Collection, National Archives and Records Administration, College Park, Md.: 35 top (image photographed by Joe McCary).

© Henry Wilmer Bannarn, courtesy Hassie Bannarn Betz: 36 (sculpture).

Art © Romare Bearden Foundation/Licensed by VAGA, New York, NY, courtesy AFRO-American Newspapers Archives and Research Center: 20.

Courtesy Bennett College, Greensboro, N.C.; art © Heirs of Aaron Douglas/Licensed by VAGA, New York, NY: 18.

© Bettmann/CORBIS: 42 bottom.

© 2015 Corinth Films, Inc., photograph The Museum of Modern Art Film Stills Collection: 23.

Courtesy Stephanie and David Deutsch: 40.

Courtesy Manuscript, Archives, and Rare Book Library, Emory University: 22 bottom left.

Courtesy EverGreene Architectural Arts (mural conserved and restored by EverGreene Architectural Arts): 14.

Photograph by Franklin Ferguson Hopper: 6.

Hulton Archive/Getty Images: 26 bottom.

Courtesy Manuscript Division, Library of Congress, Washington, D.C.: 25.

Courtesy Harmon Foundation Collection, National Archives and Records Administration, College Park, Md.: 2, 32, 41 (all images photographed by Joe McCary).

Digital image © The Museum of Modern Art/Licensed by SCALA/Art Resource, NY: 4, 21 bottom, 168.

The Museum of Modern Art, Department of Imaging Services: 21 top (book spread photographed by Thomas Griesel), 38–39 (all images by John Wronn; portrait on opening spread of *Fortune* by Kenneth F. Space, Harmon Foundation Collection, National Archives and Records Administration, College Park, Md).

The Museum of Modern Art, Department of Imaging Services (book spread photographed by Thomas Griesel); © Bettmann/CORBIS (photo on left in book spread); © 1941 Richard Wright (captions in book spread): 22 bottom right.

Digital image © The Museum of Modern Art/Licensed by SCALA/Art Resource, NY, photograph by Eliot Elisofon: 34 left, photograph by Soichi Sunami: 42 top.

Photograph © The Gordon Parks Foundation, head of Harold Kreutzberg © Richmond Barthé Trust: 35 bottom right.

Courtesy The Phillips Collection Archives, Washington, D.C.: 34 right.

Courtesy Michael Rosenfeld Gallery LLC, New York, NY: 22 top.

Photographs © Morgan and Marvin Smith: 16, 24.

© 1939–1940 The Charles White Archives: 19.

© 1941 Joshua White, Folk-Blues Music Co./ASCAP (lyrics); courtesy Estate of Josh White, Sr., Folk-Blues Music Co./ASCAP (album); courtesy Elizabeth Campbell Moskowitz (album design); images reprinted courtesy Mercury Records, Inc., under license from Universal Music Enterprises, a Division of UMG Recordings, Inc.; © 1941 Richard Wright (liner notes): 27.

Published in conjunction with exhibitions featuring Jacob Lawrence's Migration Series organized by The Museum of Modern Art, New York, and The Phillips Collection, Washington, D.C., in collaboration with the Schomburg Center for Research in Black Culture.

One Way Ticket: Jacob Lawrence's Migration Series and Other Visions of the Great Movement North,
presented at The Museum of Modern Art, New York, from April 3 to September 7, 2015, is organized by Leah Dickerman, Curator, with Jodi Roberts, Curatorial Assistant, Department of Painting and Sculpture.

People on the Move: Beauty and Struggle in Jacob Lawrence's Migration Series,
presented at The Phillips Collection, Washington, D.C., from September 10, 2016, to January 17, 2017, is organized by Elsa Smithgall, Curator.

The MoMA presentation and accompanying initiatives are made possible by the Ford Foundation.

Major support is provided by The Museum of Modern Art's Research and Scholarly Publications endowment established through the generosity of The Andrew W. Mellon Foundation, the Edward John Noble Foundation, Mr. and Mrs. Perry R. Bass, and the National Endowment for the Humanities' Challenge Grant Program.

Generous funding is provided by The Friends of Education of The Museum of Modern Art, Marie-Josée and Henry Kravis, MoMA's Wallis Annenberg Fund for Innovation in Contemporary Art through the Annenberg Foundation, Karole Dill Barkley and Eric J. Barkley, and the MoMA Annual Exhibition Fund.

Special thanks to the Jacob and Gwendolyn Knight Lawrence Foundation.

The Phillips Collection is grateful to A. Fenner Milton, Judy and Leo Zickler and the Zickler Family Foundation, and the Henry Luce Foundation for their generous support of the museum's Jacob Lawrence microsite launched in conjunction with the exhibition. We are also grateful to Kymber and Bo Menkiti for their support of The Phillips Collection's exhibition and microsite on the occasion of Menkiti Group's tenth anniversary.

Produced by the Department of Publications, The Museum of Modern Art, New York

Christopher Hudson, Publisher
Chul R. Kim, Associate Publisher
David Frankel, Editorial Director
Marc Sapir, Production Director

Edited by David Frankel
Designed by poly-mode, Silas Munro, with Brian Johnson
Production by Matthew Pimm
Printed and Bound by Conti Tipocolor S.p.A., Florence, Italy

This book is typeset in Eames Century Modern by House Industries and Plan Grotesque Condensed by Typotheque. The paper is 130gsm Hello Fat Matt.

Published by The Museum of Modern Art
11 West 53 Street
New York, New York 10019
www.moma.org

and

The Phillips Collection
1600 21st Street, NW
Washington, D.C. 20009
www.phillipscollection.org

Distributed in the United States and Canada by
ARTBOOK | D.A.P., New York
155 Sixth Avenue, 2nd floor, New York, NY 10013
www.artbook.com

Distributed outside the United States and Canada
by Thames & Hudson ltd
181A High Holborn, London WC1V 7QX
www.thamesandhudson.com

Printed in Italy

Cover: Jacob Lawrence. The Migration Series. 1940–41. Panel 60: "And the migrants kept coming. And the migrants kept coming" (detail). Casein tempera on hardboard, c. 18 by 12" (45.7 x 30.5 cm). The Museum of Modern Art, New York. Gift of Mrs. David M. Levy. See p. 167

Frontispiece: Jacob Lawrence with Migration Series panel 44, c. 1941. Harmon Foundation Collection, National Archive and Records Administration, College Park, Md.

P. 4: Jack Delano. *Group of Florida migrants on their way to Cranberry, New Jersey, to pick potatoes. Near Shawboro, North Carolina.* 1940. Gelatin silver print, 7 3/16 x 9 1/2" (18.3 x 24.2 cm). The Museum of Modern Art, New York. Purchase

P. 6: northeast corner of West 135th Street and Lenox Avenue, Harlem, with view of a residential building adjacent to the 135th Street branch library (now the Schomburg Center for Research in Black Culture), 1919. Photographs and Prints Division, Schomburg Center for Research in Black Culture, The New York Public Library, Astor, Lenox and Tilden Foundations

Trustees